DATE DUE

E - 9 '0			

Demco, Inc. 38-293

t Crown Point Press

Thirty-Five Years at Crown Point Press : Making Prints, Doing Art

FINE ARTS MUSEUMS OF SAN FRANCISCO

Crown Point Press

Karin Breuer

Ruth E. Fine

Steven A. Nash

THE UNIVERSITY OF CALIFORNIA PRESS

BERKELEY LOS ANGELES LONDON

THIRTY-FIVE YEARS AT CROWN POINT PRESS:
MAKING PRINTS, DOING ART

has been published in conjunction with the exhibition
Thirty-Five Years at Crown Point Press
organized by the Fine Arts Museums of San Francisco
and the National Gallery of Art.

National Gallery of Art, Washington
8 June 1997 — 1 September 1997

Fine Arts Museums of San Francisco
California Palace of the Legion of Honor
4 October 1997 — 4 January 1998

University of California Press
Berkeley and Los Angeles, California

University of California Press, Ltd.
London, England

Published in association with the Fine Arts Museums of San Francisco

Published with the assistance of the Andrew W. Mellon Foundation Endowment for
Publications; the Achenbach Graphic Arts Council; and the National Endowment
for the Arts, a Federal agency.

Cataloging-in-Publication data is on file with the Library of Congress.
ISBN: 0-520-21061-1 (softcover)

Printed in Hong Kong
9 8 7 6 5 4 3 2 1

Front and back cover image: *HV2 19c*, John Cage, 1990 (cat. 198)
Frontispiece images: *CrownPoint*, Sol LeWitt, 1980 (cat. 68)

Contents

Director's Foreword

Crown Point Press is widely acknowledged as one of America's foremost contemporary print publishers. Founded and guided by Kathan Brown, the Press has worked with nearly one hundred artists since its beginnings in 1962 — from Richard Diebenkorn, Helen Frankenthaler, Pat Steir, Wayne Thiebaud, and William T. Wiley, to Vito Acconci, Chris Burden, John Cage, Joan Jonas, and Dorothea Rockburne. Among its achievements is the revival of etching as a medium of serious contemporary art.

The Crown Point Press Archive was acquired in 1991 by the Fine Arts Museums of San Francisco with an initial purchase and gift, bringing into a museum collection the work of one of the great print publishing houses in the country not to be so represented. The acquisition consisted of one impression of every print the Press had produced, a large number of Working Proofs, preparatory sketches, copper plates, and other technical materials. Brown and the Press donated a number of important prints and continue to donate an impression from every edition produced, contributing to a collection that numbers 3,699 works.

The work of acquiring the Crown Point Archive owes in large part to the efforts of Steven A. Nash, Associate Director and Chief Curator of the Museums. Phyllis Wattis, a longtime benefactor to the arts and culture of the Bay Area and an admirer of Brown and Crown Point Press, was a leading donor in the fundraising effort. Her efforts were enthusiastically supported by thirty-seven other donors. Major contributors include Mr. and Mrs. Gordon P. Getty, Mr. and Mrs. George R. Roberts, the Museum Society Auxiliary, Mr. and Mrs. Robert J. Bransten, Mr. and Mrs. John N. Rosekrans, Jr., members of the Graphic Arts Council, Mr. and Mrs. Peter McBean, Mr. and Mrs. George M. Marcus, Mr. and Mrs. Douglas W. Grigg, Dr. and Mrs. Joseph R. Goldyne, and Mrs. Jack N. Berkman.

We are especially pleased that the exhibition will be shown first at the National Gallery of Art, and we express our thanks to Earl A. Powell, Director, and the Gallery's Board of Trustees for presenting the exhibition in Washington. In conjunction with the opening, the Gallery announces its recent acquisition of a major collection of Crown Point Press "OK to Print" Proofs and other impressions.

Work on the exhibition and the catalogue *Thirty-Five Years at Crown Point Press: Making Prints, Doing Art* was undertaken by Karin Breuer, whose essay demonstrates the value of the Archive as an art-historical research tool. She is joined in her curatorial efforts by Ruth E. Fine, Curator of Modern Prints and Drawings at the National Gallery of Art. Fine, who was actively involved in the exhibition and catalogue from the start, provides a valuable profile of Kathan Brown and Crown Point Press. Nash, also a cocurator, writes on the importance of prints in the creative process of artists who worked at the Press.

It is particularly gratifying to the Fine Arts Museums of San Francisco that through our efforts the Archive of this innovative press is retained in the Bay Area. But it is to Kathan Brown that we owe our primary thanks for holding fast to her vision throughout the years.

HARRY S. PARKER III
Director
Fine Arts Museums of San Francisco

IX

Acknowledgments

Richard Diebenkorn's words to Kathan Brown during a 1963 printmaking project at Crown Point Press — that he'd rather be "doing something" than "making something" — have inspired the title for this publication. The "doing" of some of the most admired prints of the past thirty-five years by artists working at Crown Point brought the Press well-deserved international recognition. Brown's remarkable achievements were also recognized by Steven A. Nash, Associate Director and Chief Curator of the Fine Arts Museums of San Francisco, who was the primary force in acquiring the Crown Point Press Archive for the Museums in the spring of 1991. His efforts, and those of the Director, Harry S. Parker III, and Acquisitions Committee Chair, Robert J. Bransten, culminate with this exhibition and catalogue honoring Kathan Brown and Crown Point Press.

I thank my cocurators, Steve Nash and especially Ruth E. Fine, Curator of Modern Prints and Drawings at the National Gallery of Art. I am grateful for their efforts in the selection of works for the exhibition, their thoughtful essays, and their most welcome suggestions for the catalogue manuscript.

The staff at Crown Point Press, particularly Mari Andrews, Sasha Baguskas, and Valerie Wade, supplied essential information and have been very helpful with the many questions posed throughout the organizational phases of this catalogue and exhibition. I also acknowledge with thanks Pamela Paulson, a Master Printer formerly with Crown Point Press, who assisted in the preparation of the

exhibition checklist by identifying the complicated printmaking processes involved in the creation of the prints. Hidekatsu Takada, a Master Printer with Crown Point for nine years, has also been extremely helpful with insights and information as the catalogue essays were evolving.

I thank my fellow staff members at the Achenbach Foundation for Graphic Arts, the repository for the Crown Point Press Archive at the Fine Arts Museums of San Francisco, notably Robert Flynn Johnson, Maxine Rosston, and Mark Garrett. In addition, I gratefully acknowledge the efforts of the many museum volunteers who have catalogued the numerous prints in the Archive since its acquisition, particularly John Flather and Evelyn Packer, and also Adriane Dedic, Stephanie Mayer, Allison Pennell, and Emily Peters.

My colleagues at the Fine Arts Museums have participated in many ways during the preparation of the exhibition and catalogue. I thank Robert Futernick, Chief Conservator, for developing an innovative computerized database of the Archive that has allowed much of the preparation for this catalogue to be performed in record time. Through his efforts, a digitized catalogue of the Archive is now available on the World Wide Web (http://www.thinker.org). I am grateful to Debra Evans of the Western Regional Conservation Laboratory for providing invaluable advice on the housing, mounting, and framing of the many works in the exhibition.

Ann Karlstrom and Karen Kevorkian of the publications department cheerfully presided over the catalogue creation. Joe McDonald is to be commended for his photography of over 200 prints serving as illustrations in the catalogue, Michael Sumner designed the catalogue and Melody Sumner Carnahan edited the texts. On behalf of my coauthors, I thank them.

The Achenbach Graphic Arts Council, under the direction of Andrew C. McLaughlin III (1992–1996) and Nancy Constine (1996 to the present), has been unwavering in its encouragement of this project. This membership group contributed significantly not only to the acquisition of the Archive but also towards this publication. I am pleased to acknowledge their enthusiastic support.

I extend deepest appreciation to Kathan Brown without whom the Crown Point Press Archive, this publication, and the exhibition could not have existed. Her advocacy has inspired great enthusiasm for this project over the past five years. Tom Marioni has also been extremely gracious and informative to Ruth Fine and myself as the catalogue and exhibition were being prepared. I am grateful for his ongoing interest and assistance. Finally, I thank the many artists whose printmaking at Crown Point Press has provided some of the most beautiful and memorable art of the last four decades.

KARIN BREUER

Associate Curator
Achenbach Foundation for Graphic Arts

FIG. 1
Kathan Brown printing in the first Crown Point Press studio, Point Richmond, California, 1962

Kathan Brown
and
Crown Point Press

RUTH E. FINE

CROWN POINT PRESS, founded in the San Francisco Bay Area in 1962, is among the oldest and most highly respected of a talented corps of printers, publishers, and printer/publishers operating collaborative printmaking workshops in the United States, a center of printmaking activity. Printmaking and print publishing have evolved during the second half of the twentieth century as virtually every artist of stature has explored the indirect processes of picture making that yield multiple original printed images: intaglio, lithography, stencil, and relief. Invitations from printmaking workshops have enabled painters and sculptors not interested in the repetitious nature of printing editions, or in mastering minute details of complex techniques, nevertheless to complete printmaking projects of significance.[1]

In addition to Crown Point Press, other important workshops include Universal Limited Art Editions (ULAE) founded on Long Island in 1955 by Tatyana Grosman, the talented Russian-born entrepreneur who worked with such major artistic figures as Helen Frankenthaler, Jasper Johns, and Robert Rauschenberg. Also important is Tamarind Lithography Workshop, opened in Los Angeles in 1960 by artist June Wayne with financial support from the Ford Foundation.

One aim of Tamarind was to train Master Printers in the lithography methods important to Wayne's own artistic work and which she feared would be lost for lack of skilled practitioners. Tamarind also introduced artists of diverse styles to the lithography process, many of whom had already specialized in other printmaking media, such as Adja Yunkers

who was expert with woodcut. Among the painters and sculptors invited to Tamarind during the workshop's decade in Los Angeles were Richard Diebenkorn, Sam Francis, Louise Nevelson, and Ed Ruscha.[2] Artists took with them for their own distribution the editions produced at Tamarind; thus, this workshop, distinct from Crown Point Press, ULAE, and others, was not technically functioning as a publisher, whose role includes supporting projects financially at the outset and marketing them when they are completed.

Gemini Ltd., also in Los Angeles, was founded in 1965 by Kenneth Tyler, one of Tamarind's first Master Printer graduates. Originally, Tyler supported his publications by operating as a contract shop (printing for other publishers), but in 1966 the name of his enterprise was changed to Gemini G.E.L. and he dropped contract work to concentrate on publishing in partnership with Sidney B. Felsen and Stanley Grinstein, who continue to run Gemini today. Some artists who worked at ULAE also worked at Gemini, including Rauschenberg and Johns; and Gemini is credited with introducing lithography to Frank Stella, and collaborating with Roy Lichtenstein on some of his most ambitious print projects. Later, Tyler separated from his partners to open Tyler Graphics Ltd. in New York, where he has put great emphasis on hand paper-making, an essential component of the work done in the new shop by Stella, as well as by Ellsworth Kelly, and David Hockney.

One of the many other workshops established by Tamarind Master Printers is Jack Lemon's Landfall Press, which he opened in 1970 in Chicago after

over a year as director of the lithography studio at the Nova Scotia College of Art and Design in Halifax, the institution credited with introducing the growing interest in lithography into Canada. Landfall's publications include prints by Claes Oldenburg, Pat Steir, and William T. Wiley, all of whom have worked at Crown Point Press, as have Diebenkorn and Ruscha of artists previously mentioned.

Apart from Crown Point Press, the initial process these workshops embraced (excepting Tyler's later enterprise) was lithography, the drawing of images directly on limestone or specially prepared metal plates, which was considered the printmaking technique best synchronized with the spontaneity and directness of painterly impulses. All but Tamarind later branched out to work in other media. Screenprinting in fact was found equally, if not more, sympathetic to the hard-edge abstractions and Pop imagery many artists explored during the 1960s.[3] Moreover Gemini and Tyler Graphics, referred to as *print* workshops to this day, also published edition sculpture.

By contrast to these other enterprises, Crown Point Press for its first two decades had the distinction of exploring exclusively the intaglio, or etching, media (the terms are generally used interchangeably). Crown Point was founded by Kathan Brown with her husband at the time, painter/printer/musician Jeryl Parker. Parker's role was relatively short-lived, so the Press is associated with Brown's name alone. In keeping with the gender hierarchy of the early 1960s, however, the brochure for the first exhibition (in 1963) of prints from what was called the "Crown Point Intaglio Workshop" described the Press as having been founded by Jeryl Parker and his wife, Kathan Brown.[4]

Brown was drawn to intaglio printing (and to relief printing two decades later) because these techniques "use old processes that have no commercial value andp need all the help they can get to stay alive."[5] Brown's interest in sustaining intaglio printmaking bears some relationship to Wayne's purpose for Tamarind — to breathe new life into a specific medium.[6] This impulse was in marked contrast to Tyler's philosophy which, according to his foremost chronicler, Pat Gilmour, was rooted

in large measure on "the belief that craftsmen working in a society based on technology and automation had to capitalize on new materials and techniques."[7]

Crown Point Press has been in existence nearly as long as ULAE and Tamarind, and longer than most other workshops active today; and the Press has been as influenced by Brown's personality and style as the others were by those of Grosman and Wayne respectively.[8] But despite numerous studies in recent years about important women in the arts, Brown has yet to achieve the renown of these other influential founders of printmaking workshops. Her more "underground" reputation is undoubtedly owing to a combination of factors, among them her quiet style and her youth when she started Crown Point, at age twenty-seven.

The Press's West Coast location, in relation to the art establishment in the East, was an important factor as well. Also, San Francisco was a less ebullient artistic milieu than Los Angeles, as suggested in a 1975 interview Brown conducted with Oldenburg that contrasted artistic activity in the two California cities. Brown commented that "people started coming out here to make etchings at Crown Point four years ago. Now [gallery owner] Dan Weinberg is bringing people and occasionally a museum or art school brings someone. But it's still slow."

Oldenburg's response was: "Well, the reason it's slow may be that there aren't too many collectors out here. That always makes a big difference. Los Angeles is a better market."[9]

Other reasons for Brown's more low-key reputation are that, during the 1960s, printing and publishing were part-time activities for her — a struggling young artist financially dependent on secretarial jobs until 1966 when she began teaching printmaking at the San Francisco Art Institute. Also, from 1971 through 1977, overlapping with Brown's teaching, Crown Point functioned mainly as a contract printing shop for other publishers whose names were more prominently associated than Crown Point's with the work produced.

Paradoxically, other considerations that subdued Brown's visibility have secured her singular place in the story of late twentieth-century printmaking. For

example, the intaglio methods she embraced arguably yield the most visually quiet and complex printed surfaces, and, in addition, because of particular demands that structure etching presses, etchings generally are worked at a smaller scale than has come to be common for contemporary lithographs, screenprints, and woodcuts. It was these quiet processes at small size that Brown championed, introducing them to a wide range of artists who wished to explore them, or with Brown's encouragement were willing to try at a time when bigger, brighter, bolder prints were receiving great acclaim for rivaling paintings in their powerful presence on a wall.

Indeed, Brown's importance, in part, is based on the major role she played in pioneering the intaglio media among late twentieth-century painter/print-makers when lithography and screenprinting were dominating the movement. It is important to remember, however, that intaglio methods *were* popular among specialist printmakers working at this time, guided by traditions established at Stanley William Hayter's Atelier 17, the highly influential printshop temporarily transferred from Paris to New York during World War II and operating into the early 1950s.[10]

In addition, the dozens of artists from around the world to whom Brown has introduced intaglio/etching represent an exhilarating array of artistic points of view: figurative painters of such diversity as Wayne Thiebaud and Italo Scanga; Conceptual and performance artists such as Tom Marioni and Joan Jonas, whose work would have more modest appeal for mainstream print aficionados. Thus, the roster of artists whose prints Brown has published is as distinctive from that of other print studios as is her commitment to these processes.

THE START OF CROWN POINT PRESS

Born in New York City in 1935, Kathan Brown spent most of her childhood in Florida. Her mother, Clarissa, an indomitable women who had studied at the Art Institute of Chicago, was the backbone of the family. The first of Clarissa's two children and her only daughter, Kathan, inherited her inquiring mind and adventurous spirit. Brown's paternal grandmother, a successful business woman, was a

profound influence on her as well. Louise Brown had engaged in the manufacture of hand-embroidered silk lingerie for several years in the 1920s, when she was with her missionary husband in the Phillipines. Her business would inspire a short-lived project at Crown Point Press in the early 1980s. Before that, however, on several occasions Brown's grandmother's material support facilitated important ventures in her life, for example, her education at Antioch College where she started as an English major but took courses in art. Equally important to her education were the work-study program at the college and the generally stimulating atmosphere on campus.

According to Brown, Antioch was "a very exciting, liberal thinking, intellectual place to be at that time. We were all interested in Zen."[11] This commitment to Eastern philosophy, Zen in particular, remained important to her approach to life and has undoubtedly served her well over the years in her ability to assume a somewhat detached, nonjudgemental approach to events that swirled around her, slightly apart from the mainstream, while remaining an important participant in late twentieth-century artistic developments.

Planning for her junior year abroad, Brown decided to shift her major from English to art and to attend the Central School of Arts and Crafts in London. There, she especially enjoyed drawing classes given by painter Roger Hilton, and a basic design course with sculptor William Turnbull, which, according to Brown, was more accurately a study of the philosophy of contemporary art. She tried and rejected lithography, but became captivated by intaglio printmaking, which, as she has described it "was tactile, and I enjoyed developing the skill. The Zen idea is that you become so skillful that you don't even have to think about what you are doing while you are doing it. I really was trying to develop etching skills to that point. . . . I believed, and still believe, in a devotion to it and in the discipline of it."

Traditionally, an intaglio print requires an image to be embedded in a metal matrix, usually copper; the copper plate is then inked and the image transferred from the inked plate to a substrate, usually paper. An artist manipulates tools and chemicals in

a variety of ways to create his or her image: hard ground and soft ground etching typically produce lines, and various lift ground and aquatint methods yield areas of tone. All require portions of the plate to be removed, eaten away, "etched" by acid. Several acids may be used. Nitric diluted in water is a popular one; but at Crown Point, Dutch Mordant, composed of hydrochloric acid diluted in water is most common.

The drypoint, engraving, and mezzotint methods, by contrast, call for direct physical work on the metal using the appropriate tools: needles, burins and gravers, rockers and roulettes, each of which yields a distinctive mark. The grooves, whether etched or carved into the metal, carry the ink which is transferred to paper under great pressure from an etching press. Multiple plates often are employed for multi-color prints.[12]

Brown returned to Antioch as a senior, graduating in the spring of 1958. Another year of study at the Central School in London followed, during which etching became her preoccupation, as it has remained for four decades. Brown's teachers included artists Merlyn Evans and Tony Harrison, and a craftsman, Jack Coutu, an etcher of bird pictures. Coutu emphasized a rich but crisp-looking print resulting from the combination of a plate that employs a complexity of preparatory methods (for example, combining hard ground etching with aquatint and drypoint), and from "wiping the surface of the plate so the image results from marks held in the plate rather than from uneven surface tone. Put the work into the plate," Brown recalls Coutu saying, "then you can print consistently."

The concern with maintaining consistency throughout an edition was antithetical to the printing practices at Hayter's Atelier 17 which were then popular in the United States. For Hayter, collaboration in printing was not between artist and printer but between an artist's improvisatory impulses and the materials he or she was using.[13] In the tradition of Rembrandt and Whistler, Hayter believed the artist must *do*, rather than direct, every stage of the printmaking process. For him and his admirers, each impression in an edition might be enhanced by printing it differently from the others purposefully, because of how the plate was inked and wiped.

For both Hayter and Brown it was essential, in the final preparation for the press, that the printer wipe excess ink from the surface of the etched plate with his or her hand. By varying the hand's pressure and leaving more surface ink in some areas than in others to give tonal variation, Hayter and his followers added to the complexity of the work in the plate itself, and developed individualized images within an edition. Brown and the printers she has trained, by contrast, emphasize consistent editions achieved by wiping the plate's surface evenly and with a delicate touch,

FIG. 2
Kathan Brown handwiping a copper plate, 1972

swiping across it "with whispers and caresses"[14] for every print in the edition — what Brown refers to as printing "straightforwardly." In addition, Brown incorporated into her platemaking procedures the extensive use of aquatint, which Hayter did not favor. Brown remembers him lecturing in the 1970s, saying "aquatint destroys line and drives out light."

Brown had little if any awareness of Hayter and his followers when she took up etching, so she was by no means rebelling by pursuing an alternate course. But rebel she did, making her contribution to the current practice of etching a new approach in which, 1) aquatint played a prominent role among processes used to develop the plate's surface, and, 2) the plate itself carries the *entire* image with none of its subtle modulations dependent upon printing variations.

In the summer of 1959, during a holiday trip before her return to the United States after her

second year in London, Brown discovered in the backyard of a rooming house in Edinburgh a dismantled etching press. It had been spirited there to prevent its being melted down during World War II, and apparently remained ignored until Brown was offered it and made it her own. With press on board she traveled by freighter for two and a half months, through the Panama Canal to San Francisco where she joined Jeryl Parker, also a student at the Central School. She set up the treasured press in the studio of Parker's friend, artist John Ihle, where it remains to this day. There it was shared by several members of the California Society of Etchers (now part of the California Society of Printmakers), who were intrigued by the techniques Brown and Parker had learned abroad.

The couple married in 1960 and soon moved from San Francisco to Oklahoma, where Parker spent a brief period in the Army, leaving the etching press behind. By the time Parker was released from service Brown was pregnant, and her grandmother Louise Young (she had remarried after Mr. Brown died) offered the couple a rent-free cottage on her Van Hornesville property in New York. Their only child, Kevin, was born there in 1961.[15] Brown had continued with her work as an artist throughout this period, exhibiting when opportunities arose. On the move to Van Hornesville she received a few commissions for etchings, and since her press had remained on the West Coast, she purchased a Craftool table-top model to print the editions.

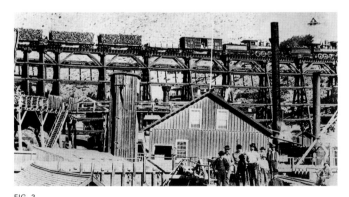

The financial benefit of the Van Hornesville cottage was countered by inhospitable weather, its severity intimated by Brown's comment on domestic life: "I'd take this pail of wet diapers down to the big house to use the washing machine and by the time I got them down there they were all frozen." One winter was enough. In early 1962 the Brown/Parker family returned to the Bay Area, crossing the country in a Volkswagen bus: baby, cats, and new printing press in tow. They rented in Richmond, across the bay from San Francisco, a storefront studio space for the press with living quarters adjacent. This marked the start of Crown Point Press.

The Press name was inspired by a nineteenth-century photograph of Crown Point Gold Mine employees (fig. 3). Brown admired their obvious pleasure in building a railroad trestle strong enough to support two train engines. Intuitively, she saw their accomplishment as a metaphor for the printmaking odyssey upon which she was embarking. Soon after starting Crown Point, Brown traveled to Los Angeles to visit June Wayne at Tamarind. Wayne introduced her to the concepts of Master Printers, *bon à tirers* (the printed impressions that are used as the standards for the editions), what Brown calls the "OK to Print" Proofs, and other aspects of running a professional printshop.[16]

Brown's goals, however, were different from Wayne's, which, in addition to training printers and introducing lithography to artists also involved research into the overall needs of print workshops.[17] By contrast, Brown's intention at that time was less ambitious. She wanted to print and publish her own etchings and those of her friends. She started out by modeling Crown Point Press on a cooperative studio run by her artist friend Birgit Skiöld, The Charlotte Street Print Workshop in London. As at Skiöld's studio, artists worked at Crown Point for an hourly or daily rate. Among those who worked there in the early years were Roy DeForest and Diebenkorn. Some artists printed and published their own editions, others paid Brown (and Parker at the start) to print for them.[18] Later, when Crown Point was responsible for publishing as well as printing, Brown assumed expenses for the projects.

THE BERKELEY STUDIO

Grandmother Young reentered the picture in 1963 with a gift of funds for a down payment on a house in North Berkeley. Brown and Parker were separating (they have remained professional colleagues and friends), but with his help, including his building some of her studio furniture and equipment, she set up Crown Point's second home in the basement of the Berkeley house, where it remained until 1972 (fig. 4). "The studio was pretty small," remembers Wayne Thiebaud who worked there frequently in the mid-1960s, "with a low ceiling; fairly straightforward and modest in size. But it was nice."[19] It must have been rather crowded, fully equipped as it was with worktables, acid baths, aquatint box, press, and print drying racks.

FIG. 4
The tabletop press in the second Crown Point Press studio, Berkeley, California, 1968

To support herself and her son, in addition to running the workshop and printing for other artists, Brown taught etching classes at Crown Point, and from 1966 through 1974 at the San Francisco Art Institute, serving as chair of the printmaking department for the last two years. Throughout this period she exhibited her own prints (mainly photoetchings starting about 1971) and built her reputation as an artist. [20]

Brown's attitudes about teaching relate closely to the expansive atmosphere of Crown Point Press. As Hidekatsu Takada, one of her students whom she later hired as a printer, recalled: "Kathan was not interested in teaching only technical problems [but] in teaching the student as an *artist*. She had students question the reasons why they made prints as an art form, or whether they could do their images in other media. Her seminar was constantly about why you wanted to make a particular image, and in making that image what did you learn. It didn't have to be abstract or representational. Whatever you did was fine. Although she was very interested in Conceptual and Minimal art."[21]

The two artists with whom Brown worked most frequently from 1963 to 1965, just before she started teaching at the Institute, were Diebenkorn and Thiebaud, both of whom, like Brown herself, worked figuratively at the time. Neither of their talents were widely recognized outside of the Bay Area, and both were dedicated and admired teachers who would have had an influence on Brown's ideas about working with young artists and printers. Diebenkorn, moreover, had a profound impact on her ideas about how artists work, and on her development as an artist, printer, and publisher.

Diebenkorn had been a visiting instructor at the University of California, Los Angeles, during the summer of 1961, where he was introduced to drypoint by his graduate assistant. He was immediately sympathetic to this process of drawing directly into copper with a sharp needle-like tool to create a burr of metal that, when inked, printed as a rich, velvety line. The experience was similar to drawing on paper, albeit lacking the flowing nature of a graphite or brush line. When he returned to the Bay Area, Diebenkorn contacted Brown to see if he might join the group of artists

FIG. 5
Richard Diebenkorn's first drypoint made at Crown Point Press, annotated "1" at lower left, pl. 19 from *41 Etchings Drypoints* (cat. 173), 1963

who drew from the model directly onto copper on Thursday nights at her Richmond studio.

Brown has described how Diebenkorn's dislike for printing equaled his enjoyment in drawing, so she took to printing his plates for him. He worked at Crown Point not only in drypoint, but also made line etchings and aquatints; and he worked in drypoint in his home studio, focusing on subjects similar to those of his drawings: family, studio still lifes, landscapes viewed from his windows. The plates that became Diebenkorn's *41 Etchings Drypoints* (fig. 5, cat. 173) were among some 100 he had underway in 1964 when Brown issued the first Crown Point Press imprint, a book of poems by Judson Jerome, *The Ocean's Warning to the Skindiver*, with twenty-one of her own etchings. Impressed by books she had seen at the British Museum while a student, making "books with prints in them" was Brown's focus at the start. It was an interest she shared with both Grosman and Wayne, whose love of *livres d'artistes* also inspired some of their early publications.

Brown published Diebenkorn's *41 Etchings Drypoints* in a small edition of twenty-five, thirteen sets as bound volumes and twelve as unbound portfolios, in 1965. The following year the artist moved south to Santa Monica, and neither worked at Crown Point Press nor did etchings again until 1977.[22] Brown published two other books in 1965, *Delights* (cat. 1) by Thiebaud, the first artist she actually *invited* to the Press for the purpose of publishing his work, and *The Nude Man* (cat. 96) by Beth Van Hoesen, a Crown Point Press regular from the start. *Delights* was in an edition of 100, much larger than *41 Etchings Drypoints*, but likewise made available in both bound and unbound formats.

Crown Point continued for some years to focus on illustrated books, including Fred Martin's *Beulah Land* (cat. 97), 1966, and *Log of the Sun Ship*, 1969; and Bruce Conner's *Dennis Hopper/One Man Show/ Volumes 1–3* (cat. 27), 1971–72. Brown also added publications with her own prints. *Serenade*, one poem from the earlier Jerome book, came out in 1967 followed by three books of Brown's photo-etchings with her texts; 1972 brought *Album*, about her family and memory; 1975, *Sardinia*, filled with views of ruins on the island where Brown took a vacation trip with artist Dorothea Rockburne; and, in 1982, *Paradise*, about places she had visited on a 1978 freighter trip to the South Pacific.

When Brown invited Thiebaud to work at Crown Point she did not know him personally, but she held his work in high esteem. As was true with Diebenkorn when working on *41 Etchings Drypoints*, Thiebaud made far more plates (forty-seven in all) than the seventeen he included in *Delights*. He drove to Berkeley from his Sacramento home in the mornings, worked six or eight or sometimes ten hours, and then drove back. "It was like working in your own house," he has said of the time spent in Brown's Berkeley studio, "and it was a chance to learn about etching and all the things that it could do. I had no notion for instance of aquatints or sugar lifts or soft ground. And Kathan was very patient. She let me make a lot of mistakes, a lot of trial and error which is the only way I know how to work, and that's why it's comfortable working with her." Thiebaud has described the art of making prints with equal enthusiasm: "Layering, or reducing, reversing, the idea of

sequence, attempting to anticipate with a degree of hypothetical power what's going to happen . . . and often happily in some cases making something which is better than what you planned on, is another nice surprise and a characteristic of printmaking."[23] Thiebaud taught Brown an important lesson: that making a print of an image he previously had used in a painting was not the equivalent of copying himself; it was a way of finding out how etchings were different from paintings.

"When you change anything," she remembers him saying, "you change everything."[24]

Through the 1960s Thiebaud occasionally created small plates that Brown printed in proof impressions only or in very small editions. After that, not until 1982 did Crown Point again *publish* his work, and he since has returned repeatedly. In 1970, however, Thiebaud became a key figure in Crown Point's next important phase when he brought Brown's impressive printing skills to the attention of New York print publisher Robert Feldman, who had opened Parasol Press Ltd. that year. Feldman had engaged Thiebaud to do a portfolio of prints in several media, titled *Seven Still Lives and a Rabbit*. Along with screenprints, lithographs, and linoleum cuts, Thiebaud wanted to include prints made with Brown. Feldman viewed etchings as old-fashioned works made of little scratchy lines so he did his best to divert Thiebaud from using the medium. When the artist prevailed the publisher held fast on his interest in color prints, thereby pushing Thiebaud beyond black and white line etchings to combining line with areas of aquatint printed in bright yellows, reds, oranges, and blues. The results were *Big Suckers* and *Triangle Thins*.

Brown did not yet know about the process of steel-facing an etching plate to avoid discoloration of hues by the interaction of copper and certain pigments, so achieving the necessary clarity of Thiebaud's brilliant color was a real struggle. She succeeded, however, with results pleasing to both artist and publisher. Thus began a spectacularly productive seven-year professional collaboration between Brown and Feldman as well as their continuing friendship.

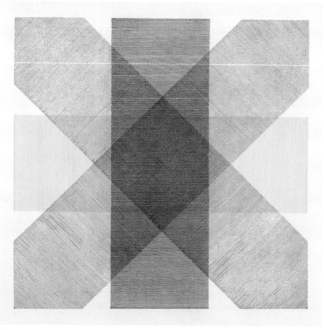

FIG. 6
Sol LeWitt, pl. 16 from *Bands of Color in Four Directions & All Combinations*, 1971, color etching, 323 x 321 mm, FAMSF/CPPA 1991.28.815

PARASOL PRESS AND THE MOVE TO OAKLAND

The relationship between Crown Point Press and Parasol Press brought major East Coast artistic figures to the Bay Area where they produced many of the most beautifully luxurious etchings of the 1970s with an emphasis on Minimalism: spare compositions, expansive aquatint fields, geometric linear structures, using "limited material means in order to elicit maximum participation from the viewer." [25] Feldman has described his association with Crown Point enthusiastically:

I had the best printer in the world, and it couldn't have been better for me. I just let artists go and do what they wanted. Publishing is a business that is based entirely on faith. Kathan was absolutely perfect for the Minimalists. They were made in heaven for each other. You have to intuit as a printer what it is that the artist is trying to get out. The artist doesn't know how to make it happen. You have to make it happen. And there isn't any blueprint for that. You have to get somehow into the psyche of the artist. And I think it's extremely difficult. And every printer has his or her own style.[26]

Indeed, in 1971, the year Feldman first sent artists to Berkeley to work in the quiet, hand-oriented etching methods, the Museum of Modern Art's exhibition *Gemini G.E.L.: Art and Technics* was offering work of a very different style, one that emphasized grand size and the most highly technological aspects of contemporary printmaking.[27]

Sol LeWitt was the first artist Feldman sent to the Bay Area in 1971 (fig. 6), and it was apparent immediately that Brown's style (and that of the printers she hired and trained) would work well for the publisher's interests. However, the following year Brown reminisced about the experience in words that suggest less than perfection: "Sol must have felt confounded when he arrived to find that he had traveled 3,000 miles to this little basement in somebody's house with kids and dogs about, and only myself and two students to help him (fig. 7)."[28] Like many of the artists who have worked at Crown Point, LeWitt stayed in Brown's home, sharing meals and a family atmosphere. (For five years in the affluent late 1980s Crown Point rented an artists' apartment in San Francisco.)

LeWitt has since made over 300 etchings in Brown's studios, ranging from the early geometric line drawings in black and white to the boldly colored spit bite aquatints of 1991. Since 1980 they have been published under the Crown Point Press imprint. All but his *CrownPoint* (cat. 68), a book of photoetchings, have been *drawn* by LeWitt on the copper plates, a somewhat different approach than he uses for prints in other media where his hand generally does not play a role.

In 1972 Brown wrote about working with LeWitt as a turning point in her career: "Up to then working with artists had been almost like a hobby. I did it when I felt like it, with whom I felt like it, always someone whose work I had affection for to start with." And while she didn't dislike LeWitt's work, she "just hadn't thought about that kind of thing before."[29] By the time she had printed the hundreds of impressions that resulted from her first project with him, however, she not only had become immersed in his process but loved the work.

After the LeWitt project, Feldman's promise of ongoing contract work for Parasol Press gave Brown both the reason to expand Crown Point's physical

FIG. 7
Kathan Brown printing in the Berkeley studio accompanied by her son, Kevin Parker, ca. 1965

space and the financial possibility of taking the Press out of her Berkeley basement. In 1972 she moved to the upper floor of an industrial building at 1555 San Pablo Avenue in Oakland, where Diebenkorn's studio had been briefly located prior to his move to Southern California. After some nine years of working below ground, Brown sought light-filled spaces with windowed walls for this and all of her subsequent studios. Crown Point remained on San Pablo Avenue until 1986, expanding over the years from one room into a big rambling space on several floors that housed three printing presses, a full photographic studio, and a gallery.

Even as Crown Point expanded in size, the essential character of the facilities remained low-key and inviting, quiet, like the etching medium itself. Brown was committed to a homelike, handmade

FIG. 8
Proofs for Chuck Close's *Keith* (cat. 2), 1972

feeling in the studio, with printers John Slivon and Patrick Foy continuing the tradition established by Parker, building furniture and inventing equipment when necessary.

Kathan Brown refers to Crown Point as a studio rather than a printshop. The artists' workspace was always integrated with the printing presses rather than occupying a separate enclosed space, as, for example, at Gemini and Tyler Graphics. Describing the Crown Point environment Brown suggested that "there's a lot of wall space for pinning things up, a lot of table space. I've tried to keep the machines from dominating the feeling of the place. The machines are there because they are necessary and right — part of the tools. But it's more a place for making discoveries, which is what art is about, than for manufacture."[30]

At Crown Point there has always been a place for artists and staff to sit and relax, eat and talk: the living quarters behind the shop in Richmond; the kitchen of the Berkeley house; a coffee nook in the Oakland studio; and designated lunch rooms in subsequent San Francisco spaces. Books and journals

lay about for research and relaxation. Several artists and printers who have worked at Crown Point, both male and female, suggest this homelike atmosphere results from the fact that Brown is a woman. The idea is in keeping with the importance of the legendary homemade lunches Grosman served at ULAE, but less elaborate in style.

Crown Point's move to Oakland was accomplished in time to work on Chuck Close's first print, the spectacular mezzotint, *Keith* (cat. 2), a tour de force for both artist and printer.[31] A Parasol publication, it called for Brown to purchase a 200-line commercial halftone screen and a large vacuum table for exposing the screen to the etching plate, thereby creating a dot pattern that was etched into a tooth — evenly distributed raised and lowered areas of metal — that would serve as the start for the mezzotint process, which requires the artist to work from dark to light. This tooth, before reworking by the artist, would print as an overall velvety black surface. From it, Close formed his image in the plate using scrapers and burnishers, tools that graded the tooth to hold variant quantities of ink for printing a range of grey tones. Two months of working the plate and proofing were required for *Keith* to come to life in the metal (fig. 8). To print it required Brown to purchase a printing press with a 42 x 60 inch bed (till then she had used the table-top model purchased in Van Hornesville limited to 22 x 30 inch plates). An edition of only ten impressions was made, but the powerful, large scale,

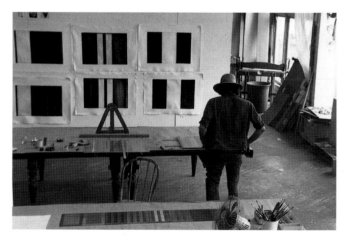

FIG. 9
Brice Marden at work in Crown Point's third studio, Oakland, California, 1976

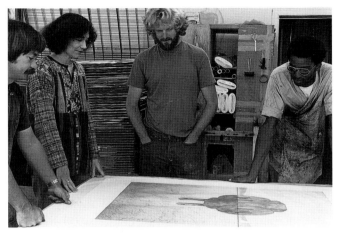

FIG. 10
John Slivon, Kathan Brown, Patrick Foy, and Stephen Thomas discussing a proof for Claes Oldenburg's *Floating Three-Way Plug,* 1976

image, and astonishing technical virtuosity have caused *Keith* to become one of the most admired intaglio prints of the late twentieth century.

Parasol publications were the most numerous of Brown's contract jobs for the next several years. Among other artists whom Feldman sponsored to work in Oakland were Mel Bochner, Robert Mangold, Sylvia Plimack Mangold, Brice Marden (fig. 9), Dorothea Rockburne, and Robert Ryman.[32] Rockburne's six *Locus Series* prints (cat. 30, 31) presented particularly complex printing problems. The large aquatint plates were printed in white onto sheets that had been folded so the edges of the paper created embossed lines. A final unfolding yielded works Susan Tallman has aptly described as "defiantly physical."[33] The *Locus Series* prints, indeed virtually all the prints these artists produced at Crown Point, became greatly admired by the devotees of Minimalist and Conceptual art.

Print Collector's Newsletter (PCN), the primary information source for prints was started in 1970. PCN reported on Parasol's Crown Point publications as they were issued, although initially the prints received more notice in Europe than in the United States. Feldman recalled that "when we started the only place we sold prints was in Europe. Nobody in the United States was interested. And about 1976 or 1977 that changed. The Europeans were getting interested in Europeans, and in the United States, fortunately, there was economic growth."

As Brown's skills and those of her printers became known in this country, she also was engaged by other publishers. For example, John Berggruen Gallery in San Francisco asked her to work with Helen Frankenthaler on her lyrical *Nepenthe*, 1972. Also, Crown Point printed a group of eleven prints by Claes Oldenburg, including *Floating Three Way Plug* (fig. 10, cat. 3) for Marion Goodman's Multiples, Inc. in New York City.[34] Brown's association with these publishers extended her artistic interests and introduced her to the business of art, as distinct from the making of it. Feldman had been telling her for years that she would never earn a reasonable living by practicing the "medieval craft" of printing alone and that to survive financially she would have to become a publisher as well as a printer, committing more of her time to business and maintaining a less hands-on involvement with the work she so loved. She had long avoided making this move, at least in part, according to Feldman, because "Kathan is a visionary. She's on a mission. And when you're dealing with crusaders, logic isn't necessarily the main issue."

By 1977, however, Brown acknowledged her need to push forward as a publisher, for both economic and aesthetic reasons. To help establish her independence, Robert Mangold and Brice Marden, whose prints were greatly admired, each published one piece under the Crown Point imprint, *Untitled Aquatint*, 1978, and *Tile #1*, 1979, respectively. They did them with Feldman's blessings, a strong statement of the publisher's support and friendship toward Brown. Most typically print publishers prefer the artists whose work they champion to publish prints with them alone.[35]

Although for the most part Brown ran Crown Point Press as a contract shop from 1970–1977, she did publish a few projects in addition to her own art. And she began to develop ideas about a publishing program that, while extending her interest in books, would also include work by artists not readily associated with printmaking, such as, Conceptual artists, performance artists, and installation artists.

As would be the case with many publishers, Brown's publications are as much a part of her life's work as of the artists'. It has been especially important to her to understand the particular point of

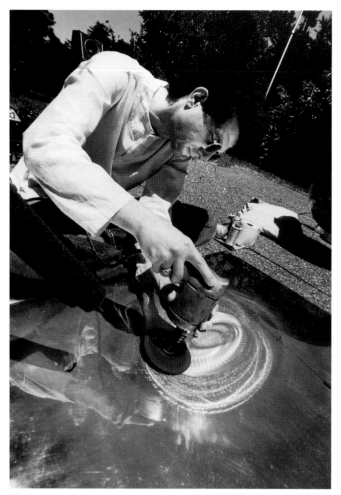

FIG. 11
Tom Marioni drawing the sun's image on the copper plate for
The Sun's Reception (cat. 41), 1974

CROWN POINT PRESS AND THE MUSEUM OF CONCEPTUAL ART

The Conceptual art approach of some of Crown Point's publications was established by Tom Marioni in 1974 with *The Sun's Reception*. The etching was not only the first of many prints by Marioni that Crown Point published, it also became a hallmark of the Press's distinctive achievement: using one of the oldest and most traditional print-making processes, etching, in radically nontraditional ways. *The Sun's Reception* resulted from an "action" (Marioni's term for the performance aspect of his art, generally involving sound, bodily gesture, and visual images) at the Sausalito, California, home of collectors David and Mary Robinson.[37]

To produce the plate for *The Sun's Reception*, Marioni set up a large sheet of copper by the Robinson's swimming pool and used a spinning electric grinder to draw an ellipse around the shape of the sun's reflection in the plate, thereby also suggesting the earth's elliptical path around the sun (fig. 11). Then he sanded and polished the central area of the reflection while a contact microphone

view of each artist with whom she works within the broader context of contemporary art. Given the diversity of her publications, it is fascinating to realize what motivates her choices of artists: 1) she selects people whose work she believes has the possibility of being important 100 years from now; 2) she doesn't try to discover artists, almost all with whom she has worked have had international exhibition histories before their Crown Point Press projects; 3) she wants the artists to be people with whom her staff and she will enjoy spending time; 4) she tries not to limit her publications to her personal taste, believing "it is human nature to like what we already know and not to like what is new to us."[36] As with LeWitt's art, she has often come to admire an artist's work through her participation in its creation, extending her own point of view.

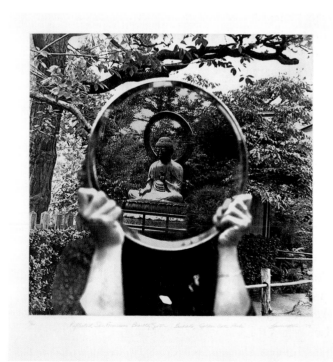

FIG. 12
Iain Baxter, *Reflected San Francisco Beauty Spots (Buddha in Golden Gate Park)*, 1979, photoetching with color aquatint, 606 x 607 mm, FAMSF/CPPA 1991.28.594

attached to the underside of the plate dispersed the sounds of the polishing action. The plate was printed in blue — the afterimage color of the sun. Brown recalls how she "was very excited about the idea of a *real* performance print. That seemed like something nobody had done before."

Marioni had founded the Museum of Conceptual Art (MOCA) in San Francisco in 1970 as what he called a "social artwork." Brown was a strong admirer of both his art and his ideas.[38] Artists whose work most engaged him were involved with performance art, body art, systems art, language art, site-specific installation art, and earth art, developments that followed Minimalist concerns of the early 1960s. Brown and Marioni formed a personal as well as a professional liaison, and have together undertaken numerous fascinating projects. (They married in 1983.) His travels, especially during the 1970s, introduced him, and subsequently her, to a wide variety of artists, including Günter Brus, the Viennese performance artist; Daniel Buren, the French installation artist known for his placement of stripes in surprising locations, both interior and exterior, throughout the world; Italian Francesco Clemente, whom Marioni met at a performance festival in Belgrade, Yugoslavia, in 1974, and whose interest in things Eastern appealed to Brown; and Robert Kushner, generally known for his association with art based in decoration, whom Marioni met at the First International Performance Festival in Vienna, Austria, in 1978. Brown invited them all to work at Crown Point Press.

A few Conceptual artists had taken the unlikely step of making prints at the Lithography Workshop of the Nova Scotia College of Art and Design prior to Brown's invitation to make etchings at Crown Point. Among those who worked both in Nova Scotia (all of them in 1971, the year the Crown Point/Parasol collaborations started) and at Crown Point Press either under the aegis of other publishers or later by invitation from Brown are Vito Acconci, John Baldessari, Iain Baxter (fig. 12), LeWitt, Oldenburg, and Ryman.[39]

Between 1975 and 1982, Brown and Marioni jointly undertook publication of a journal, *Vision*, edited by Marioni and published by Crown Point Press (as Point Publications). "A publication by and

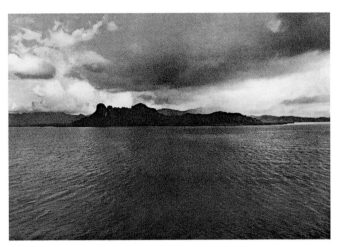

FIG. 13
Kathan Brown, *Ponape* from *Paradise,* 1982, from a bound book of photoetchings, 13 x 15-1/2 inches, edition 10

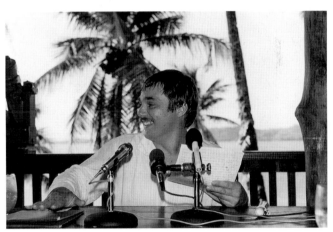

FIG. 14
Chris Burden during his dinnertime presentation at Ponape, 1980

for artists. No art criticism — artists present their own work."[40] *Vision* documented artistic achievements in California, New York, and Eastern Europe. One issue, in the form of a phonograph record, titled *Word of Mouth*, documented performances, lectures, and other dinnertime presentations by twelve artists at a January 1980 conference cosponsored by Crown Point Press and the Museum of Conceptual Art. The conference was held in praise of the beginning of a decade, on the island of Ponape in the South Pacific (figs. 13, 14). It was also a celebration of the first year Crown Point actually made a profit.[41] The fifth and last issue of *Vision* served as the catalogue for a 1982 exhibition, *Artists' Photographs*, selected by Marioni for the Crown Point Press Gallery in Oakland. It

included work by Conceptual artists rather than artists who were considered to be photographers.

The Brown/Marioni relationship has had an important impact on Crown Point's program. Shared interests brought them together and their mutual support for each other's independent ideas has been essential to their work. Marioni has completed almost thirty editions at the press since *The Sun's Reception*, including several pieces that emphasize his concerns with sound and with using unusual drawing tools — drum brushes and feathers among them. Marioni continues to offer suggestions to Brown of artists to publish, some of which she acts on, some she rejects; he was, as he put it, "the guinea pig" for the China woodcut project (discussed below);[42] and he generally acts as an in-house sounding board for Brown's ideas and problems.

DIVERSITY AS A POINT OF VIEW

Between 1977 and the end of the decade, Crown Point Press's commitment to artists of far-reaching aesthetic positions and from around the world was firmly established. The artists with whom Brown completed projects in 1977 alone suggest the catholicity that has since dominated her program: Diebenkorn, Marioni, and newcomers, Acconci, Burden, Terry Fox, and Steir. Immediate attention was paid in the art press to Brown's venture: *Print Collector's Newsletter*'s November–December 1977 issue (page 141) reported that "Crown Point Press moves to publishing prints by conceptual artists." This was a rather limiting notion of what Crown Point Press was doing, contradicted by Brown herself in an interview with Nancy Tousley in the same issue (pages 129–134). Brown, in fact, had several agendas.

First, she wanted to work with Diebenkorn again, convinced of his importance among contemporary artists. He still lived in Santa Monica but gladly added stops at Crown Point to his Northern California travels. Second, she wanted to work with other artists like Marioni, whom one might not readily associate with etching, thereby exploring her belief that if "printmaking is a way to make art, any good artist who can think how to use it will be able to make good prints" with skilled printers.[43] A third

motivation for publishing was to schedule enough ongoing projects to enable her to train and maintain a full-time staff who worked well together, something she could not do as a contract printer with an unpredictable workload.[44]

Burden was among the most nontraditional artists of the 1970s, his fame immediate from his November 1971 performance in which a friend shot him in the arm — the most extreme example of that aspect of his early work which focused on the force of guns and money in American life. Invited to Crown Point, Burden wanted to "make money" with pictures of artists on it.[45] The Italian 10,000 lire note, which bears a portrait of Michelangelo as well as a watermark rendering of his great sculpture, *David*, became the subject of *Diecimila* (cat. 60), the first of Burden's two Crown Point publications. A photoetching printed in fourteen colors on both sides of the paper and *à la poupée* (various color inks applied locally with a dauber), "its large 'artistic' margins preclude its practical use; its 'utilitarian' content excludes its acceptance as 'art'."[46] Needless to say, the idea of the art workshop as counterfeiting shop amused everyone who saw the print in progress.

Pendulum Spit Bite, Fox's only work with the Press, was etched by very unusual means: the artist rigged a pendulum that dripped acid onto the metal to create concentric rings that wind down to a line. Acconci made three prints in 1977, socio-political in content. He returned three years later to complete three more, all concerned with architectural presence: heroic in scale (*2 Wings for Wall and Person*, over 22 feet wide), installation oriented (*20 Foot Ladder for Any Size Wall*), and political (*3 Flags for 1 Space and 6 Regions*, cat. 69). Although making prints of expansive size was not one of Crown Point's priorities, when artists wished to do so — not only Acconci, but others, including Joel Fisher, Hamish Fulton, Marioni, and Steir — multiple sheets of paper were used to carry the image, to be assembled after printing rather than seeking ways to enlarge the presses, as has been done over the years at other workshops.

In keeping with Brown's interest in the book form, Steir's 1977 publications included a volume of five drypoints entitled *Word*. Diebenkorn and

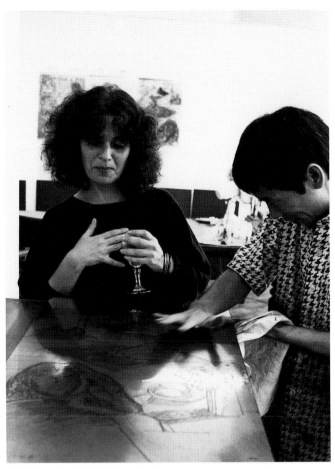

FIG. 15
Pat Steir watching Hidekatsu Takada handwiping
Abstraction, Belief, Desire (cat. 4), 1981

Marioni also worked in series, the former, *Nine Drypoints and Etchings* (cat. 174–77), the latter, seven mezzotints entitled *Landing*. Diebenkorn and Steir, like Marioni, also became central to Crown Point's artistic program. Diebenkorn worked there steadily from 1977 until his death in 1993, completing a magnificent body of prints including all of the large color aquatints related to his *Ocean Park* paintings. Marioni and Steir continue to create editions as well as series of monotypes and monoprints. Marioni has done these by using the etching press as his image-making tool, varying the flow of ink for his *Process Landscapes* (1992). Steir has worked more traditionally, usually starting with an image on the etching plate, for example, her series of self-portraits with allusions to artists of the past, from Dürer and Rembrandt to Courbet and Picasso. Steir has described her Crown Point prints as "a body of work that comes from friendship.

It's the relationship that built the quality because it is a collaborative effort."[47] Brown, by contrast, has always rejected the term collaboration, believing it overstates the role of the printers, which she sees as essentially that of helpmate in relation to the artists' essential creative contribution. She prefers to stay in the background; and she trains her staff to do the same.

Hans Haacke, like Burden, of a radical political bent, was engaged by the relationship between art and capitalist corporate wealth. Haacke worked at Crown Point in 1978, as did composer Steve Reich and Conceptual artist Robert Barry.[48] Performance artist Joan Jonas came the following year, which also marked Brown's first invitations to European artists. Daniel Buren, based in France, did his first published print at Crown Point, *Framed/Exploded/Defaced* (cat. 66): an installation work in twenty-five parts individually framed at the artist's request, the project caused Brown to install an in-house frame shop. The segments, each group of which is unique in color ranging from yellow through oranges to red, are to be evenly spaced as a grid that spans the wall on which they are hung, corner to corner, top to bottom, with segments omitted if there are interruptions such as doors or light switches in the specified places.

Also in 1979, the rather reclusive Jannis Kounellis, among the primary artists associated with the *Arte Povera* movement, traveled from Rome to San Francisco to complete two photo-etchings. *Untitled* (cat. 65) presents the contrast of a massive and weighty black square, a seemingly immutable man-made element, with delicate, graceful, and ephemeral flowers from nature. According to Brown, having him at Crown Point "was one of the great things I was able to do early. Kounellis is one of the really important artists in Europe."

From a personal standpoint, however, the most important artist with whom Brown started working in the late 1970s was John Cage. As with Diebenkorn, Cage grew to have a profound impact on her life, and likewise, their association lasted until Cage's death in 1992. Brown had admired Cage since her Antioch days, and Marioni also viewed his work as immensely influential and important. The couple was introduced to him

through Margarete Roeder, a vanguard dealer for performance and Conceptual artists who represented Cage's work, and, starting later, Marioni's as well. Brown met Roeder at the 1977 Basel art fair and asked her to initiate with Cage the idea of working at Crown Point on etchings. Long an admirer of Brown's publications, Roeder was happy to oblige. On New Year's Day 1978, Cage arrived in Oakland. He "loved being there," according to Roeder. "It was just like home to him. He respected what Kathan would do, the freedom she gave him. It was a very natural, harmonious relationship."49

FIG. 16
John Cage at work in the light-filled Oakland studio, 1978

Almost all of Cage's thirty-three Crown Point titles are unique variations on a theme, or series of related images. The moves he made to create them were determined by chance operations based on the *I Ching,* the ancient Chinese *Book of Changes.* The foundation of Chinese philosophy, the *I Ching* comprises sixty-four hexagrams accompanied by supplemental texts offering alternative explanations of meaning or alternative possibilities for actions.50 The hexagrams are composed of straight and broken lines that are to be interpreted by a reader who counts through forty-nine yarrow stalks or, more conveniently, throws three coins six times in order to numerically determine meaning. To arrive at his moves in creating his prints, Cage consulted a printout of numbers he brought with him to Crown Point, composed by computer simulation of coin throwing.

Virtually everyone who worked with Cage warmly remembers the distinctive experiences he offered.

Printer Nancy Anello, for example, described how "he really wanted you to just enjoy it and have this wonderful spirit about making the work. He would push etching and printmaking to the limits. He also wanted to know if there were limits, or what we thought the limits were, asking, for example, how many plates can we print on top of each other, reasonably. But then he would come up with these systems that drove everybody beyond what we thought the limits were." For example, with several series the substrates were smoked as part of the process, and they were also branded with hot metal, sometimes creating holes. Anello described how for Cage's *Fire* series, the printers "would crumple up some paper, set a match to it, and throw it on the press (fig. 17). The damp printing paper was ready, and as we cranked it through the press, the press would put out the fire. We had a fire extinguisher ready and we were always afraid the smoke alarm would go off."51

According to Kushner, Steir, and Wiley, Cage's impact was similarly important to the artists who came to know him through Crown Point. Wiley also suggested that Cage and Brown shared an inclusive attitude toward the world. Both were involved with Zen, with reaching out, trying to bring more of everything into their view, into what they were assessing artistically, politically, about their environment, and about the way society works.52

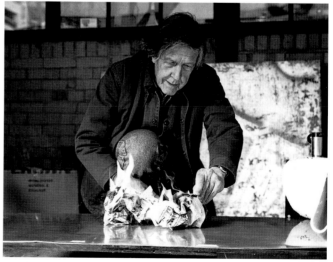
FIG. 17
John Cage lighting a fire on the press bed to smoke paper for his prints, 1989

FIG. 18
Kathan Brown and Robert Bechtle discussing *Sunset Street,* 1982

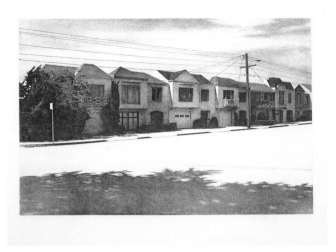

FIG. 19
Robert Bechtle, *Sunset Street,* 1982, color soft ground etching,
404 x 606 mm, FAMSF/CPPA 1992.167.211

Four of the artists Crown Point published in 1977 — Burden, Diebenkorn, Fox, and Marioni — lived in California, and Brown has continued to work with numerous artists based on the West Coast, not for political or social reasons, but because she admires their art. In the eighties, Californians added to the Crown Point roster were realist Robert Bechtle (figs. 18, 19); abstractionists William Brice, Tom Holland, and Robert Hudson; and Ed Ruscha, who holds a pivotal place among painter/printmakers, credited, as he is, with stimulating interest in artists books with his 1963 *Twenty-Six Gasoline Stations.* Thiebaud returned to work at Crown Point, and, along with several others mentioned previously, has continued to work at the Press into the nineties. In this current decade, Californians John Baldessari, Christopher Brown (no relation to Kathan), Nathan Oliveira, and Gay Outlaw worked with Brown for the first time, continuing to highlight her interests in both Conceptual art and figuration.

FROM OAKLAND TO SAN FRANCISCO

The 1980s brought other expansions to the Crown Point Press program. Reflecting Brown's concern with art from all parts of the world, she increasingly published prints by artists based outside of the United States. As her son, Kevin Parker, pointed out, "Kathan loves to travel. If you can't travel, the next best thing is to be with travelers, hear their stories and their viewpoints. You experience your own surroundings differently when you hear travelers talk about them. Half of traveling is experiencing things anew."[53]

Francesco Clemente traveled from India to be introduced to etching at Crown Point in 1981, completing twenty-one editions that were the start of the large body of complex and sensuous figurative images he has continued at Crown Point into the 1990s. Both narrative and allegorical in content, they are rooted in myth and dream. Günter Brus, one of the earliest performance artists ("such a pioneer, such a thinker" according to Brown) came from Austria in 1982 to complete four searing hard ground etchings, the three in the *Grosse Erdangst* series incorporating aquatint and drypoint as well (cat. 103). That same year, British artist Hamish Fulton walked the Sierra Nevada in preparation for *Porcupine* (cat. 70). Shoichi Ida, whose initial involvement with Crown Point was his assistance with the woodcut project in Japan discussed below, came from Kyoto to make etchings in 1984, and returned in several subsequent years.

There were others as well, and as the decade wound down, production moved at an extraordinary pace. A banner year was 1988. Tony Cragg, Anish Kapoor, Markus Lüpertz, and José Maria Sicilia all traveled from abroad to the Crown Point Press studios. Cragg, the British sculptor now based in Germany, completed a remarkable body of thirty-five prints in one ten-day session, exploring for the first time a wide range of etching processes, and suggesting the extraordinary scope of his visual concerns with technology and the social and natural

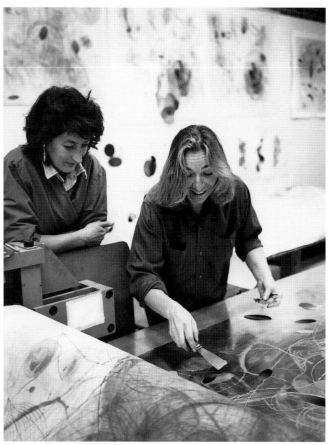

FIG. 20
Judy Pfaff (right), working on *Flusso e Riflusso* from her series
Half a Dozen of the Other (cat. 156); printer Daria Sywulak looks on, 1991

on aquatints that incorporate a layer of beeswax, a material he often uses in his unique works.

Along with these artists from abroad, the eighties brought Elaine de Kooning, Al Held, Bryan Hunt, Yvonne Jacquette, Joan Jonas, Joyce Kozloff, Sherrie Levine, Judy Pfaff, Janis Provisor, Sean Scully, Richard Smith, and graffiti artist Rammellzee, to the Press. Held's etchings incorporate as many as thirty colors and are unanimously singled out by the printers as presenting their greatest technical challenges. To achieve the required registration, each color is distributed among several plates, each plate carrying elements of several colors. Something akin to a series of road maps enables the printers accurately to locate all the colors on all the plates before layering them in the printing.

Working with Pfaff presented a different sort of challenge. The artist recalls that she "knew Crown Point was a classy etching place" when Brown first invited her to work there in 1981, but despite considerable previous experience with printmaking Pfaff "couldn't think of what to do."[55] Four years later in 1985, however, she accepted an invitation to work in the Japanese woodcut program, and, after that, in 1987, on her arrival on the West Coast she announced that she wanted to do woodcuts again. And she did, creating a series entitled *Six of One*, the first six woodcuts to be made in Crown Point's Bay Area workshop. By her own admission, Pfaff created quite a stir. The noise was particularly invasive: "Routers. Do you know what a router sounds like in that place? It is like a sanctuary there, a little church. They have never heard that kind of noise." Pfaff's woodcuts were followed in 1992 by an equal number of etchings, *Half a Dozen of the Other* (cat. 156). Thus, eleven years after Brown's first invitation to make etchings at the classy etching place, Pfaff actually did so (fig. 20).

Between 1981 and 1987 Parker maintained Jeryl Parker Editions in New York City. He printed works for Parasol Press, mainly, but for other publishers as well, including Crown Point: works by Clemente, Rackstraw Downes (Brown was fascinated by the fact that he drew on his etching plates outside, on site), Kushner, and David True. Alex Katz did his first print with Crown Point as part of

environment.[54] Kapoor, another sculptor, born in India but living in London, translated the organic form and lush color of his three-dimensional work into luxuriously rich intaglio images. Cragg and Kapoor both returned, Cragg in 1990, and Kapoor in 1990 and 1991. Lüpertz, from Germany, completed six complex prints incorporating various combinations of soft ground etching with soap ground, spit bite, and lift ground aquatint, some in black and white, some in color. Working with Sicilia presented unique challenges since he neither had previously tried etching nor spoke English. Master Printer Renée Bott, however, recalls her sessions with him as among her most memorable projects, dependent as she was on her high school French to teach Sicilia the complexities of the etching processes. On this first of two sessions in San Francisco, he completed the eight prints in his *Fleur Rouge* series (cat. 79), returning in 1990 to work

the Japanese project in 1985 and then worked in Parker's New York shop in 1986. Brown had admired Katz's work as far back as her student days, and both Clemente and Crown Point staff member, Karen McCready, spoke highly of it as well. When Katz declined to travel to San Francisco, Brown asked Parker to invite Doris Simmelink, a former Crown Point Press printer, to work with him in the East, the start of a strong artist/printer bond that continues outside the Crown Point connection.

Of course, Diebenkorn completed a number of projects in the 1980s (fig. 21). According to Brown, he referred to his work at Crown Point as "his printmaking vacations," thought of it as a more social time, away from the solitude of his painting studio. She recalls that "Dick loved lunch, sitting around and talking." Diebenkorn's first color intaglios date from 1980, and between that year and 1982, he completed more than thirty prints. After that he virtually always had etchings in progress, both color and black and white. The last print

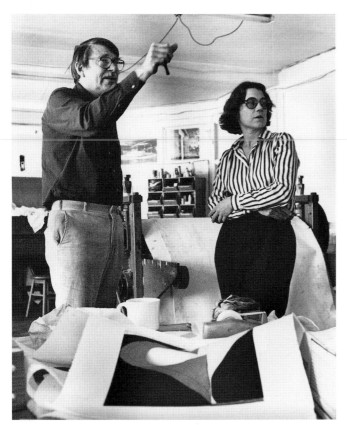

FIG. 21
Richard Diebenkorn and Kathan Brown discussing Diebenkorn's *Clubs and Spades* project, 1981, with proofs on the table in the foreground

editioned in Crown Point's Oakland studio was Diebenkorn's *Green* (cat. 8). His largest color etching, *Green* was worked on six 36 x 45 inch copper plates, the maximum size the press bed could accommodate, plus a seventh strip of metal added to the bottom. (Diebenkorn's previous etchings were never larger than 26 x 40 inches.)

He started right in with color, as he generally did, evolving his image by using collage elements of printed papers generated in his rejected proofs from old projects which he saved and organized by color. Five printers worked with him off and on for many months before *Green* was resolved to the artist's satisfaction. Then it took the five of them almost two hours to print each impression in the edition of sixty. Many connoisseurs consider *Green* to be Diebenkorn's masterpiece of printmaking. Released to the public in 1986 at the price of $15,000, *Green* brought $42,000 at auction the following year as the print boom was moving toward the heights of the decade's end.[56]

After completing *Green* in the Oakland studio Diebenkorn immediately set to work on the three *Folsom Street Variations*, the first etchings undertaken in Crown Point Press's first San Francisco studio, at 871 Folsom Street (fig. 22). Brown moved in 1986 to these very elegant quarters designed by architect Denise Hall. The building provided approximately 12,000 square feet of space, its most important amenity being a freight elevator. The press prospered there for three years, working with artists in-house about two weeks of every month and completing approximately twelve etching projects a year during the last years of the decade.[57] A more normal production schedule, both before and after the late 1980s, would be from three to five projects a year.

THE 1990S

October 17, 1989: a devastating earthquake hit the San Francisco area, with more than a hundred aftershocks throughout the following few days. *Print Collector's Newsletter's* January/February 1990 issue quoted Brown's description of Crown Point after the quake: "the heavy anchoring wall that divided the studio space from the gallery . . . [looked] like a cracked hardboiled egg." The note went on

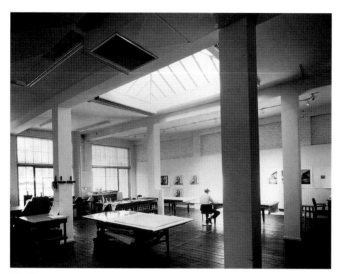

FIG. 22
Wayne Thiebaud working in Crown Point's first San Francisco studio, on Folsom Street, 1988

FIG. 23
Kathan Brown, with printers Renée Bott, Pamela Paulson, Brian Shure, and Linda Geary in Crown Point's temporary studio following the Loma Prieta earthquake, 1990

to tell how within a week the Press's inventory, archive, and equipment were removed from the building and operations established in three locations: offices in the basement of the Ansel Adams Center for Photography, a makeshift studio (fig. 23), and a temporary gallery nearby.[58]

Editions by Shoichi Ida were immediately underway as well as the first of two series of prints to accompany Gustave Flaubert's *Temptation of St. Anthony* by Tim Rollins + K.O.S. ("Kids of Survival"). The Kids, a group of Hispanic teenagers from the South Bronx, had worked at Crown Point the previous August, the Press's first project with an artists' collaborative. Considerable new artistic activity also took place in the temporary studio: Cragg produced plates for an even larger body of work than in 1988, forty-one prints in all; Diebenkorn worked there too; and, new to the Press, Gary Stephan. Stephan's editions were the first printed in Crown Point's next studio at 20 Hawthorne Street/657 Howard Street (the building has two addresses), a 1922 structure originally built for the San Francisco Newspaper Company. The building, its interior again designed by Denise Hall, opened with much celebration on 20 October 1990 — almost a year to the day after the earthquake. Demonstrations by Crown Point Master Printers took place, as well as the reception for the exhibition *Post-Earthquake Prints*, with Stephan's etchings

the centerpiece of work by twenty-two artists, including Tim Rollins + K.O.S., Sherrie Levine, and Katsura Funakoshi.[59]

The new facility had almost 40,000 square feet on three L-shaped floors with two light shafts. The gallery and bookstore were placed at street level (fig. 24). Two full working studios (fig. 25) and one studio for printing editions occupied the second floor, with separate rooms for storing and cutting copper, acid baths, aquatint box, photography, and offices. A storage area and the staff lunchroom were in the basement. The speed and success with which Crown Point reconfigured itself after the earthquake led Valerie Wade, Crown Point's gallery director, to suggest "Kathan is like a Phoenix; she just comes back up out of disaster and recreates something that's even more interesting."[60]

From 1978 Cage continued to produce work at Crown Point during January of most years, including three sets of prints the year he died, 1992. Cage's death was the first of two devastating blows both personally and professionally for Brown. The second great loss was of Diebenkorn, in 1993. But, despite growing frailty in the few years prior to his death, Diebenkorn also continued his output of remarkable color aquatints including *Touched Red*, and *High Green Version I* (cat. 183, 184). He moved into new directions with *The Barbarian*, and *Flotsam* (cat. 182), dominated by forms that are free-floating

in relation to his earlier tightly structured geometry.

Within the figurative tradition both Bechtle and Thiebaud completed extensive bodies of watercolor monotypes in the early years of the decade. Figurative artists Crown Point published for the first time included Christopher Brown, starting in 1991, and, in 1994, Nathan Oliveira, an artist greatly respected for his lithographs and mono-types as well as his paintings. William Bailey had first worked at Crown Point during the Parasol days, and he returned in 1994 and 1996 to com-plete seven still lifes, some in black and white, others in the subtlest of colors. Joan Nelson completed a colorful landscape, *Untitled (#1)*, with quiet overtones of history and fantasy in 1995 (cat. 166). Also in the figurative mode, Japanese sculptor Katsura Funakoshi — whose work Karen McCready and Constance Lewallen, Crown Point director and associate director respectively in the late 1980s, admired at the 1988 Venice Biennale — traveled from Japan to complete his first eight etchings in 1990. He returned in 1993 to add seven more. Danish artist Per Kirkeby (who had exten-sive experience in etching before his work at Crown Point) completed four large color prints and eighteen smaller ones in black and white, emotionally charged images embedded with his interests in geology and the landscape.

In the conceptual vein, two artists new to the Press in the 1990s, both from Europe, were Markus Raetz and Christian Boltanski, the latter of whom had been included in Marioni's 1982 *Artists' Photographs* exhibition. For the Boltanski project, *Gymnasium Chases* (cat. 129–152), all of the faces in a 1934 photograph of the graduating class at a Jewish high school in Vienna were printed larger than life to create a haunting comment on the Holocaust. The project caused Brown to set up a darkroom for photogravure and to give her printers time to learn and experiment with the process. Though photomechanical, it employs aquatint rather than the halftone screen Brown had used twenty years earlier for photographically based work by Acconci and others, and for the mezzotint tooth on the plate for Close's *Keith*. The gravure work led Crown Point to publish in 1996 its first group portfolio, *Gravure Group*, including images by (Christopher) Brown, Marioni, Outlaw (her first time at the Press), and Ruscha (cat. 168–171).

Artists including Marioni, Pfaff, and Wiley all continued their collaborations at the Press, as did Steir who embarked upon the waterfall series that has had a profound impact on her paintings as well. This brief summary confirms that despite a severe downturn in the print market that took place between the 1989 earthquake and the 1990 opening of Crown Point's Hawthorne/Howard building, Kathan Brown managed to support new prints in significant numbers and to maintain the diversity of artistic viewpoint that has always marked her Press.

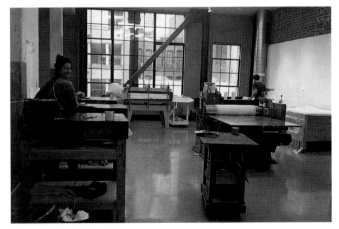

THE ASIAN WOODCUTS

In the early 1980s, shortly after the Ponape conference cosponsored by Crown Point and the Museum of Conceptual Art, when Brown was approaching twenty years of working solely in etching, she felt restless, eager to move in new directions. Lithography didn't interest her, partly because so many lithography workshops already existed. But screenprint (stencil printing) and woodcut (relief printing) seemed fertile territory for new exploration. The screenprint undertaking, the Crown Point Pure Silk Project, produced results first but was short-lived. Envisioning this as a catalogue-based mail order business, Brown invited artists as unlikely as Acconci, Cage, and LeWitt to make designs to be painted, stenciled, and screen-printed on silk for lingerie. The three took to the challenge, as did Fisher, Jonas, Marioni, Ruscha, and Wiley (fig. 26), as well as Kushner and Joyce Kozloff whose decoration-based ideas seemed most apt. All had previously made etchings at the Press.

Brown's idea was rooted in her grandmother's Philippine lingerie business and was originally called "Louise Brown Silk" in her honor. But the silk kimonos and pajamas produced were so sump-tuous that they were more like evening clothes than lingerie.[61] By the time they were featured in a 1984 fashion show held at the North Beach Restaurant for the benefit of the San Francisco Museum of Modern Art's Society for the Encouragement of Contemporary Art and in I. Magnin's Union Square department store, Brown had learned it was more costly to make handprinted lingerie than fine art prints. Also, there was little demand for such elegant attire. So the project ended.

Brown's woodcut undertaking was longer lasting — from 1982 to 1994 — and took her first to Japan and later to China. Like etching, the woodcut process had remained popular with specialist print-makers in the 1950s and 1960s, but it was not a method readily embraced by the painter/printmaker movement of the 1960s. Renewed interest in the medium surfaced when Helen Frankenthaler, work-ing at ULAE, started her first woodcut *East and Beyond* in 1972 (to be published in 1973); Jim Dine picked up the woodcut as well, completing the *Woodcut Bathrobe* (which also incorporates

lithography) at the University of South Florida's Graphicstudio workshop in 1974–75. The direct-ness of the cutting process itself, and the expressive potential of the resulting vigorously carved marks and forms attracted increasing numbers of painters and sculptors. By the early 1980s, the use of wood-cut had become widespread.

Critic Pat Gilmour wrote in 1986 that "a speedy reaction to minimalism, in the guise of a revivified form of expressionism, focused attention again on the vigor and simplicity of the woodcut."[62] Given Kathan Brown's preeminent place in the field of Minimalist prints, this suggests a backlash against work produced at her shop. And the comment overlooks that woodcut also was used by artists not engaged by Expressionism, Minimalist Donald Judd, for example, and Pop-oriented artist, Roy Lichtenstein.

FIG. 26
William T. Wiley, 1983,
silk kimono from the Crown
Point Pure Silk project
FAMSF/CPPA 1993.51.356

It would have been unlikely, in any event, for the bold character-istics of the Western woodcut to attract Brown, whose profes-sional life had been devoted to the sub-tleties of intaglio printing. In turning to woodcut in the early 1980s, she did not embrace the tradition of Albrecht Dürer, Edvard Munch, or the early twentieth-century German Expressionists, but a tradition of a very different sort, that of Japan, in which exquisite nuance equal to the delicate aquatint fields Brown so loved could be achieved. The method called for water-based ink to be used rather than oil-based ink, and as many as fifty blocks might be carved to produce subtle gradations of tone within hues. Brown was not alone in exploring this direction. Well before the Crown Point project Jennifer Bartlett had made woodcuts

in Japan with Shinya Katsuhara, a printer located by Hiroshi Kawanishi of Simca Print Artists, a Japanese-born printer/publisher of exquisite screenprints working in New York City. By 1978 Neil Welliver was working in the Japanese woodcut mode with printer Shigemetsu Tsukaguchi who was based in Philadelphia. And in 1982 Lichtenstein started his *Seven Apple Woodcut Series*, some of them printed by Tsukaguchi and Diane Hunt in Philadelphia and others printed by Michael Berdan, a Boston printer who had been trained in Japan.[63]

Brown's interest in things Eastern provided the original stimulus for her consideration of undertaking woodcut in the Japanese rather than the Western form. In addition, working with Richard Newlin on the catalogue *Richard Diebenkorn: Etchings and Drypoints 1949–1980*, published in 1981 by Houston Fine Art Press, took her and Marioni to Japan to oversee the printing. She was fascinated and captivated by the country. The possibility of making prints in Japan then evolved

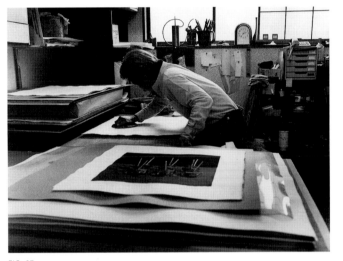

FIG. 27
Tadashi Toda printing Wayne Thiebaud's *Candy Apples* (cat. 9), Kyoto, Japan, 1987

through Brown's conversations with former student and Crown Point printer Takada who played a central role during the years the woodcut project was sustained, as conduit, translator, technical expert, and tour guide.

First of all, Takada interviewed Tadashi Toda to be the Crown Point woodcut printer in Kyoto. Toda had been brought to Brown's attention by Shoichi Ida. In the Japanese tradition, along with the artist and printer, there are craftsmen who make the woodblocks themselves, those who trace the various colors onto the blocks (for Crown Point's prints, the Kotobuki Art Company), and the woodblock carvers (primarily Reizo Monjyu and Shunzo Matsuda), all of whom are highly trained and traditionally brought together by the publisher. With

Crown Point's base in California, however, it would be practical for Toda to select the others on the team, and this plan also conformed to Brown's practice of letting the person in charge of a project *really* be in charge.

At their introductory meeting, Takada showed Toda examples of watercolors as a way, as Takada described it, "to figure out whether Toda would be willing to become the artist's hands and legs, to work for the artist, but also to work *with* the artist. You have to be very sensitive but to never push, to be just one step behind. Don't step on the artist's shadow, but be right next to it. That's Kathan's philosophy. I was translating this English thought into the Japanese language." By the end of the meeting, Takada was satisfied that Toda was capable of developing the necessary congenial attitude. The Crown Point woodcut project was underway.

Toda's family had been woodcut printers for generations, printing a wide variety of images from *Ukiyo-e* fine art prints to commercial pieces such as fans. Thus, he had the broadly-based skills necessary to undertake the variety of subjects and styles Crown Point would send to him in the form of artists' watercolors specially drawn for the project. Toda would then supervise having each color separately traced onto a thin sheet of paper to be glued to a woodblock and then carved by a craftsman. After all of the blocks were cut and a proof printed, the artists would travel to Kyoto with Takada and Brown, or later, with Constance Lewallen. During a two week period he or she would review proofs and work with the printer on revisions or corrections. When an OK to Print Proof was reached, the printer was left on his own to complete the edition, usually 200 prints.

FIG. 28
Hisako Toda, Robert Moskowitz, printer Tadashi Toda, and Constance Lewallen in Mr. and Mrs. Toda's living quarters downstairs from the studio, Kyoto, Japan, 1988

As the program evolved there were many details to work out. Steir was the first artist to work in Kyoto, for example, and, during the printing of her *Kyoto Chrysanthemum*, she, Takada, and Brown found they could not fit upstairs in the tiny studio where Toda and his father normally printed together (fig. 27). Needless to say, trying to convey information to the printer from the floor below was hardly satisfactory, as Takada communicated to Toda. For subsequent proofing sessions his father (who did not approve of this foreign project) worked elsewhere when a Crown Point artist was on site.

The twenty-three artists who participated in the Japan woodcut project included Thiebaud. When the proof for his first woodcut, *Dark Cake*, 1983 (cat. 105), was ready, he and his wife Betty Jean, Takada, and Brown flew to Kyoto to examine the proof and do whatever further work was necessary. But Thiebaud commented that the trip was not only a working session: "Kathan would give us a historical lecture in the morning. Then we'd go out and see the sights." Moreover, according to Lewallen, "Each artist brought to Japan his or her interest in the culture. So we would tailor our recreational time to fit those interests. We went to Tokyo, we went to Nara, we went to some pottery villages and papermaking villages."

After sightseeing, however, in Thiebaud's words, "we'd go to Toda's studio and proof the work, check the colors and check the carvings and the relation-

ships of the image." If needed, Toda would make minor cutting changes himself, rather than returning the blocks to the cutter. Thiebaud further explained how "in trying to realize a translation to something like that [a watercolor transformed into a woodcut] you have to reassess and reconfigure what you *thought* you were going to get as distinct from what you were getting," a comment that confirms the working process as a thoughtful and creative one, not the "reproductive" one it was considered to be by some.

The question of "what is an original print" that the Crown Point woodcut project raised for a few print aficionados was a throwback to a curatorial controversy of the 1950s and 1960s. Its public culmination was a conversation among artists, curators, and a woodcut printer published in *Print Collector's Newsletter*.[64] Old ideas about what made prints original had become increasingly outmoded through artists' use of photographic means as both method and content, to say nothing of their growing interest in appropriation as an aspect of subject. As Richard Field pointed out a decade before the woodcut project started, "what was an acceptable working hypothesis [for curators to use in understanding originality] from 1850 to 1950 has now become a flawed definition."[65] Indeed, it is artists not curators who take the creative and intellectual lead in such matters. And the artists' embrace of the Crown Point woodcut project was all the support it needed to remain the lively program it was. Many artists showed delight in working in Japan through their woodcut titles: Held, *Pachinko* (the popular game throughout Japan) and *Kyoto-wa*; Steir, *Kyoto Chrysanthemum*; Wiley, *Eerie Grotto? Okini* (cat. 102) (*arigato* means "thank you" in Japanese; *okini* means the same in Kyoto dialect); Pfaff, *Yoyogi I* and *II* (named for a Tokyo park where Pfaff and Karen McCready "spent most of a day observing young teenagers doing rock-and-roll Japanese style"[66]).

In 1987 when Lewallen was hired as Crown Point's associate director, her skills in working with artists were highly respected, so she was well-suited to accompany them to Kyoto, one of her primary responsibilities. Lewallen's reflections about Brown's initial introduction of the Japan project

to her are fascinating, and they offer further confirmation of the creative work that took place:

> It all sounded somewhat mystical. I remember Kathan trying to describe what my function would be. I wasn't going to make the prints; I wasn't going to do the interpreting. It's really this difficult-to-describe role of making sure it all happens. Giving encouragement when the artist needs encouragement; making sure the personalities mesh. There were times you would have to sit like a Buddha in the studio and really not interfere, but be very alert to everything that was going on. Sometimes a few words at the right moment can further the project if its stuck somewhere.

Lewallen went on to describe how, when an artist arrived at Toda's studio, "there was always some kind of an emotional response. And then it was a matter of starting. In every case the final print—and this is what I think Kathan hoped—really didn't resemble the watercolor because it went beyond the reproductive to something really new."[67]

In 1991 Kushner was the last artist to work in Crown Point's Japan project. He had worked with Toda in 1985 completing *Daphne I* and *Daphne II,* so the printer was aware of Kushner's nontraditional approach to printmaking involving variants within an edition, often with collage. "Toda became very interested in the fact that I was that free," Kushner reported. On a 1989 trip to Japan

(unrelated to Crown Point Press), the artist had visited Toda who proposed a project: "we print, collage, print, collage" was what Kushner understood him to be saying.[68] Takada confirmed Toda's proposal, and with Crown Point's support and Takada's help with both language and printing Kushner collaborated in the fullest sense with Toda to create two series: thirty-six unique impressions of *Delphinium* and forty-one of *Peony.* Kushner described how they used a wide variety of papers, and were "making up techniques as we were doing this." Some prints used blocks that were cut prior to the artist's arrival based on his watercolor; some required new blocks from the cutter; some new blocks were cut by Kushner on the spot. In almost ten years of working with Crown Point Press, Toda, schooled in a centuries-old tradition of printing editions, had become so embued with the Western spirit, according to Takada, that he really enjoyed this digression from his norm.

A number of artists started their association with Crown Point through the woodcut project, including Held, Katz, and Pfaff, all of whom went on to work in intaglio. Others worked with the Press in woodcut only: Eric Fischl, April Gornik, Sylvia Plimack Mangold (who had made Parasol Press prints at Crown Point in the early 1970s), Robert Moskowitz (fig. 29), David Salle (fig. 30). When the Japanese woodblock project was fully underway, two or three woodcuts were released annually along with the twelve or so etching projects. And from 1987 until 1994, woodblock prints from China were added to the mix.

Five years into the Japan project Brown's restlessness resurfaced. In addition, Japan was becoming increasingly expensive. Throughout 1987, with Lewallen covering Japan, Brown explored possibilities for making woodcuts in the People's Republic of China where they used a method that was even older, indeed was the original source for the Japanese tradition. Writing in the spring 1988 issue of the Crown Point newsletter, *Overview,* Brown reported that she was about to go to Beijing for the third time in five months, in order that a woodcut project similar to the one in Japan might be developed in China. As in Japan, the China program depended upon a few special

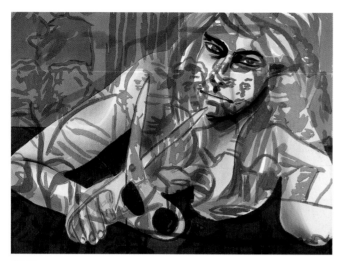

FIG. 30
David Salle, *Portrait with Scissors and Nightclub,* 1987, color woodcut, 458 x 610 mm, FAMSF/CPPA 1991.28.1144

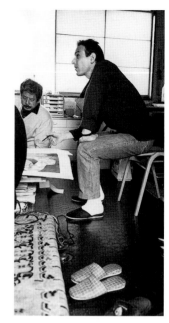

FIG. 31
David Salle working on a proof for *Portrait with Scissors and Nightclub* with printer Tadashi Toda looking on, Kyoto, Japan, 1987

people, notably Sören Edgren as general advisor, Xia Wei as translator, and Yong Hua Yang as facilitator. All of the studios in China were communal in nature, rather than dependent upon one Master Printer such as Toda. Methods, as well, were very different. Little irregularly shaped blocks of pear wood were carved, bearing individual segments of the image. To print them, ink was puddled to achieve dark and light areas in one printing — far less precise a method than was used in Japan. Registration was incredibly risky, although a high degree of consistency was maintained.

At the time of the 1988 *Overview* article, prints had been successfully completed on two images based on feather drawings by Marioni: *Peking*, printed at Rong Bao Zhai (fig. 32), a Beijing handprinting company in business for 300 years; and *Pi* (cat. 12), printed by an independent printer in Hangzhou. One print by Clemente, *The Two Flames*, had been completed as well. Bechtle was scheduled to accompany Brown on the upcoming trip to Beijing, with hopes to produce "a full-blown color print." The spring 1989 *Overview* reported on the Bechtle print as well as two new editions by Steir, one printed in Beijing, the other at a third studio, Duo Yun Xuan in Shanghai. Eventually a fourth studio, in Suzhou, was used as well. And now, Brown was preparing to leave for Shanghai with Janis Provisor (fig. 33).

The fall 1989 *Overview* recorded how the China

trip with Provisor had been followed closely by the student uprising at Tiananmen Square: "shock and bitterness crowded against the lovely sweetness of the trip." Brown, of course, felt she had to rethink her ambitions for China, but, after weighing all of the issues, she decided to continue the program, despite both the political situation and the difficulty of locating printers who could consistently provide a high quality product. As she has written, she asked herself, "will it affect anything at all outside ourselves and our small circle if we, on principle, don't go back? And if we do go back, will it make a difference to someone in China? Will it cultivate knowledge and allow its use? The answer was clear."[69]

"If Kathan wants to do something," confirms Lewallen, "she finds a way. Anybody else would have given up on the China project. She just kept hammering at it, through all kinds of disappointments and what seemed to be insurmountable obstacles and somehow made it happen, at least as long as she did. It was so complicated. Communication was impossible and they would double and triple their prices. The cultural differences were extraordinary."

Brown was not alone in her fascination with the China project. The method presented new challenges to the artists, who in addition to those previously mentioned included Brad Davis, Kushner, Li Lin Lee (a Chinese-American artist living in Chicago for whom Crown Point provided his first opportunity to visit the country of his family), Steir, and Richard Tuttle. Tuttle's *Trans Asian*, printed in Japan and in China, conjoined

both Asian projects. Davis and Provisor were so profoundly moved by the China experience they returned to live there, eventually closing down the Crown Point China project in 1994, essentially for economic reasons.

McCready described how in China, "each time a print was made they'd geometrically raise the price. There's no negotiation. Sometimes printers would farm the work out to other printers. Projects in China became very complex; you never knew what you were going to get or when you were going to get it. A lot of prints had to be thrown away, [because for various reasons extraneous to the

FIG. 34
Pat Steir, Kathan Brown, Tom Marioni, and Joost Elfers toasting the China woodcut project, Hangzhou, China, 1990

FIG. 32
Printers at work, Rong Bao Zhai, Beijing, China, 1987

FIG. 33
Janis Provisor with translator Yong Hua Yang, and printer Jin Da Fong, Tao Hua Wu workshop, Suzhou, China, 1989

printers' skill] they were not of the highest quality. The mounting had to be done here [because it was not done in a pristine enough manner in China]."[70] But the problems are by no means evident in some thirty woodcuts the nine artists produced there over an eight-year period.

STAFFING THE ETCHING SHOP

Back in 1962 when the Press was still in Richmond, Brown and Parker both printed, though Parker, a brilliant craftsman, also taught and had a separate painting studio. In Berkeley, in the late sixties Brown was the Press's sole printer, occasionally aided by an assistant. The first of them was Patricia Branstead, a former student at the San Francisco Art Institute, whom Brown hired full-time when Crown Point moved to Oakland in 1972. Others followed. Parker returned from 1974 to 1977 both to print editions and to help train a group of highly skilled Crown Point Press staff. As a rule, Brown hires printers with no workshop experience and therefore no habits to break, preferring to train them in-house. According to Takada, "Kathan doesn't *tell*. She says 'there's this way to do it, just try it.' But if we came up with another way for ourselves, that was fine too."

"It's not really about printing the prints," Brown has said. "It's whether the printer can make the whole thing work — seeing it through. I can teach printing in an afternoon. And once you get it, you

get it. It's like riding a bicycle. And the more you practice, the better you are. Platemaking is much harder to teach than printing."

Brown gradually stopped printing and by 1979 had virtually relinquished those responsibilities to her staff. Takada described how "Kathan always wants to have printers who are not technicians. We lay out all the possibilities and techniques available, quietly, on the table, and then let the artist see and handle the tools. We watch, and, when needed, suggest a way to do a particular technique." Nancy Anello, who has worked off and on at Crown Point for many years, added that "if you ever run into any difficulty technically or even personality-wise, Kathan's always there to listen and to support, and to help out."

Today for the most part, the Master Printers rather than Brown teach newcomers. "It's trial under fire," according to Mari Andrews, Crown Point's registrar who started at the Press as an edition printer. Her descriptions of learning to hand wipe a plate — that highly critical aspect of the process — and to prepare the paper and the ink for printing, suggest the complexity of the Crown Point apprenticeship:

> Every printer's movement of the hand, the part they lay on the plate, is different. Some people use the side of the palm, some use the whole range from the thumb all the way around. And sometimes you can wipe with your fingers if you have a very light touch. I would see printers working so vigorously I had no idea their hands were floating across the surface so lightly, barely gliding across the top.
>
> Each paper is a little bit different. Some you spray, some you dip, some you put between wet blotters. It depends on how much sizing is in the paper. You're also taught how to mix ink from scratch; and to condition ink with various additives. You just learn through each project.[71]

Each Crown Point Master Printer is in charge of one or two projects a year: responsible for seeing that any supplies and materials an artist might want are available; working with the artist in developing the plates; and carrying through by printing the editions. The printer in charge also acts as curator for the edition, deciding if any impressions must be discarded for lack of quality before the artist sees them, preparing for the artist to sign the edition, assisting him or her through this process.[72]

The registrar at Crown Point handles documentation of the prints, basing the information on worksheets the printers prepare. As with most print publishers, these documentation sheets are provided to clients, offering data on numbers of colors printed in a particular work, paper used, printers' names, edition size, and, if pertinent, notes on unusual aspects of the print.

Brown's penchant for simplification and directness has kept the Crown Point documentation sheets more economical than at many presses. Proofs have only four categories: l) Working Proofs are usually unique, printed to show new work on the plates or blocks; sometimes they are altered with additions by hand; 2) Artist's Proofs are generally identical to the edition, but printed for the artist and others involved with projects, rather than for sale by the Press; 3) the OK to Print Proof (*bon à tirer*), the impression that is the standard for the edition; and 4) Trial Proofs, which include all others.[73] All *signed* impressions are listed in the Crown Point documentation, not so for unsigned working proofs which normally are kept from the market. Many of them are destroyed or taken by the artists to convert into other works of art. Those the artists do not destroy or take are placed in the Press's archives.

Additional staff handle sales, packing and shipping, and bookkeeping and other business concerns. Brown has figured that for an average project that consumes two weeks of an artist's time, a printer and a support person each work approximately half a year, and she, herself, works at least a full month. The turnover at Crown Point is minimal, and Lewallen confirms "Kathan's belief for the artist having every tool also extends to the staff; so everybody has everything they need. And because she trusts everybody, they respect everything."

THE BUSINESS OF PUBLISHING PRINTS

Printing and publishing prints is a risky and unpredictable business, involving an enormous outlay of funds at the outset of every project. Assuming that

FIG. 35
STANDING: Kathan Brown, Renée Bott, Susan Jay, Miriam Mason, Lawrence Hamlin, Robert Seidler.
SITTING: Hidekatsu Takada, Wendy Diamond, Vandy Seeburg, Marcia Bartholme, and Karen McCready,
at Crown Point Press, 1986

invested in a project only to have the artist decide it is unsuccessful and reject it completely, although Brown has indicated this seldom happens at Crown Point. The fact remains, however, that even if the artist and publisher are excited about the way a project turns out, the public may not agree; and, if not, sales will never achieve the heights essential for the publisher to recoup the project's costs.

Assuming the majority of projects completed are successful in the eyes of the artist, the printer/publisher, and the public, every publisher must renew and revise his or her intentions in order to remain interested in the work being done as well as to remain interesting to the public. Such adventurousness is risky as well.[74] That Brown has remained committed to the evolution of her press has been shown over the years both by the diverse and changing group of artists with whom she has worked, and by shifts in the kinds of projects she has undertaken, such as the screen-printed lingerie, or the more successful Japanese and Chinese woodcuts.

When Brown decided to turn Crown Point Press toward serious publishing, not only to the publishing of her own prints and those of her friends but to publishing as a *business*, she had little or no experience or knowledge on which to depend. Her way of learning to do anything is to read everything she can find related to the subject. Consequently, in thinking about setting up her publishing business, Brown conducted extensive research, reading voraciously, attending weekend seminars on business methods, and so forth. She determined that "in a successful business, production costs should not exceed 50% of sales, the other 50% being needed for administration and

the workshop is fully equipped — no small investment to begin with — the printer/publisher must supply money in advance for an artist's travel and living expenses, for all of the materials necessary for a project (and ideally, everything an artist *might* possibly call for will be available, whether or not it is eventually used), for printers' and other staff salaries, and for the general overhead of the facilities. Brown reports she has never had any partners, and essentially has kept Crown Point afloat by reinvesting profits from successful projects.

Once a project is underway, the length of time needed for development of the matrices and proofing en route to the artist signing the OK to Print Proof is unpredictable. For artists with little or no experience in printmaking, including many of those with whom Crown Point has worked over the years, this will often take a greater amount of time than when working with a highly experienced artist such as Jasper Johns, and thus, it may be a more expensive undertaking. Needless to say, the difference in the profit margin from selling works by the former group as compared with works by Johns may not offset a publisher's initial investment.

Also, it is always possible that the months of time and effort on the part of both artist and printer, and the necessary funding to support them, will be

FIG. 36
Crown Point's Oakland gallery, 1981

marketing." Eventually she came to see that Crown Point's longevity resulted from the fact that she thought about the Press "as a whole rather than artist by artist or project by project." Brown consistently pays 30% of each sale to the artist, and so long as yearly studio expenses (the other portion of production costs) are kept to 20% of annual sales, she "can keep going." Brown became captivated by the ideas of management consultant Peter Drucker who championed an "information-based," non-hierarchical system for running a work place, employing methods to which Brown has tried to adhere, for example, meeting with staff weekly to discuss virtually everything related to the Press, both important and incidental.[75] Many present and previous staff members have echoed the view of the gallery director, Valerie Wade, that they have "never worked anywhere so democratic, where everyone's opinion is as valuable as the next person's."

Brown realized at the start that her strong suit would not be selling, so she hired Thomas Way to take on that aspect of the business, from 1978 until

1981. To help establish a base of collectors, until 1979 Brown offered a subscription plan "as a way that a few people can invest in Crown Point Press, both to enable us to continue our work and to build a beautiful and meaningful and valuable collection for themselves."[76] She also began exhibiting at international art fairs, with her teenage son Kevin assisting. In Bologna in 1978, Burden's "counterfeit" *Diecimila* created quite a stir, clearly causing local police to look at fine art prints more closely than usual. That same year at Basel, Brown underscored the conceptual bent of her Press by distributing flat compressed sponges, with the Crown Point Press name and address followed by the information that "This is a symbolic object; DIP IN WATER — WATCH THE ACTION." She was especially pleased when Aldo Crommelynk, whom she considered "the best etching printer in the world" visited her booth and complimented her on her printing.[77]

Brown has not paid attention to the demands of the marketplace by limiting her selection of artists to those who would probably sell; she has done so by regulating prices and the sizes of her editions. For the etchings, editions have been quite small, usually from ten to thirty-five impressions, what she believes the market might bear. The Asian woodcuts, by contrast, were printed in editions of up to 200, "the initial idea," according to McCready, being "to make a beautiful print that was the same quality as the etchings. By making larger editions of attractive images, the prints could be cheaper, and theoretically at least, more popular with the public."[78] This was not always how it turned out, but in general, the theory worked.

In 1979 Margarete Roeder opened a gallery in Manhattan at 545 Broadway, occupying the main front section and leasing the rear to Brown for Crown Point's first New York City office. It was manned by Way who traveled coast-to-coast coordinating sales. The following year Brown opened her first Crown Point Press Gallery, on the street-level of the Oakland building that housed the studio. Originally an aviary, a hat manufacturer had later occupied the space. "Twenty-two-foot high ceilings and a 200-square-foot cathedral skylight provide[d] an optimal space for viewing the work of

FIG. 37
John Cage reading his *Composition in Retrospect* at Crown Point's Oakland gallery, surrounded by his *Dereau* edition, 1982

Crown Point artists."[79] From this time on, Way spent most of his time in Oakland, and Roeder, who had been representing Crown Point publications in the European market where they were as admired as the earlier Parasol Press publications, took to representing them in New York City as well.[80]

The opening exhibition at the Oakland Gallery (fig. 36), *Italians and American Italians*, accompanied by a catalogue with an essay by Brown, included prints by Acconci, Kounellis, Marioni, and Scanga. It was handsomely installed as were all subsequent exhibitions. "Artists respected the fact that Kathan was an artist," Wiley suggested. She would do "impeccable, beautiful shows with sensitive presentation of the work." In addition to hosting exhibitions, other programs took place at the spacious gallery. A high point among these was the celebration of the twentieth anniversary of the Press in 1982: Brown invited John Cage to do a reading, and he wrote a new word piece, *Composition in Retrospect*, especially for the occasion. The accompanying exhibition was a survey of Cage's prints from 1978 through 1982, again with a substantial catalogue (figs. 37, 38).

FIG. 38
John Cage, *Dereau #3,* 1982, one from a group of 38 related color etchings with aquatint, engraving, photoetching, and drypoint, 457 x 623 mm, FAMSF/CPPA 1991.28.22

The year prior to this celebration, reading, and exhibition, Way left his sales post, and McCready, then director of Pace Editions, became Crown Point's sales director.[81] Based in New York, McCready traveled to the Bay Area frequently, becoming an increasingly active participant in all aspects of Crown Point's activities. She was named director in 1987, and along with Marioni, is preeminent among those to whom Brown feels indebted, specifically for her contributions to the Press's visibility, and for her suggestions

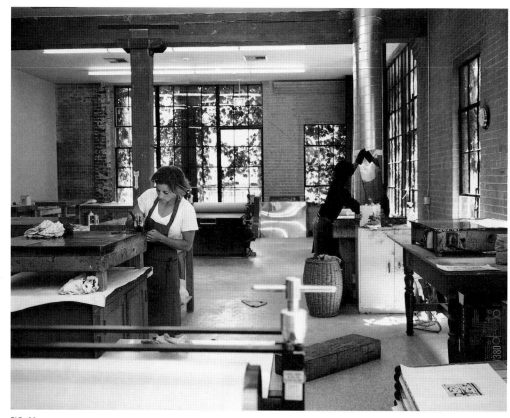

FIG. 39
Renée Bott and Daria Sywulak in the Hawthorne studio, 1991

of artists to publish, among them Frankenthaler, Held, Jacquette, Katz, Nelson, Tim Rollins + K.O.S., and True.

McCready started out in the back of the Margarete Roeder Gallery, but by February 1985, she was at the helm of Crown Point's own New York City exhibition space at 568 Broadway, among the pioneers in the SoHo building that also housed John Gibson, Curt Marcus, and (later) Lorence/Monk galleries. The interior was elegantly designed by architect Denise Hall, a McCready suggestion who later was to take on the Press's two San Francisco studios. Brown's propensity to permit her employees to work independently is confirmed by McCready's report that Brown saw "the New York space raw and she never saw it again until it opened. That's how Kathan operates."

McCready was very familiar with Crown Point publications before she joined Brown's staff: "I went out there when I was at Pace. It was a beehive; there were ninety-seven things happening in a very quiet way. Everything is done for the artists in the best possible manner." Despite the quality of the work, however, "not only was there no presence in New York, but the artists were not well known. Not even Diebenkorn. That's why in the beginning we spent a lot on advertising to get the Crown Point name out. California is another world." Half-page color advertisements were taken in journals including *ARTnews*, *Art in America*, *Artforum*. Exhibitions of new publications, rotating displays of earlier ones, and theme shows including *Not So Plain Geometry*, *Ideas/Image* (Conceptual art), and *Altered States* (State Proofs), some of which would include prints by publishers other than Crown Point, filled the Gallery for the next ten years.

Crown Point's West Coast galleries, first in Oakland, then on Folsom Street in San Francisco were similarly active through the 1980s. The print market, however, which had reached unprecedented heights by the end of that decade, plummeted at the start of the new one. Soon after Brown moved into her Hawthorne/Howard building in 1990, downsizing became necessary. Much of the building's lower

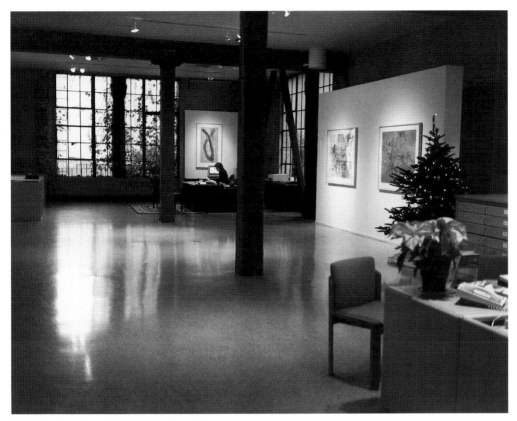

FIG. 40
The Hawthorne studio converted to the Crown Point gallery, 1996

handling the Crown Point Press prints in New York City, and other art as well.

In keeping with Brown's ongoing concern with teaching people about prints, gallery director Valerie Wade sees her role as demanding an active involvement with education and community relations as well as with sales. Conducting group tours of the Press, inviting visitors for demonstrations and to talk to the Master Printers, are attempts to remedy "so much misinformation about what prints are in terms of reproductions versus an original activity." This problem of differentiating original prints from, for example, cheap reproductions of paintings, which are "printed," has always been a concern of print publishers — many of whom are similarly committed to educating the public. What has been distinctive about the Crown Point Press program, however, has been Brown's extensive series of instructive books, pamphlets, and newsletters.

Apart from the books with original prints that were essential to Crown Point's initial publishing program, Brown also undertook book publishing, sometimes under the imprint of Point Publications. *Voyage to the Cities of the Dawn*, 1976, is both written and illustrated, with photographs by Brown and Kevin Parker. Brown considers it one of her works of art. Like her earlier books with etchings, *Album* and *Sardinia*, and the later *Paradise*, this book explores the relationship of Brown and her contemporaries with the past. The text recounts a trip to archaeological sites of the Ancient Maya in Mexico and Guatemala, including Uxmal, Chichén Itzá, Copan, Kaminaljuyú, and Tikal.

level was rented to the Achenbach Foundation for Graphic Arts of the Fine Arts Museums of San Francisco, which acquired the Crown Point Press Archive in 1991, and the Western Regional Paper Conservation Laboratory, normally located at the Achenbach. (The Achenbach's parent museum, the California Palace of the Legion of Honor, was undergoing renovation.)

In 1993 Brown vacated the expansive ground-floor gallery in the building and transferred the exhibition and sales space to the smaller of the two working studios (figs. 39, 40). The ground-floor eventually was leased, later to open as the Hawthorne Lane restaurant, the walls of which display seasonal rotations of prints from Crown Point. Also in 1993, Brown greatly reduced her staff to seven people, three of them printers. This was a far distance from the twenty-two people, including ten printers, that comprised the staff at its largest in 1989. In 1994, almost a decade after it opened, Brown closed Crown Point's New York gallery, and McCready became a private dealer

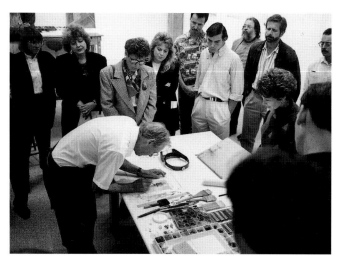

FIG. 41
Wayne Thiebaud demonstrating watercolor monotypes to
Season's Club members, Crown Point Press, 1991

In addition to the *Vision* series noted above that Brown published jointly with Marioni, the diverse body of written material, often by Brown herself, that Crown Point has issued includes ephemeral pieces and ongoing series, much of it about the Press's goals and programs, and the artists who have worked there. Late in 1977, for example, Brown issued a 1978 calendar with a brief history of Crown Point Press inserted, including thoughts on "Serious Publishing" and "The Best Circumstances—What Artists at Crown Point Press Receive." It included a summary of that year's publications: Acconci's and Burden's involvements with photoetching "for art that involves social comment"; Marioni and Fox as environmental artists whose prints were the "result of philosophic or scientific exploratory actions"; and Steir's and Diebenkorn's involvements with "etching as mark-making." The 1979 calendar included Brown's *Discussion of Value*; in 1980, her *Discussion of Meaning*; in 1981, her *Discussion of Beauty*.

Prior to Brown's catalogue essay for *Italians and American Italians* for the Oakland Gallery's opening show, she had completed essays related to other exhibitions of Crown Point publications. These started with the Press's first major exhibition, at the San Francisco Art Institute in 1972. Others were for traveling shows coordinated by Roeder: *Music Sound Language Theater: Etchings by John Cage, Tom Marioni, Robert Barry, Joan Jonas* in 1979, which

traveled in the United States and was circulated in Europe by the United States Information Agency; and *Representing Reality: Fragments from the Image Field*, in 1982, including prints by Brus, Clemente, Fisher, Kushner, Steir, and Wiley.[82]

In 1978 Brown initiated the *View* interview series, which was published steadily until 1981. It was taken up again in 1983 and has been issued intermittently since. Robin White, primarily, conducted and edited the interviews for the first group, and Lewallen, primarily, for the second. Except for Laurie Anderson (who was part of the 1980 Ponape conference) and Howard Fried (who started a project with the Press that was never completed), the subjects were the artists whose works were published by Crown Point. In general, the *View* series is extremely useful, broadly philosophical, and it only incidentally deals with printmaking.

Since spring 1984 the Crown Point newsletter, *Overview*, has been issued about three times a year. A uniquely personal publication, it was an outgrowth of "Dear Friends" letters Brown had sent clients from time to time. *Overview* is filled with news of Crown Point's recent prints, how they were made, their relationship to the artists' current work in other media; and updates on Crown Point artists, their exhibitions and important publications about them. *Overview* also includes Brown's philosophical musings, a continuation of her earlier discussions of value, meaning, and beauty, or her thoughts on collecting prints or some aspect of the current art scene. Brown's most recent and most ambitious writing project was published by Chronicle Books, San Francisco. It was the expansion of an exhibition brochure to a full scale 288-page volume, *ink, paper, metal, wood: Painters and Sculptors at Crown Point Press*, a distinctively personal account of Crown Point Press and the artists who have worked there.

In the 1990s, when interest in prints and the accompanying sales that it brought dropped, Brown initiated new programs to make her Press more visible. In 1991 she announced the *Seasons Club*, enabling collectors to acquire Crown Point prints at a discount on a seasonal basis. And bringing the Press's activities full circle, also since 1991, Crown Point has offered summer etching workshops, enthusiastically received by some three dozen

students each year, twelve per weeklong class (fig. 42). According to Thiebaud, "Kathan is dedicated to teaching and educating, helping people come to love prints and understand them."

Thinking Print: Books to Billboards 1980–1995, a 1996 international exhibition at the Museum of Modern Art, New York City, indirectly demonstrated Kathan Brown's prescient vision. From books in 1965, Brown worked at billboard scale with Acconci as early as 1979. The two media-based sections of the show featured intaglio and woodcut, the two processes Crown Point Press has embraced since 1962 and 1982 respectively. And two of the exhibition's thematic highlights, "Language" and "Social and Political Issues" have been essential to the Crown Point vision from the start.

However a printer/publisher perceives his or her role, it undoubtedly has a profound impact on the artists with whom he or she works. That impact will probably best be assessed by historians of the twenty-first century able to weigh with dispassion the many declarations and disclaimers about collaborative printmaking that are being published as this century comes to a close. In any account of the period, Kathan Brown and Crown Point Press undoubtedly will play a major role. They will be credited with groundbreaking work in placing both intaglio/etching and the conflation of Eastern and Western woodcut traditions in the mainstream of late twentieth-century art. As McCready put it, "Kathan likes to live on the edge. Anything she can do to perpetuate that edge, she'll do."

Note: All figure captions referenced as "FAMSF/CPPA" are numbered as part of the Fine Arts Museums of San Francisco, Crown Point Press Archive. Full information on works referenced as "cat." in the figure captions or the text will be found among the numbered checklist entries in this catalogue.

1. Three useful recent publications on contemporary prints are: Trudy V. Hansen et al., *Printmaking in America: Collaborative Prints and Presses, 1960–1990*, exh. cat. (New York: Harry N. Abrams, Inc., Publishers in association with the Mary and Leigh Block Gallery, Northwestern University, 1995); Susan Tallman, *The Contemporary Print: from Pre-Pop to Postmodern* (London and New York: Thames and Hudson, 1996), which presents a balanced overview of printmaking as defined by print publishing in the United States and Europe during the period from 1960 to the present; and Deborah Wye, *Thinking Print: Books to Billboards, 1980–95*, exh. cat. (New York: The Museum of Modern Art, 1996), which records selections from the Museum's acquisitions over fifteen years.

 Kathan Brown's book, *ink, paper, metal, wood: Painters and Sculptors at Crown Point Press* (San Francisco: Chronicle Books, 1996), provides technical data and a recollection of Brown's life as a print publisher, including personal reflections about artistic practice.
2. In 1970 Tamarind was transferred to the University of New Mexico, Albuquerque, and renamed Tamarind Institute. Other important workshops have had university associations as well, for example Graphicstudio, U.S.F., at the University of South Florida.
3. Among the most beautiful screenprints of the period are those by artists including Richard Hamilton and R. B. Kitaj printed by Chris Prater at Kelpra Studios in London. See Pat Gilmour, *Kelpra Studios: The Rose and Chris Prater Gift, Artists Prints 1961–1980*, exh. cat. (London and New York: The Tate Gallery, 1980).
4. The exhibition, *Etchings from the Crown Point Intaglio Workshop*, was held at the Richmond Art Center from 24 October – 30 November, 1963. According to the one-page brochure, the exhibition brought together "about 25 of the best prints made in the workshop over the past year."— prints by Dennis Beall, Geoffrey Bowman, Helen Breger, June Felter, Sally Fox, Anne Jenkins, Alfred Smith, Alan Williams, Jeryl Parker, and Brown. Activities at Crown Point included "weekly sessions with a model, enabling artists to draw directly on the etching plate from life."
5. Brown, *ink, paper, metal, wood*, p. 28.
6. Without the formal commitment to training printers that was among Tamarind's goals, Brown has shared her skills with many apprentices who became Master Printers at Crown Point Press and went on to open their own studios. Among them are Patricia Branstead (Aeropress, and Branstead Studio, New York, N.Y.); Doris Simmelink (Simmelink/ Sukimoto Editions, Marina del Rey, Calif.); Peter Pettengill (Wingate Studio, Hinsdale, N.H.); Marcia Bartholme (Beta Press, Seattle, Wash.); David Kelso (made in California, Oakland); Larry Hamlin (Mad Dog Press, Urbana, Ill.); Pam Paulson (Paulson Press, Emeryville, Calif.); Lothar Osterburg (Lothar Osterburg Photogravure, New York, N.Y.); Mark Callen (Infinity Press, Seattle, Wash.).

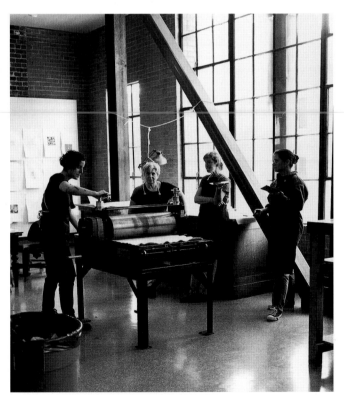

FIG. 42
Dena Schuckit leading an etching workshop in the Howard Street studio, 1996

7. Pat Gilmour, *Ken Tyler — Master Printer and the American Print Renaissance* (New York: Hudson Hills Press, 1986), p. 7.

8. Two articles in *Art News* 60 (January 1962), pp. 34–37, introduce the idea of a bicoastal print revival: Jules Langsner, "Is there an American print revival? Tamarind Workshop" discussing June Wayne's contributions; and James Schuyler, "Is there an American print revival? New York" discussing Tatyana Grosman and Universal Limited Art Editions.

9. "About California," *Vision* I (September 1975), p. 7.

10. See Joanne Moser, *Atelier 17*, exh. cat. (Madison, Wisconsin: Elvehjem Art Center, 1977).

11. This quotation and all subsequent ones not otherwise cited are from the author's conversations with Kathan Brown, 11 January, and 11–12 June 1996. Additional data in this essay comes from informal conversations over several years.

12. For further technical information, consult John Ross, Clare Romano, Tim Ross, *The Complete Printmaker* (New York: The Free Press, 1990); or Donald Saff, Deli Sacilotto, *Printmaking: History and Process* (New York: Holt, Rinehart and Winston, 1978).

13. This point about collaboration was articulated by Tallman in *The Contemporary Print*, p. 16.

14. Brown's method as described by Nancy Anello, in conversation with the author, 12 June 1996.

15. Kevin Parker, who presently owns the Powis Parker Company which has patented the Fastback Document Binding System, worked in a variety of capacities at Crown Point Press as a teenager, becoming an accomplished photoetcher, printer, and bookbinder. He also invented the print drying system and aquatint oven in use at Crown Point. Brown has shared the plans for them with other print shops.

16. Because Brown objected to using French terminology such as *bon à tirers* (or "B.A.T.s"), in her studio these impressions are referred to as the "OKs" and are inscribed by the artists as: OK to Print.

17. See Garo Antreasian and Clinton Adams, *The Tamarind Book of Lithography: Art and Techniques* (New York: Harry N. Abrams, Inc., with Tamarind Lithography Workshop, 1971). Mainly about technique, Chapter 16, "The Lithography Workshop," pp. 423–440, discusses the organization and offers cost tables for the professional shop, the school shop, and the private shop.

18. *Etchings from the Crown Point Intaglio Workshop* in 1963 was the Press's very first exhibition. The next show had a more serious catalogue with an introduction by Brown: Kathan Brown, *Crown Point Press*, exh. cat. (San Francisco: San Francisco Art Institute Emanuel Walter Gallery, 1972) documented the artists who had worked there up to that time.

19. This and subsequent quotations from Wayne Thiebaud are from the author's conversation with him, 11 June 1996.

20. Tom Marioni recalls seeing Brown's art in the 1960s at San Francisco's Hansen Gallery. Although she downplays her own work as an artist, Brown's prints have been in many exhibitions, including Therese Heyman, *Three Etchers in California: J.A.M. Whistler, Max Pollack, Kathan Brown*, exh. cat. (Oakland, California: The Oakland Museum, 1982).

21. This and subsequent quotations from Hidekatsu Takada are from the author's conversation with him, 12 January 1996.

22. In the interim, however, Diebenkorn did lithographs at Tamarind Lithography Workshop in 1961, 1962, and 1970.

23. Wayne Thiebaud, *California Printmaker* #1, April 1995, p. 14.

24. Kathan Brown, *The California Printmaker* #1, April 1995, p. 12.

25. Richard S. Field and Daniel Rosenfeld, *Prints by Contemporary Sculptors*, exh. cat. (New Haven, Connecticut: Yale University Art Gallery, 1982), p. 6.

26. This and subsequent quotations from Robert Feldman are from the author's conversation with him, 16 February 1996.

27. Several reviewers took a somewhat negative view of Gemini's technical heroics, for example, Judith Goldman, *Print Collector's Newsletter* 2 (May–June 1971), pp.30–31. But there remains a lingering suspicion that some of these comments may have had to do with the East Coast critical establishment downplaying the West Coast workshop.

28. Brown, *Crown Point Press*, unpaginated. This 1972 publication notes two student helpers, but Brown only remembers one and adds that she frequently worked alone with the artist.

29. Ibid.

30. *Print Collector's Newsletter* 8 (November–December 1977), pp. 131–132.

31. This print has been written about extensively. For example, see Richard S. Field, *Recent American Etching*, exh. cat. (Middletown, Connecticut: Davison Art Center, 1975), unpaginated, cat. 4 is a State Proof of *Keith*; and Judith Goldman *American Prints: Process and Proofs*, exh. cat. (New York: The Whitney Museum of American Art and Harper and Row, Publishers, 1981), pp. 64–69.

32. Until 1974 when Brown stopped teaching at the San Francisco Art Institute, the presence of these artists at Crown Point also had an impact on her students because she invited many of the artists to meet with her seminar classes and some gave public lectures at the school.

33. Tallman, *The Contemporary Print*, p. 100.

34. The Crown Point Press Archive at the Achenbach Foundation for Graphic Arts at the Fine Arts Museums of San Francisco contains impressions of all of the prints printed for other publishers as well as those published by Crown Point Press from 1962 to the present. The Crown Point Press "OK to Print" Collection at the National Gallery of Art includes virtually all works published by Crown Point Press since 1977.

35. Gilmour mentions Grosman's attitude on this point in *Kenneth Tyler — Master Printer*, p. 22.

36. Brown, *ink, paper, metal, wood*, p. 54.

37. Marioni's use of the term "action" derives from a group of German-speaking performance artists of the 1960s, the "Actionists," including Günter Brus and Hermann Nitsch.

38. MOCA thrived from 1970 through 1984 and brought to San Francisco Conceptual artists from around the world. Its archives are housed at the University Art Museum, University of California at Berkeley.

39. See *NSCAD: The Nova Scotia College of Art & Design*, a catalogue for an exhibition circulated by the New England Foundation for the Arts (Halifax: Press of the Nova Scotia College of Art & Design, 1982). The catalogue lists book publications as well as prints issued by the Press, including texts by and about Daniel Buren, Hans Haacke, and Steve Reich, artists also published by Crown Point Press.

40. *Print Collector's Newsletter* 6 (November–December 1975), p. 133.

41. Brown and Marioni discovered Ponape in 1978 during a freighter trip in the South Pacific. Enamoured of its beauty and peacefulness they decided to return, bringing with them Marina Abramovic, Laurie Anderson, Chris Burden, Daniel Buren, John Cage, Bryan Hunt, Joan Jonas, Robert Kushner, Brice Marden, Pat Steir, and William T. Wiley, all of whom, with Marioni, made dinnertime presentations. In addition to the artists and their partners, critics, collectors, and curators attended — it was "a miniature art world," according to Marioni, in conversation with author, 10 January 1996.

42. The quotation is from the author's conversation with Marioni, 10 January 1996.

43. Brown, *ink, paper, metal, wood*, p. 47.

44. At various times, and with varying degrees of seriousness horoscope data and, more importantly, handwriting analysis have contributed to Brown's decisions in hiring staff. In addition, she seeks the opinions of present staff in considering whom she is adding to the mix.

45. Brown, *ink, paper, metal, wood*, p. 47.

46. Field and Rosenfeld, *Prints by Contemporary Sculptors*, p. 8.

47. Author's conversation with Pat Steir, 26 April 1996.

48. Hans Haacke returned in 1982 to complete *Upstairs at Mobil: Musings of a Shareholder*, a large and important work for both artist and publisher.

49. This and subsequent quotations from Margarete Roeder are from the author's conversation with her, 30 April 1996.

50. See Donald Saff, "It is as it Should Be" in *Rauschenberg*, exh. cat. (Stockholm: Heland Wetterling Gallery, 1989) for a discussion of the importance of the *I Ching* for Robert Rauschenberg with whom Cage collaborated on a variety of projects over the years.

51. This and subsequent quotations from Nancy Anello are from the author's conversation with her, 12 June 1996. In addition to Anello, printers Renée Bott and Takada similarly discussed the pleasures and challenges of working with Cage.

52. This information and subsequent quotations from William T. Wiley are from the author's conversation with him, 10 June 1996.

53. Author's conversation with Kevin Parker, 11 June 1996.

54. See Susan Tallman, "Laboratory Still Lives," *ARTS* magazine 63 (February 1989), pp. 17–18.

55. This and subsequent quotations from Judy Pfaff are from the author's conversation with her, 8 July 1996.

56. Wye, *Thinking Print*, p. 12, citing *Print Collectors Newsletter* XVIII, (January–February 1988), p. 209.

57. The term "project" could refer to one edition by an artist, or, as in the case of Tony Cragg, dozens of editions.

58. Brown's four page insert for *Overview* dated December 31, 1989, recounts events as they happened from 18 October, the day after the earthquake, through the 28 December acquisition of the new Crown Point Press Hawthorne/Howard Building.

59. Some of the prints were made after the earthquake, others were actually completed before the earthquake but not published until after.

60. This and subsequent quotations from Valerie Wade are from the author's conversation with her, 12 June 1996.

61. Brown, "Dear Friends," *Overview*, Spring 1984, p. 2.

62. Gilmour, *Ken Tyler–Master Printer*, p. 83. See also Richard S. Field, "On Recent Woodcuts," *Print Collector's Newsletter* 13 (March–April 1982), pp. 1–5.

63. Bartlett worked outside of the strict Japanese tradition by carving her own blocks. Lichtenstein subverted the Japanese tradition, too, by employing layers of translucent color for flat, dense, unmodulated hues, rather than nuanced color areas.

64. "Collaboration East & West: A Discussion," *Print Collector's Newsletter* 16 (January–February 1986), pp. 196–205, records a conversation among artists Jennifer Bartlett and Alex Katz; curators Clifford S. Ackley, Pat Gilmour, and Robert Flynn Johnson, and printer Michael Berdan, moderated by curator Richard S. Field. A series of "Letters to the Editors" had preceded it: from printer David Kelso, from artist Helen Frankenthaler, from publisher Kathan Brown, *Print Collector's Newsletter* 16 (March–April, May–June, November–December 1985), pp. 15, 53, 172.

65. Richard S. Field, "On Originality," *Print Collector's Newsletter* 3 (May–June 1972), p. 26.

66. Karen McCready, letter to author, 23 September 1996.

67. This and subsequent quotations from Constance Lewallen are from the author's conversation with her, 12 June 1996.

68. Author's conversation with Robert Kushner, 6 June 1996.

69. Brown, *ink, paper, metal, wood*, p. 221.

70. This and subsequent quotations from McCready not otherwise cited are from the author's conversation with her, 30 April 1996.

71. Author's conversation with Mari Andrews, 11 January 1996.

72. At many workshops these tasks are undertaken by the shop's curator.

73. Other print publishers use as many as twenty categories for proofs, including special proofs, touched proofs (specific to those with drawing or other handwork on them), presentation proofs, cancellation proofs, and so forth.

74. My thanks to Susan Lorence for our recent conversations about print publishing.

75. In the late 1980s Brown's job descriptions included an extensive quotation from Drucker's *The Frontiers of Management* (New York, E.P. Dutton, 1986). It read in part:

> Traditional organization basically rests on command authority. The flow is from the top down. Information-based organization rests on responsibility. The flow is circular from the bottom up and then down again. The information-based system can therefore function only if each individual and each unit accepts responsibility: for their goals and their priorities, for their relationships, and for their communications.

> Each has to ask, What should the company expect of me and hold me accountable for in terms of performance and contribution? Who in the organization has to know and understand what I am trying to do so that both they and I can do the work? On whom in the organization do I depend for what information, knowledge, specialized skill? And who in turn depends on me for what information, knowledge, specialized skill? Whom do I have to support and to whom, in turn, do I look for support?

> The conventional organization of business was modeled after the military. The information-based system much more closely resembles the symphony orchestra. All instruments play the same score. But each plays a different part. They play together, but they rarely play in unison. There are more violins but the first violin is not the boss of the horns; indeed the first violin is not even the boss of the other violins. And the same orchestra can, within the short span of an evening, play five pieces of music, each completely different in its style, its scoring, and its solo instruments. . . .

> The information-based organization thus requires high self-discipline. This in turn makes possible fast decisions and quick response. It permits both great flexibility and considerable diversity.

76. Brown, *Crown Point Press*, 1977, promotional brochure.

77. Brown, *ink, paper, metal, wood*, p. 49

78. McCready, letter to the author, 19 September 1996.

79. Cathy Curtis, "Crown Point Press — Workshop as Artist's Studio," *Overview* (Spring 1984) p. l. An edited reprint of an article in *PrintNews* 5 (November/December 1983). McCready, letter to the author, 23 September 1996, suggested "it was a wonderful space but a bit awkward for viewing art."

80. Roeder reported that Crown Point Press publications were eagerly acquired by museums in Germany (Berlin, Dresden, Frankfurt, Stuttgart); Austria (Vienna); Switzerland (Zurich, Basel); England (London). "They love the work of Crown Point."

81. Brown discovered that Way had taken numerous prints before his departure, and a warrant was issued for his arrest; he seems to have disappeared.

82. Two other traveling exhibitions were organized in association with Roeder, but there were no catalogues: *Against the Grain: Political Prints by Vito Acconci, Chris Burden and Hans Haacke*, in 1982; and *Installation Prints: Three Approaches to Walls*, etchings by Vito Acconci, Daniel Buren, and Joyce Kozloff, also in 1982. Roeder's press release for *Installation Prints* states there will be a catalogue for the show, with color illustrations, an essay by Brown, and statements by the artists. None was produced, but the release provides an indication of the ambition behind the project.

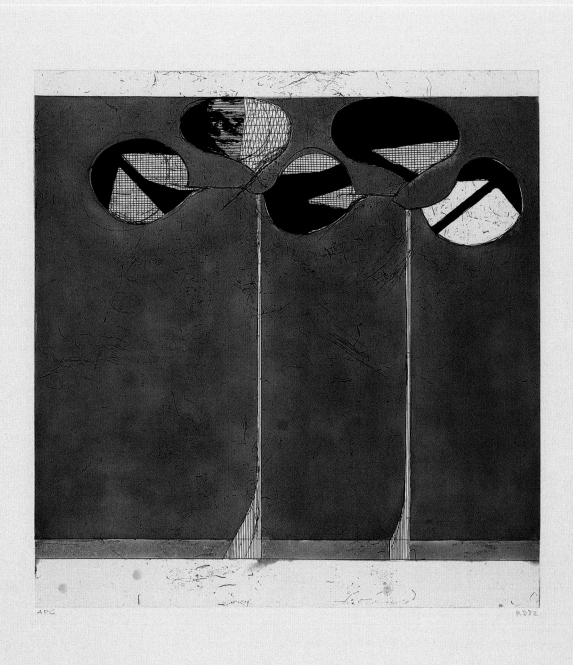

FIG. 1 / CAT. 180
Richard Diebenkorn *Clubs Blue Ground,* 1982

The Crown Point Press Archive
Documents of the Artistic Process

KARIN BREUer

WHEN THE FINE ARTS MUSEUMS of San Francisco acquired the Crown Point Press Archive in 1991, the 1,633 Artist's Proofs or editioned prints and 2,066 Working Proofs included in the archive were described by one Museum official as "an art historical gold mine" that would be utilized inexhaustibly for exhibitions, publications, and teaching.[1] On the day for delivery of the archive to the Museum, Kathan Brown described the archive as "my children . . . going off to have a life of their own."[2] Certainly, these were both apt descriptions for the group of prints and unique materials (artist's preparatory sketches, notes, Working Proofs, blocks, and plates) that form the Crown Point Press Archive. This valuable resource effectively documents the success of Brown's efforts to promote *etching*[3] as a flexible and modern printmaking medium for artists involved in all manner of art-making. The prints in the Crown Point Press Archive, produced over a period of thirty-five years, attest to the realization of Brown's belief that a traditional medium such as etching can be a vehicle for new artistic approaches.

"It's fascinating to use the old ways for really new work and, of course, we carry them further sometimes with some artists," Brown said in 1977, commenting on how Crown Point Press accommodated the varied styles and working habits of artists who came to work there.[4] Remarkable results, from the crisp, precise lines and shapes required by Minimalist artists such as Sol LeWitt and Brice Marden to the lush, transparent layers of color needed for the aquatints of Richard Diebenkorn

and Wayne Thiebaud, were achieved in a studio environment with skilled printers working under the same premise: *make the medium work for the artist*. "It's an absolutely terrific place," explained Chuck Close in a 1978 discussion of his work at Crown Point. "It's one of those really flexible printing situations, which I need. They're flexible enough to accept that the place is now going to be Chuck Close's studio for a while, and so next week it'll be Sol LeWitt's. Here you are working in a foreign material you're not used to and at least you have the feeling of being able to behave in the same way you normally behave. They are wonderful, and they give you just the right amount of guidance, suggestions, and criticism."[5] Close's masterful mezzotint *Keith* (cat. 2), made in 1972, is a well-known example of how Crown Point stretched the limits of the media to accommodate an artist's idea, keeping the artistic vision paramount over practical concerns of technique.

The Working Proofs that form the bulk of the archive are perhaps the best evidence of the creative spirit fostered at Crown Point Press. As defined by Crown Point, Working Proofs are prints that exist in one impression and are printed so that the artist can see changes in the matrix during a printmaking project. They are often altered by hand, either with notations by the artist or printer, or with drawing in various media. Some artists make numerous Working Proofs, others make only one or two; the quantity of Working Proofs does not reflect an artist's printmaking experience. In most cases, the Working Proofs are numbered by the printers in a

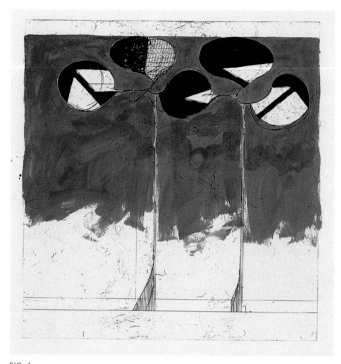

consecutive order. Working Proofs are sometimes destroyed at the end of a project, or an artist might choose to retain them. Kathan Brown thinks that the Crown Point Press Archive has more Working Proofs than other print archives because, "We never worked in a way where an artist had to come to a project with a plan. Sometimes, there was a lot of experimenting before an artist got to an idea. Also, I think that etching by its very nature requires a lot more proofing than other media."[6]

Brown early on recognized the historical importance of Working Proofs and asked many artists to relinquish them on certain projects. "If you have an opportunity to view a large group of Working Proofs, you will be able to see, in a way not usually possible with work in other media, an artist's creative processes materialized," she wrote in 1996 to describe the value of Working Proofs and why, beginning in 1977, she saved many sets of proofs from artists working at Crown Point Press.[7] In the Fine Arts Museums' Archive, Working Proofs are seen as correlates to the finished prints and therein lies their value. They can be viewed as a kind of visual diary of a project, providing testimony to the evolution of a print.

Because so many artists who worked at Crown Point Press were encouraged to consider etching as a medium that was open to experimentation, the Working Proofs also reveal an artist's willingness to work with the surprises and possibilities inherent in the medium. Etching was well-suited to the artistic investigations of Richard Diebenkorn, and consequently the Working Proof was an essential part

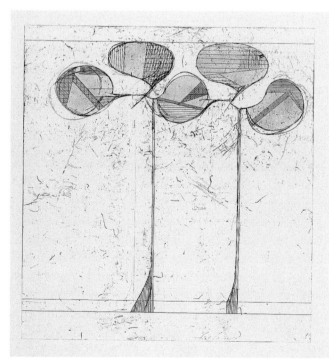

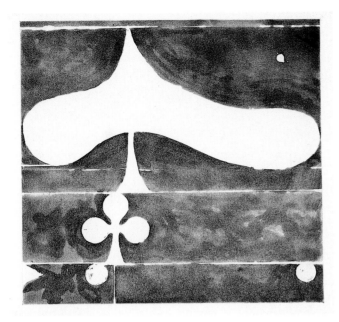

FIG. 5
Richard Diebenkorn
Working Proof 1 for *Spreading Spade,* 1981, FAMSF/CPPA 1992.167.61

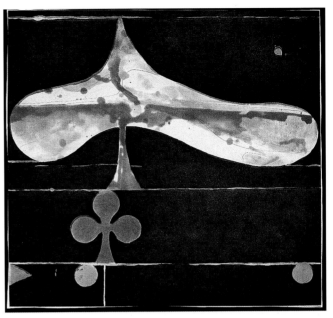

FIG. 7
Richard Diebenkorn Working Proof 2 for Spreading Spade, 1981, FAMSF/CPPA 1992.167.60

FIG. 6
Richard Diebenkorn Cut-out collage elements used in Working Proofs for *Spreading Spade,* 1981, FAMSF/CPPA 1991.28.673 A–C

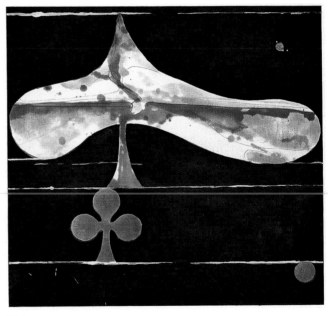

FIG. 8
Richard Diebenkorn Working Proof 3 for *Spreading Spade,* 1981, FAMSF/CPPA 1991.28.671

of his printed art. The Fine Arts Museums has thirty-five sets of Diebenkorn's Working Proofs, each an example of the unique way in which he approached printmaking. The proofs for the prints in the *Clubs and Spades* series are perhaps the most interesting.

After working off and on at Crown Point for over sixteen years, Diebenkorn began in 1981 to work on a group of prints that featured the emblematic forms of clubs and spades. The forms were often superimposed, stretched, and metamorphosed, sometimes singly or in combinations against a color aquatint background. To achieve these dynamic compositions, Diebenkorn changed and corrected proofs constantly during the working stages. For the 1982 project *Clubs Blue Ground* (fig. 1) he started with a simple drawing, (fig. 2)

made in black crayon on inexpensive paper. (Because Diebenkorn was comfortable enough in the Crown Point studio to begin a print by drawing directly on prepared plates, this drawing was an idea rather than a preparatory sketch.) The drawing shows that Diebenkorn's first idea was to position two clubs side by side, but he then drew over that and moved

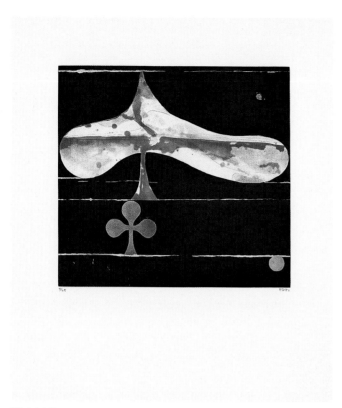

FIG. 9 / CAT. 179
Richard Diebenkorn *Spreading Spade,* 1981

Diebenkorn frequently used collage in the process of making a print. The printers who worked with him at Crown Point confirm that he almost always cut up parts of earlier Working Proofs or proofs from other projects in order to use certain passages as collage elements. (They later printed out sheets of solid aquatint for him to use so that he would have larger, more usable colored papers with which to work.) He pasted or pinned the shaped pieces that he had cut onto other proofs for additional experimentation. The Working Proofs for *Spreading Spade* (fig. 9) are typical examples of how Diebenkorn used collage. In *Working Proof 1* (fig. 5) the spit bite aquatint plate was prepared, revealing a fully-realized composition awaiting color decisions. Diebenkorn proceeded to cut out shapes from proofing papers supplied to him (fig. 6) and in *Working Proof 2* (fig. 7) the results of collaging and further printing are apparent. (The yellow circle is a collage element that was pasted into place.)

the two shapes closer together so that they over-lapped. The drawing also indicates that, at this early stage, he thought about breaking up the "leaf" shapes into dark and light sections. *Working Proof 113* (fig. 3) is the direct translation of his idea into hard ground etching. The proof demonstrates how confident Diebenkorn was at working directly on the plate, redrawing over certain passages and allowing the underdrawing to show. The random scratches and marks that he enjoyed as "texture" are also apparent in this early proof.

Diebenkorn sometimes applied watercolor to proofs in areas that he intended to aquatint later, and the appearance of the gray watercolor in *Working Proof 113* indicates that his ideas about color may not have been fully worked-out at that stage. In *Working Proof 114* (fig. 4), however, he applied bright blue watercolor to the background in order to visualize the effect of spit bite aquatint. That the bright blue was considerably toned down in the final edition print was not unusual for Diebenkorn, whose experiments with color aquatint were numerous and sometimes drastic.

FIG. 10
Pat Steir Working Proof 1 for panel A of *Abstraction, Belief, Desire* (cat. 4), 1981, FAMSF/CPPA 1992.167.424

A comparison between *Working Proof 3* (fig. 8) and the editioned print (fig. 9) shows how important collaging was for Diebenkorn, even though the resulting changes were subtle.

Other artists have used collage in various stages of the printmaking process at Crown Point, although not to the same extent as Diebenkorn. A photograph in a 1981 Point Publication catalogue shows Pat Steir using scissors to cut up a proof with three Working Proofs pinned to the wall behind her. "It must have been for a mock-up in the final color proofing of *Abstraction, Belief, Desire*," says Hidekatsu Takada, the master printer assigned to the project. "Pat always had to keep busy in the studio, especially when we were proofing. She didn't use collage like Dick [Diebenkorn] did. Pat's way of working was by layering plate over plate with continuous proofing."[8] The idea of layers in Steir's early printed work was essential, as she claimed that, "I think a lot of things over in etch-ings; I work out new ideas in etchings, because the process works well with my mind. Every time you use an overlapping color or mark, it has to be on a separate plate. It's all layered, and so are my ideas."[9]

Takada worked on three of Steir's first projects at Crown Point Press, and remembers that for *Abstraction, Belief, Desire* (cat. 4, p. 58) she wanted to make the largest print that could fit on the press. In order to achieve this, three copper plates were created separately, then joined on the press bed and printed together. The Archive contains over twenty Working Proofs for this project, several for each of the three separate plates that tell the story of Steir's layered approach to printmaking.

Abstraction, Belief, Desire was made in a progressive way, beginning with the panel (panel A) at far left. *Working Proof 1 for panel A* (fig. 10) demonstrates that Steir began by drawing an informal grid in hard ground etching and inserting a strip of "step etch" near the top of the plate. She then

FIG. 11
Pat Steir Working Proof 3 for panel A of
Abstraction, Belief, Desire, 1980, FAMSF/CPPA 1992.167.422

FIG. 12
Pat Steir Working Proof 17 for panel A of
Abstraction, Belief, Desire, 1980, FAMSF/CPPA 1992.167.419

barely drew two vertical rows of geometric shapes in sugar lift aquatint before becoming dissatisfied with the idea. The plate was abandoned and Steir worked on another, more complicated arrangement of shapes, resulting in *Working Proof 3 for panel A* (fig. 11). In this proof the smeared appearance of the red ink was caused by Steir wiping the sugar lift aquatint with her finger or a rag. The messy marks and fingerprints in the bottom portion of the panel were from Steir's unconscious placement of her hand or a cloth on the plate while she was working. She was not concerned when they appeared in the printed proof, and allowed them to remain as marks in the edition prints. In *Working Proof 17 for panel A* (fig. 12) (the proofs were not numbered consecutively) another layer

was added, this time a grid etched in hard ground with handwriting and accidental marks in the lower portion of the panel. The plate for *Working Proof 5 for panel A* (fig. 13) was proofed in elaborate color. Steir was pleased with the results and proceeded to work on the next two panels. She returned to panel A, however, at the end of the project and directed that the color should be removed from the interiors of the geometric objects, leaving the simple hard ground drawing without embellishment.

Three Working Proofs for the center panel (panel B) reveal many more color experiments than in panel A. The composition was worked out in early stages of proofing, but Steir directed at least three color changes during the course of the project. Takada explains that Steir, unlike most artists,

FIG. 13
Pat Steir Working Proof 5 for panel A of
Abstraction, Belief, Desire, 1980, FAMSF/CPPA 1992.167.420

FIG. 14
Pat Steir Working Proof 3 for panel B of
Abstraction, Belief, Desire, 1980, FAMSF/CPPA 1992.167.432

was confident and specific about her use of color. "She would say 'Print that out in cadmium red and ultramarine blue,' and she could visualize what it would be like."[10] In *Working Proofs 3 and 4 for panel B* (figs. 14, 15) she strayed from her original concept of using the primary colors red, yellow, and blue. Instead, the proofs reveal experiments with orange, burnt sienna, and brown. The color in *Working Proof 6 for panel B* (fig. 16) was closest to the final version and, as if to express her approval, Steir continued to plan new work for the print with drawing in blue pencil. These newly added marks were the inspiration for a new soft ground etching plate that added yet another layer.

Because panel C had the most complicated composition, it required six plates and consequently, many Working Proofs exist. They again tell the story of Steir's method of building up layer upon layer of etching to achieve the richness of print and depth of meaning desired. In the final stages of proofing, however, the print began to look "muddy." Steir's printer, Takada, remembers thinking that it was because there were too many plates and each one was overworked. However, he knew she would not take out any part of the work to eliminate the "muddy" look. "Pat's way of working is not like other artists' who will burnish or scrape in order to take things out. If she doesn't like something, she will add *on* rather than take *out*," he explained as he recalled that Steir finally determined that it was the blue sugar lift plate that was the cause of her dissatisfaction:

FIG. 15
Pat Steir Working Proof 4 for panel B of
Abstraction, Belief, Desire, 1980, FAMSF/CPPA 1992.167.431

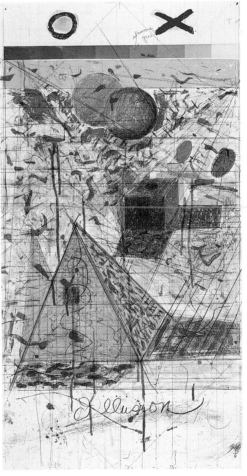

FIG. 16
Pat Steir Working Proof 6 for panel B of
Abstraction, Belief, Desire, 1980, FAMSF/CPPA 1992.167.429

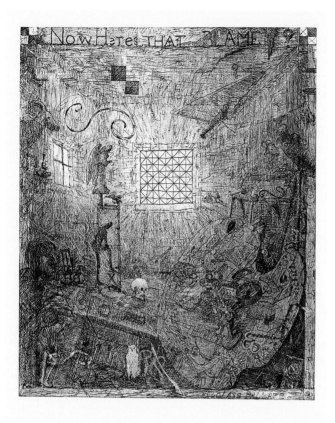

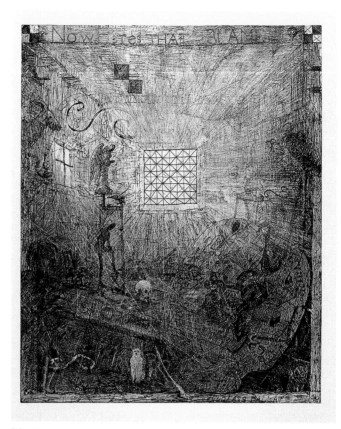

FIG. 17
William T. Wiley *NowHere's That Blame Treaty,* 1982,
FAMSF/CPPA 1992.167.1064

FIG. 18
William T. Wiley Working Proof 1 for *Now Who's Got the Blueprints*
(cat. 115), 1989, FAMSF/CPPA 1992.167.1073

Pat didn't think we were using the right blue color, but we were using ultramarine blue as she specified. And that was the blue she wanted, so I decided that we would proof while Pat was away and maybe we could come up with a solution. I knew that ultramarine can sometimes look muddy, so I toned it way, way down by adding transparent base to make it lighter and more transparent. When Pat came back that night, she told me that it was closer to what she wanted. The next day, when the ink was dry, Pat said it was right."11

According to Takada, even artists like Steir who are accomplished at printmaking don't always consider the technical aspects of printing. However, Takada was doing what was expected of him at Crown Point Press where any adjustments in printing are accommodated by the printer to fit the concept expressed by the artist. The story of the Working Proofs for panel C of *Abstraction, Belief,*

Desire reveals that "sixth sense" a printer must have when working with an artist on a complex project.

Sometimes even a special sensitivity on the part of a printer cannot prevent an unanticipated result in a print. In the case of *NoWhere's That Blame Treaty* (1979) William T. Wiley admits that, although he had been warned by a printer that a plate would print with tone, he continued to work on it without proofing. When it was finally proofed, the print had so much tone that almost all of Wiley's drawing was obscured. Wiley's first reaction was one of despair because so much of his work was hidden. He asked that the copper plate not be canceled, however, because he knew that by burnishing it, much of the drawing he had done on the plate could be uncovered. He reworked the plate at his studio over the course of the next three years and in 1982 returned with it to Crown Point Press where a second edition was pulled. The resulting print, entitled *NowHere's That Blame Treaty* (fig. 17), revealed

FIG. 19
William T. Wiley Working Proof 2 for *Now Who's Got the Blueprints,* 1989,
FAMSF/CPPA 1992.167.1072

FIG. 20
William T. Wiley Working Proof 3 for *Now Who's Got the Blueprints,* 1989,
FAMSF/CPPA 1992.167.1071

dozens of the "retrieved" images. Encouraged by that result, Wiley decided to use the same large copper plate again to make another print, likening it to a blackboard surface that could be erased and reworked. As before, he worked at his studio, nailing the plate to the wall, and driving with it in his truck bed to Crown Point for proofing sessions. "I was really enjoying the hand-working, working on the plate a little bit, getting a different image and then reworking the proofs."[12]

Over the course of proofing that resulted in the first three Working Proofs (figs. 18, 19, 20), Wiley made substantial changes in the upper portion of the plate by removing some of his earlier drawing and alternatively adding new marks and drawings to the lower left of the plate. The print changed radically in the interval between *Working Proof 3* and *Working Proof 4* (fig. 21). A new proof was printed in blue because, as Wiley said, "I got tired of seeing it in gray,"[13] but probably also because

he had changed the wording at the top of the print (the title) to "Now Who's Got the Blueprints." In this same Working Proof, the significance of an oil derrick (drawn in earlier) was made clearer by the addition of an oil tanker in a frame at the upper right. In *Working Proof 5* (fig. 22) this image was almost complete and it was clearly a reference to the Valdez oil spill in Alaska. Wiley also drew elegant, scroll-shaped strokes (inspired by the shapes of F-shaped resonance holes in stringed instruments) over the entire composition in red pencil and metallic orange paint. These were later added to the soft ground plate, as if to complete the project with a flourish. But they hardly symbolized the end of Wiley's work on the plate. "There's still a lot of copper left," was his comment when asked in 1989 if he was going to make more prints out of the (then) ten-year-old copper plate.[14]

Wayne Thiebaud, an artist who has worked at Crown Point Press since 1964, also tends to work

FIG. 21
William T. Wiley Working Proof 4 for *Now Who's Got the Blueprints,* 1989,
FAMSF/CPPA 1992.167.1070

FIG. 22
William T. Wiley Working Proof 5 for *Now Who's Got the Blueprints,* 1989,
FAMSF/CPPA 1992.167.1069

and rework plates over long periods of time. He is constantly challenged by the process of making prints and describes proofing as a step-by-step learning process, "The organization and anticipation of sequence, the layering of ideas, the surprising elements, the rich source of form variation, reversals, all of that fortifies and enriches your visual vocabulary."[15]

Thiebaud's 1989 print *Steep Street* originated from a series of watercolors done in the late 1980s. The watercolors had exhibited a softer, more impressionistic handling of architectonic urban subjects than in some of his previous cityscapes. He wanted to replicate that effect in the prints, and saw that the look of watercolor layering could be approximated by using color aquatint and spit bite aquatint. The Working Proofs for *Steep Street* reveal Thiebaud's careful, studied approach in visualizing the effect of overlapping aquatint layers. Sections of spit bite aquatint were developed on five plates,

and adjustments were made (including extensive burnishing and scraping-out) in forty-nine proofs from three different working sessions over the course of two years (cat. 117–122).

The Crown Point Press Archive has only twenty-eight of the forty-nine Working Proofs produced for the *Steep Street* project. Thiebaud elected to keep the others, as he often does with his print projects, in order to create new works of art in a process he calls "reworking."[16] Using assorted media such as pastel, watercolor, crayons, oils and acrylics, Thiebaud draws over the printed images to change them. He is careful to note, however, that he does this not because the print media have failed him, but because the prints themselves suggest possibilities for revitalization. The Working Proofs provide a fresh direction for Thiebaud that results in new works of art.

Like Thiebaud, Alex Katz has made prints for many years, finding something in all media that

was attractive and challenging, but which was also related to his method of painting. (He once referred to the way he paints as "like a printer — preconceived, in layers, color into color."[17] Therefore, it is not surprising that there are many Working Proofs for Katz's projects at Crown Point, including the color woodcut *Green Cap* which was made in 1985 as part of the Crown Point Press program in Kyoto, Japan.

As was the practice with that program, Katz sent a color drawing to Japan for the printer, Tadashi Toda, to translate into a color woodcut proof. In the initial proofing session at the beginning of the project in Kyoto, Katz's drawing was brought out and displayed alongside Toda's first proof. Decisions were made by the artist about desired changes, and the drawing was taken away, never to be seen again. The process of creating the print was begun all over again, this time with Toda working from a corrected proof. In the end, the print was no longer a reproduction of the artist's drawing but a new print created through the collaboration of artist and printer.

Katz described the hard work involved in the process of proofing *Green Cap*: "the difference between what the printer did and what I wanted was quite, quite significant."[18] Toda had translated Katz's sketch literally, including the painted brush-strokes, into the color woodcut proof. (These brushtrokes are most noticeable in *Working Proof 2,* cat 108.) It was a challenge for Katz to communicate to the printer that he wanted the brush strokes to be *felt*, but not to be *seen*. He did so in a series of Working Proofs that record an unusual kind of communication between artist and printer. Because Toda did not speak English, Katz expressed himself verbally through an interpreter (Hidekatsu Takada) and visually by marking the proofs with pencil notations. The Working Proofs show that these changes were achieved slowly, one change at a time (see cat. 107–111).

When Tim Rollins + K.O.S. (Kids of Survival), Richard Cruz, George Garces, Carlos Rivera, and Nelson Savinon, came to Crown Point Press to work in 1989, they had no idea what they were going to be making, or how they were going make it. Because it was their first printmaking experience

at a major press, they considered this a serious problem, not knowing that these are conditions generally welcomed at Crown Point. The story of their printmaking project as it unfolded over two weeks is as much a tribute to their creativity in the face of the unfamiliar as it is to the spirit of creative nurturing that was a part of the Crown Point experience.

The group had already made decisions at the beginning of their project that prepared them somewhat for work. They had decided to make prints depicting the demons in Gustave Flaubert's 1874 book *La tentation de Saint Antoine* (The

FIG. 23
Tim Rollins + K. O. S.
Working Proof 40 for *The Temptation of Saint Antony* (cat. 80–93), 1989, FAMSF/CPPA 1992.167.892

Temptation of Saint Anthony) because they were already involved in a project on the theme and had recently seen the prints made by Odilon Redon on the subject. They also wanted to make etchings in such a way as to create images that could only be obtained by etching alone. But their self-consciousness in the print studio was a problem at first. They were intimidated by the learning process, by the machinery, and they had a fear of making mistakes. The three printers on the project, Brian Shure, Lothar Osterburg, and Daria Swyulak, introduced the group to spit bite aquatint, a process they determined would allow the artists to work freely without too many technical constraints. The artists enjoyed this first interaction with the printers and invited them to collaborate on the project (even declaring them to be honorary members of K. O. S.). As soon as the group became acquainted with the basics of printmaking (how to control the acids, cleaning, inking, and running the copper plates through the press) they set about making their first proofs.

Working Proof 40 (fig. 23) demonstrates that the group wanted to approach these prints much as they do other projects, that is, working on a surface of book pages pasted together. This proof was made

FIG. 24
Tim Rollins + K. O. S.
Working Proof 39 for *The Temptation of Saint Antony,* 1989,
FAMSF/CPPA 1992.167.893

FIG. 25
Tim Rollins + K. O. S.
Working Proof 16 for Plate XI of *The Temptation of Saint Antony,* 1989,
FAMSF/CPPA 1992.167.871

on a large plate and printed with white aquatint over nine book pages. When that proved unsatisfactory, they selected a smaller plate, printing it in black on four book pages (*Working Proof 39*, fig. 24). Finally, they chose an even smaller plate and printed it on only one page from the book. However, Rollins realized at this early stage of the project that he was running out of book pages, and a solution was devised by one of the printers, Brian Shure. Page 205 was selected from Flaubert's novel and xerographed on a lightweight rag paper in multiple copies, assuring plenty of proofing paper.

Experimentation continued, including work in color that was deemed weak, and actual drawing on the plate that was rejected for its lack of originality. At the beginning of the second week, the group was on course and determined to create something totally original, "We created unreasonable combinations of gum arabic and acid, returned to using medical instruments — especially large, frightening syringes for applying and squirting our new solutions to the plates. We used glass and plexiglass sheets, plastic pieces, sprayers, air blown through drinking straws, eye droppers, *everything* to disperse and block the acids, casting strange shadows and scars into the surface of the aquatint plates."[19]

FIG. 26
Tim Rollins + K. O. S.
Working Proof 18 for Plate XI of *The Temptation of Saint Antony,* 1989,
FAMSF/CPPA 1992.167.873

FIG. 27 / CAT. 90
Tim Rollins + K. O. S.
Plate XI from the portfolio, *The Temptation of Saint Antony,* 1989

By the middle of the week they had created over 150 plates and pulled over 250 proofs depicting dozens of different species of demons. Rollins and the Kids decided that each proof was a finished product, requiring little or no reworking. The 250 proofs were then edited down to a group of the strongest prints. A comparison between *Working Proof 16* (fig. 25) and *Working Proof 18* (fig. 26) is just one example of the kind of editing choices made by the group. The only difference between the two was in the background. The group ultimately chose the proof with the lighter background, burnished it down slightly, and printed it as Pl. XI (fig. 27) in the portfolio. In another example, an early proof on a large copper plate was determined to be the wrong size. The plate was cut down to the dimensions specified by the cropping marks on *Working Proof 33* (fig. 28), then printed as Pl. XIII (fig. 29).

The prints by Rollins + K. O. S. were undoubtedly made with some of the most unusual printing practices ever used at Crown Point. Certainly the situation of having five artists in the studio all working at once made for a challenging studio session. However, in keeping with the Crown Point philosophy, it was all to be expected. "It's the doing, not the making, that's important," Kathan Brown often says about working at Crown Point Press, meaning that the emphasis is always placed on "the people involved in making something, on the way they go about it, rather than on the manufacturing. It focuses on the means rather than the end."[20] Even if it means throwing a four-foot copper plate in the back of a pickup truck for proofing sessions, communicating an abstract artistic concept to a Japanese printer in Kyoto, or working past midnight to get the right blue color to match an artist's conception, it is part of successful art-making at Crown Point Press. The Working Proofs and the editioned prints that result bear testimony to Brown's maxim about the process of "doing."

FIG. 28
Tim Rollins + K. O. S.
Working Proof 33 for Plate XIII of *The Temptation of Saint Antony,* 1989, FAMSF/CPPA 1992.167.888

"It's an extraordinary process which creates extraordinary things," said Tim Rollins of his experience making the *Temptation of St. Antony* prints.[21] It might be added that Crown Point Press is an extraordinary place where these extraordinary things do happen.

FIG. 29 / CAT. 92
Tim Rollins + K. O. S.
Plate XIII from the portfolio, *The Temptation of Saint Antony,* 1989

Note: All figure captions referenced as "FAMSF/CPPA" are numbered as part of the Fine Arts Museums of San Francisco, Crown Point Press Archive. Full information on works referenced as "cat." in the figure captions or the text will be found among the numbered checklist entries in this catalogue.

1. Steven A. Nash, Associate Director and Chief Curator of the Fine Arts Museums of San Francisco, quoted in *Overview* (Spring 1991). The Crown Point Press Archive at the Fine Arts Museums of San Francisco contains one impression (usually Artist's Proof 6) from every print edition published by Crown Point Press as well as many proofs from editions printed, but not published, by the Press since its inception in 1962.
2. Kathan Brown, "Dear Friends," *Overview* (Spring 1991), p.1.
3. The word etching is used throughout this essay as a generic term describing intaglio techniques.
4. Nancy Tousley, "In Conversation with Kathan Brown," *Print Collector's Newsletter* 8:5 (November–December 1977), p. 130.
5. Michael Shapiro, "Changing Variables: Chuck Close and his Prints," *Print Collector's Newsletter,* 9:3 (July–August 1978), p. 72.
6. Brown, conversation with the author, 21 August 1996.
7. Brown, *ink, paper, metal, wood: Painters and Sculptors at Crown Point Press* (San Francisco: Chronicle Books, 1996), p. 19. By 1977 Brown decided to begin concentrating again on Crown Point's own publishing program, gradually phasing out the practice of contract printing for other publishers.
8. Hidekatsu Takada, interview with the author, 21 August 1996. The photograph appeared as an illustration in *Pat Steir: Etchings and Paintings* exh. cat. (Oakland, California: Crown Point Press, 1981).
9. Pat Steir quoted in "In Conversation with Kathan Brown," *Pat Steir Etchings and Paintings* exh. cat. (Oakland, California: Crown Point Press, 1981), n.p.
10. Takada, interview with the author, 21 August 1996.
11. Ibid.
12. William T. Wiley quoted in "William T. Wiley in Conversation with Constance Lewallen," *William T. Wiley at Crown Point Press,* exh. cat. (San Francisco: Crown Point Press, 1989), p. 5.
13. Ibid.
14. Ibid., p. 6.
15. Constance Lewallen, "Interview with Wayne Thiebaud, August, 1989," *View,* 6:6 (Winter 1990), p.17.
16. Christopher Brown, another artist who has made prints at Crown Point Press, also retains some of his Working Proofs. Instead of "reworking" them as Thiebaud does, [Christopher] Brown usually draws with pastel crayons, sometimes obliterating the entire image on the Working Proof, to create a new image.
17. Lewallen, "Interview with Alex Katz, New York, November 1990," *View,* 7:5 (Fall 1991), p.5.
18. Alex Katz quoted in "Collaboration East and West: A Discussion," *Print Collector's Newsletter,* 16:6, (January–February 1986), p. 197.
19. Tim Rollins, "Notes on the Making of the Temptation of Saint Anthony 1987–1990," *Tim Rollins and K.O.S./Temptation of Saint Antony 1987–1990,* exh. cat. (Basel: Museum für Gegenwartskunst Basel, 1990), p. 33.
20. Brown, *ink, paper, metal, wood,* p. 21.
21. Lewallen, "Interview with Tim Rollins, Richard Cruz, George Garces, Carlos Rivera, Nelson Savinon," *View,* 6:5 (Winter 1990), p. 16.

FIG. 1 / CAT. 34–38
Brice Marden *Five Plates,* 1973

From Paper to Canvas

Prints and the Creative Process

STEVEN A. NASH

A MISAPPREHENSION contemporary printmaking frequently endures is the belief that prints reproduce paintings and drawings. On the one hand, it is difficult to clarify the notion of a multiple original, or to dispel the old confusion in the public mind between fine art prints and commercial printmaking, with its purely reproductive function. Also vexing, however, is a too common view of the print as the *end result* of a creative process, a dutiful recreation or reinterpretation of images already realized in paintings or drawings: prints may have their own visual languages, but are they not made *after* something else? Such assumptions drastically shortchange both the originality inherent in most fine art prints and the active role they often play in the development of an artist's work in other media through a dynamic and reciprocal flow of influences. This interactive process can be complex and differ from artist to artist, but it represents a significant though little-explored factor in the ongoing visual discoveries of contemporary art.

Throughout the long history of Crown Point Press, Kathan Brown has stressed the exploratory potentials of printmaking, typically inviting artists to participate who are not print specialists and encouraging them to "see where the printmaking processes might lead."[1] As a good example of what *not* to do, both Brown and Wayne Thiebaud are fond of telling the story of Thiebaud's first visit to Crown Point Press in 1964, when he began copying one of his paintings onto a prepared etching plate. Brown protested, "Printmaking should be original. What's the point of copying yourself,

or redoing something that's already been done?" Thiebaud thought for a while and proceeded to draw instead the lunch that Brown had just prepared, producing the first etching in his famous *Delights* series! (cat. 1)[2]

Fundamental to Brown's philosophy is the realization that printmaking, informed by an artist's entire working experience, can in turn inform work that follows in other media. In one especially momentous example, Pablo Picasso's etchings for *The Dream and Lie of Franco* from 1937 spawned horrific images of malevolence, destruction, and suffering that fed directly into his great *Guernica* mural, painted the same year. In more recent history, Robert Rauschenberg has noted that the freedom of handling and openness to chance effects he enjoyed in lithography during the early 1960s had a major influence on his contemporaneous paintings.[3] The review of several specific case histories from work at Crown Point Press reinforces this notion of the print as a locus of germinating ideas that can have long-term ramifications, in one way or another, within an artist's overall body of work. A print is frequently not the end result of a creative journey, but the midpoint or beginning.

One of the artists with whom Crown Point Press is most closely identified through the large and acclaimed body of work he created there is Richard Diebenkorn. Over the course of twenty-one years and 106 different editioned prints, he explored both black and white and color processes that follow a trajectory from his figurative imagery of the early 1960s, to his protracted work with abstract themes

subsumed under the generalized heading of the *Ocean Park* series, into the growing compositional diversity of prints completed during the last years before his death in 1993. General parallels of style and theme can be drawn between Diebenkorn's prints and his contemporaneous paintings and drawings, but rarely does a close, one-to-one relationship exist between any two examples. Except in the case of woodcuts, his prints did not proceed from preconceived models. Each one was a unique statement, often evolved through unusually protracted developmental processes. He observed at one point, "Should I decide to work in printmaking I think about a refreshing change of pace in my work as a whole, which in turn may provide new perspectives on it."[4]

His many prints relating to the *Ocean Park* theme, created over a long period starting around 1980, are a case in point. In the prints, as in the paintings, veils of color wash between and across architectural scaffoldings of scattered lines in luminous compositions that seem at once abstract and inspired by the light and colors of landscape. Clearly, commonalities of vision exist between the paintings and prints, but no two match up exactly.[5] As can be said of many of the artists who have participated in the program at Crown Point Press, Diebenkorn's prints both amplify and reflect on work in other media, with one body of work providing "new perspectives" on the other.

Even in the case of his woodblock prints, where master carvers and printers worked by necessity from an initial design, Diebenkorn welcomed evolutions in the developmental process that brought greater life to the final image and kept it from becoming predictable.[6] He was one of the first artists Brown invited to take part in the new woodcut program she established in 1982 in Japan, an invitation he readily accepted despite, or perhaps as a way of looking differently at, the importance of direct touch in his work. He made a total of four woodcut prints (cat. 181), closely directing the evolution of the images — in one instance, after working two weeks in Japan, he continued to make adjustments by mailing proofs back and forth from California. He commented:

> As must happen (and I counted on it), distortions do present themselves. It is not my way to throw that away. Then you begin to work with the distortions and finally find yourself quite a distance away from the original thrust . . . In a way, however, it isn't far from what can happen in one's studio when one is alone.[7]

This readiness to work with change and the unpredictable dictates of the creative process provide an example of how one artist constantly evolved and avoided "copying himself." For two other participants in the woodcut program, Al Held and Chuck Close, experiences with this medium led not only to prints that stand out within their respective oeuvres, but also to significant ramifications for their later painted work.

Brown asked Held in 1985 to submit a watercolor to be used as the model for a woodblock print, initiating the project that led to *Kyoto-wa* (fig. 2)[8] Held was interested but explained that he had never worked seriously in watercolor before and didn't feel comfortable with the medium. He finally produced a drawing that was relatively minimal in its use of watercolor but that featured an extensive amount of linear work in graphite — an effect that Brown had specifically warned against since the thin variability of a graphite line is almost impossible to capture in woodblocks. Brown agreed to use the drawing but when she saw the first proofs

FIG. 3
Chuck Close *Leslie/Watercolor II,* 1986, watercolor on paper, 30 1/2 x 22 1/4 inches, collection of James R. Palmer

FIG. 4 / CAT. 112
Chuck Close *Leslie,* 1986

of the print she noticed that some of the lines were slightly askew. The master printer admitted that he was forced to use photolithography to reproduce the lines, but because his plates were not large enough to cover the full drawing, he had used two plates that had printed slightly out of registration.

Photographing an image to make a print of it, however, was on principle not acceptable to Brown. She did consent to the use of straight lithography for the lines, so a master lithographer traced the lines of the drawing and made impressions over which could be printed the woodblocks. For Held, the final results were so satisfying that he decided to make more watercolors and also to explore the coloristic effects of spit bite aquatints. In both media he subsequently compiled impressive bodies of work: substituting the luminous textures achievable through overlays of color for the flatter applications of paint applied in his compositions in oil and acrylic.[9] In contrast to the impression of solid, gravity-controlled forms in the oils and acrylics, the translucent films in the watercolors and aquatints added to Held's complex spatial deployments a special lightness and even something of the glow of

mystery to complement the extension of geometry and the laws of perspective into realms of visual fantasy. In 1989 Held completed a second, masterful woodcut titled *Pachinko,* exploring these same, new vocabularies.

For Chuck Close, participation in Crown Point Press's woodcut program contributed to similarly significant stylistic developments. The print he produced was *Leslie* from 1986, the formal handling of which helped engender in Close's work a radically new way of mapping forms with color. Brown had wanted Close to take part in the early phases of the woodcut project. He had already made at Crown Point the celebrated mezzotint titled *Keith* (cat. 2), a technical tour de force representative of the compellingly up-close, larger-than-life portraits for which the artist had become so well known during the 1970s and early 80s. Brown recognized, however, that the tight drawing and fine, smooth tonal gradations characteristic of such works would be difficult to capture with woodblocks.

For *Leslie,* Close had prepared two watercolors that he showed to Brown, one tightly finished and, for fear that this would not be suitable for the

woodcut technique, another that was far more loose and painterly in handling (fig. 3).[10] Together they decided on the latter. Working against the web of a finely drawn linear grid, Close broke down the image of Leslie into roughly shaped spots or cells of color, some distinct, some overlapping, and some doubled or tripled. The overall effect is to blur the portrait into impulses of light and color, similar to neo-Impressionist dot patterns but more abstract and animated. In the woodcut, where denser color marks are built up through overlays of thin films of ink, the cells are captured as an intense, pulsing patchwork. The print is read, on the one hand, as an engaging and friendly countenance, and on the other, as a rhythm of light-dark and warm-cool contrasts, energized by individual bursts of color (fig. 4).

Although the two watercolors for *Leslie* and the woodcut document concisely a dramatic shift of style, Close had shown in other paintings and drawings of the period a tendency to move toward looser handling, perhaps encouraged by the individualized scales of form in his pulp paper portraits.[11] It is this painterly direction that has dominated his subsequent development. Tight modeling gave way more and more to a fragmentation of the image into spots, dots, and oddly shaped pixels of light and color. In December 1988, Close was stricken with the collapse of a spinal artery that left him a quadriplegic, but following his partial recovery during the next year and his return to painting with the aid of a special brace to help him hold his brush, the handling of paint became even freer, with the discrete cells of the image taking on an abstract life of their own. Up close they seem like strange psychedelic mosaics but from a distance they coalesce into disorienting but powerful physiognomies.[12]

Numerous other examples from the history of Crown Point Press can be found of this proactive role of printmaking in an artist's overall development. In some cases, a thematic or compositional idea first engendered in prints is further amplified in later works. Sometimes a formal or technical statement involving the special languages of printmaking can take on lasting importance and interpretation into other art forms. And in certain cases, it is a harder-to-define matter of a fresh idea, a new start, or that "new perspective" that Richard Diebenkorn spoke of that effects the course of subsequent work. As Jasper Johns put it, "The process of printmaking allows you to do things that make your mind work in a very different way than, say, painting with a brush does . . . things that are necessary to printmaking become interesting in themselves and . . . become like ideas."[13] A look at some of the outstanding works produced at Crown Point Press by Pat Steir, Brice Marden, Sol LeWitt, Wayne Thiebaud, and Christopher Brown reinforces this ideational role of printmaking.

Pat Steir is an artist who has worked regularly at Crown Point Press from its early days of activity. For her, printmaking plays a particularly central role in the overall creative flow of her work providing, in effect, a replacement for drawing. One of Steir's first projects at Crown Point Press was a series of seven prints titled collectively *Drawing Lesson*, dating from 1978 (cat. 48–55), which examines a broad range of marking techniques as translated from drawing into etching. She notes that making marks on a flat surface, whether paper, canvas, a metal plate, or a cave wall, is and always has been a first step in the impulsive desire to

FIG. 5 / CAT. 4
Pat Steir *Abstraction, Belief, and Desire,* 1981

FIG. 6
Pat Steir *Abstraction, Belief, and Desire,* 1981, oil on canvas, 60 x 180 inches, courtesy of Robert Miller Gallery

communicate visually.[14] Steir has consciously explored the way earlier artists physically marked with brush or drawing instrument, and these lessons from history regularly circulate back into her own prints and paintings. *Drawing Lesson* was a declaration of the uniqueness of printmaking through an exposition of how drawing in printmaking relates to but is different from drawing per se. Steir has said that "etching is really itself because everything about it is different from everything else."[15] It is different, of course, both in the visual effects it generates and the physical act involved in doing it, the latter providing part of the special qualities that Steir appreciates: "Etching for me is halfway between sculpture and drawing rather than between painting and drawing."[16]

Steir relishes these differences and for many years has used etching rather than drawing as a means of testing, exploring, and generating new visual ideas:

> For years I didn't draw at all but I would go every year to Crown Point and make one or two etchings in which there would always be the idea for the work I was going to do. Often I go with an idea or a half-formed idea of what I would like to be working on in general for the next year. I form it in the etching and then later take it farther in painting.[17]

This process can be clearly seen at work, for example, in Steir's sequential production of a print and painting, both titled *Abstraction, Belief, Desire* (figs. 5, 6). Steir's print of the subject is a color aquatint with soft ground and hard ground etching, spit bite aquatint and drypoint, dating from 1981,

and her painting on the theme dates from later the same year. The print is complex visually and conceptually, pairing heavily worked visual signs and constructions with their respective thematic couplets: "abstraction/form," "belief/illusion," and "desire/myth." In its linking of form and meaning, the print is a particularly clear document of the way Steir thinks about the making of, and the symbolic functioning of, art. The much larger painting from the same year recreates basically the same composition but tightens up and regularizes the forms significantly, in a way that speaks of the handling of paint rather than etched line and aquatint.

With some of her more recent prints on the themes of flowing water and waterfalls (e.g., cat. 124, 125), Steir notes that she was attempting to capture, almost like photography, an instantaneous gesture of water falling or being flung.[18] She had done paintings on the waterfall theme before making any prints, but the process of working with the prints taught her a great deal about how to layer the images to give them full depth and resonance. She refers to the building up of an image with separate plates as working with "layered thoughts." This methodology in turn influenced the construction of later paintings, in a direct, practical instance of interdependence.

A similar cross-fertilization is evident in the early work of Brice Marden, of which a significant part is formed by etchings printed by Brown for the New York publisher Parasol Press. Marden had made prints during his student years at Boston University's School of Fine and Applied Arts (BFA, 1961) and Yale University's School of Art and Architecture (attended 1961–63), and subsequently

FIG. 7
Brice Marden *Grove Group III,* 1973, oil and wax on canvas, 72 x 108 inches, private collection

constituting *Five Plates* are a good example. Each presents a different, symmetrical division of the rectangular field and a basic opposition of black and white panels. The contours of the fields, however, are not sharp and pure, but instead are scored with dark edges of variable width. The white areas are not truly white but subtly nuanced in tone and marked by foul biting and uneven wiping. An unevenness of aquatint and a depth of color due to repeated layers of aquatint mark the dark passages. In all, the prints have a physicality and textural quality that contradict the first impression of rarefied minimalism.

he worked with screenprints (1966), lithography (1969), and etching (1971).[19] In these various projects he tended to address issues he was exploring simultaneously in drawings and paintings, progressing from figurative imagery to an abstract gestural style and into the geometric abstraction for which he became known. Even at this early stage of his career, it was clear that the apparent minimalism of his work was not truly minimal at all. In drawings, prints, and paintings alike, as he worked with grid formats and generally flat surface treatments, he stressed activation rather than regularization of the surface, no matter how subtle his markings, texturings, or plays of contrast.

The works he produced with Brown are milestones in this development and indicative not just of his personal aesthetics but also the steady dialogue that existed between different aspects of his art. Most notable are the portfolios titled *Ten Days* (1971, published 1972), *Five Plates* (fig. 1, see p. 54), *Five Threes* (1976–77), and *12 Views for Caroline Tatyana* (1977–79, published 1989).[20] Together these works document a growing elaboration of geometric formats and also show the expressive frisson that Marden was able to coax out of even the seemingly most reductive means. The prints

To understand fully the importance of the prints Marden made with Crown Point Press, they must be seen in the context of his other work. The stark light-dark contrasts of the *Ten Days* portfolio, for example, which continue into the *Five Plates*, differ from the much more muted combinations of color Marden used in his paintings of the period — anticipating paintings of a later date. For the compositional formats of the *Five Plates* series, Marden purposefully utilized schemas he had developed in a group of paintings — still in progress at the time — known as the *Grove Group* (begun in 1972 but continued until 1976),[21] which were inspired by olive groves near his house in Greece (fig. 7). Marden noted that by addressing the same themes in the black and white language of prints, he could be "involved with the more romantic subject matter of the *Grove Group*." Once he had worked out the compositional aspects he "could concentrate in the *Grove Group* on the light and color and the idea about place."[22] In this respect the prints are not just a variation on the Grove Group but also a study for it.[23]

In the steady exchange of ideas between media in Marden's work, other key examples are found with the portfolios *Five Threes* and *12 Views for Caroline Tatyana*. The former group of prints relates closely to Marden's three *Moon* paintings and also to the painting *For Hera*, and in fact, were consciously conceived as studies for the paintings.[24] In *12 Views for Caroline Tatyana*, we find a clear statement of the "post and lintel" theme that had been introduced more tentatively in *Five Threes* but would soon become a major new direction for the paintings, as seen first in the *Annunciation* series of 1978.[25] During his time in Greece, Marden had responded in a profoundly personal way to ancient architecture as both formal experience and sacred, spiritual force. In his prints and then in his paintings, he translated his perceptions of the volumes and architectural divisions of these ancient structures, using the post and lintel form plus bands suggestive of columnation and contrasts between light and shade, exterior and interior space.

For both Steir and Marden, prints provided a means of thinking through compositional and formal problems in ways that directly influenced their other work. Steir's observation that she has "always used [printmaking] as a way to think"[26] recalls Johns's celebration of the fact that prints can make "your mind work in a very different way." Two other artists who participated at Crown Point Press in its early years, and have continued to work there regularly, are Wayne Thiebaud and Sol LeWitt. For them, printmaking can be seen to have played still different roles in their respective working methods and stylistic developments.

In LeWitt's systems-based art, printmaking has held a privileged status as one of the primary vehicles for the communication of his conceptual strategies. Etching proved an especially congenial medium due to its potential for a sharp, clean, "impersonal" line with which to diagram a pre-scribed formal schema, and also due to the fact that compositions can be easily varied through the modification of color or the addition or reposi-tioning of plates to produce a serial image. Some of the early sets of prints he produced at Crown Point became well-known manifestos of his idea-driven methodology: for example, *Squares with a*

FIG. 8 / CAT. 153
Sol LeWitt *Color & Black #3 (24 x 24),* 1991

FIG. 9
Sol LeWitt *Wavy Brushstrokes (mostly horizontal),* 1995, gouache on paper, 60 x 60 inches, courtesy of Daniel Weinberg Gallery

Different Line Direction in Each Half Square (1971, cat. 17–26); *Bands of Color in Four Directions & All Combinations* (1971, p. 8); *Grids, Using Straight, Not-Straight & Broken Lines in All Vertical and Horizontal Combinations* (1973).

LeWitt applied the same discipline of conceptual visual thinking to sculpture, book art, and wall drawings, often using forms he had first worked out in prints. Over the past six or seven years, however, his work has veered more and more away from the strictly linear and geometric toward a looser, more colorful, even "baroque" handling, especially apparent in recent prints and paintings on paper. Color has always been important to LeWitt, but previously it was harnessed within a geometric framework. His wall drawings gradually became more sensuous in appeal, thanks to fine overlays of line and rich shadings of ink, and it is this luminous, coloristic side that pushed forth strongly in etchings and aquatints made at Watanabe Studio in New York in 1989[27] and then even more so in prints made at Crown Point in 1991.

Color & Black #3 (24 x 24) (fig. 8) is a representative example of the latter.[28] For the total project, LeWitt worked in five formats, creating three square and two vertical images. He approached each set of prints in serial form, produced from the same images differently treated and exploring the same concept in different ways, and in all cases he painted the acid onto copper plates himself. What is distinctive about these prints, especially compared to earlier work, is the dark glowing quality of the light they project and the soft, watercolor-like handling of the color. Although the color passages are defined in individual cells, often surrounded by scratchy outlines that come from ink lines LeWitt had drawn on the plate at the outset, they tend to blur into soft veils of tone. Subjective intuition here takes the upper hand over logical determination. It is the allover luminosity of colors and tones, one merging into another, that provides the primary impact, with little acknowledgment of the old notion that "the idea becomes a machine that makes the art." Brown recalls that LeWitt was concerned that the prints not become too sensuous or "too pretty" and toned them down with black.[29]

Although some of his subsequent works reverted

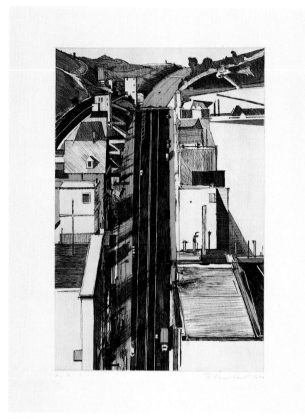

FIG. 10
Wayne Thiebaud *Downgrade* (PL. 1 from the portfolio, *Recent Etchings II*), 1979, etching and aquatint, 505 x 326 mm, FAMSF/CPPA 1991.28.264

to hard-edge compositional modes, the loose, painterly handling of these prints found even more extreme expression in paintings on paper and prints done in 1995 and 1996 featuring ribbons of color that wind in dense, whiplash waves across the surface (fig. 9).[30] The sheer exuberance of these works is remarkable, possibly signaling a major stylistic change in direction for LeWitt that he will continue to pursue further. In his prints from 1991, one finds a key evolutionary step in the development of his work.

Wayne Thiebaud's publication of his book *Delights*, begun in 1964 with the previously mentioned sketch of his lunch, initiated a long and fruitful collaboration between the artist and Crown Point Press, which remains active today. Over this more than thirty-year period, Thiebaud has made in excess of 125 editioned prints, working not only in etching but also lithography, woodcut, linocut, screenprint, and monotype.

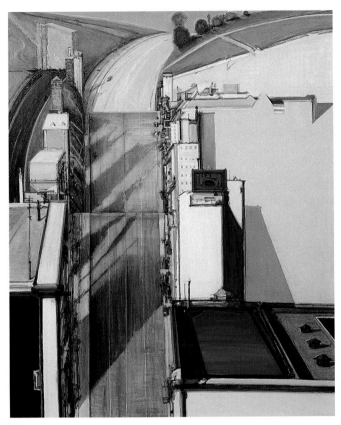

Etching, however, with its variant techniques, has been his preferred medium, and Crown Point Press has published, aside from monotypes, a total of forty-six prints by Thiebaud.

These many works provide not only a chronicle of the key themes that have preoccupied Thiebaud but also an entrée into the distinctive dialogue of action and reaction, of statement, question, and response that characterizes Thiebaud's working methods. Prints play a vital role in this dialogue. At no point can a particular work that Thiebaud has finished be considered "done" unless he judges it to be a failure, for images often reincarnate in many different guises. A drawing might lead to a painting, which in turn leads to a print, over which the artist might add color or more composition, with a considerable time lag between any two stages. Or, the progression might be reordered to painting-print-drawing or print-drawing-painting. Thiebaud refers to this recycling of ideas and

images as a "process of transposition" which, he says, he finds "truly fascinating" in terms of the problems it presents and the answers to which it can lead.[31] The transposition might take place between media, or different scales, or different lighting or coloristic effects. In going from one model to another, Thiebaud notes that "the little differences are the big differences." The challenge lies in "how you resolve certain problems that may seem simple but turn out to be complex, such as the difference between size and scale."[32] As a way of underlining the discipline that is necessary to retackle the same or related problems, Thiebaud quotes Edgar Degas's dictum, "Do the same drawing over and over again and again ... ten times ... a hundred times."

In this process, prints often inform paintings, drawings, or other prints, as part of an ongoing, reciprocal interaction. The exhibition *Vision and Revision: Hand Colored Prints by Wayne Thiebaud,* presented at the California Palace of the Legion of Honor in 1991, highlighted the instigative role prints can play in Thiebaud's work, demonstrating some of the many instances in which he has drawn or painted over prints of one kind or another, giving images a new, distinctly different lease on life. Other examples of this transformative process abound. A lengthy series of monotypes that Thiebaud made at Crown Point in 1991 on the theme of clouds reprised a motif from his paintings of the mid-70s but led, in turn, to a new series of cloud and landscape paintings.[33] A recent etching of *Eyeglasses* from 1994 refers back to a lithograph from 1971 which had inspired a painting on the same theme in 1992.[34] In one highly characteristic reverberation of compositional ideas from medium to medium, a charcoal drawing titled *Streets and Pathways* from 1977 led to a hard ground etching from 1979 called *Downgrade* (fig. 10),[35] which in turn laid the groundwork for the powerful oil painting *Streets and Pathways* from 1990 (fig. 11). Thiebaud's colors in the painting function strategically both to add descriptive information to the black and white rendering of the drawing and print and to break the composition into semi-abstract zones that are locked into the complicated geometry of Thiebaud's spatial structure. Taking

a first step in this direction, the artist had water-colored the etching several years prior to his oil painting of the theme.[36]

However, the active participation of prints in Thiebaud's working method and development is more than just a matter of compositional research. Thiebaud credits certain of the themes in his early paintings, such as gambling machines and suburban landscapes, to the screenprints he made as demonstrations at California State Fairs in the late 1950s, and he also notes that his use of stark white backgrounds derives from printmaking and his isolation of objects within an expanse of white paper.[37] During the making of prints, an effect can arise — the slight off-registration of an image, for example — that triggers ideas to be used later in a painting. One of the things particularly interesting to Thiebaud about printmaking is the surprises it presents and the potential for change, to be capitalized upon in different ways. "It is hard to think of printmaking separate from painting, or painting separate from printmaking."[38]

Other artists feel basically as Thiebaud does. In a contrary vein, William Bailey has observed: "In my case, the prints do not affect the paintings — at least not yet. I have not made many color prints yet, so it remains to be seen what happens in the future."[39] However, he acknowledges that for him, "the real interest in printmaking is the anxiety about what will come out the end of the press," that is to say, he is attracted to the elements of surprise and unpredictability in the printing process.

Christopher Brown also acknowledges appreciation of some of the same aspects of printmaking ("It's like drawing but better. It is the malleability of the process that intrigues me — the ability to change your mind, make adjustments, utilize accident, and react with further adjustments."[40]), but he is attentive to its interactive potentials with his drawings and paintings. With a group of etchings he made in 1982, for example, he was searching for a way to "loosen up [his] method of painting, to make it a little more chaotic."[41] His recent aquatints of birds, made at Crown Point in 1994 in the *Birder's Log* series, represent one side of a dialogue with a group of heavily worked (some of them made over prints), glowingly coloristic pastels

on similar themes, from 1993–95 (fig. 12).[42] In these series, one sees the artist attacking familiar issues of spatial coherence between layered multiple images, precision of description versus suggestive abstraction, and textured surface played against depth of light and color.

It is this interactive relationship between printmaking and work in other spheres, with complex, back-and-forth reverberations of search and discovery, trial and error, cause and effect, that characterizes the methodologies of all the artists considered here and many others who have worked at Crown Point Press. Distinctive in its means and formal vocabularies, printmaking is not a stand-alone activity, nor are its reproductive potentials paramount. It is another way of capturing visual thought, and another link in complex chains of visual creativity.

Note: All figure captions referenced as "FAMSF/CPPA" are numbered as part of the Fine Arts Museums of San Francisco, Crown Point Press Archive. Full information on works referenced as "cat." in the figure captions or the text will be found among the numbered checklist entries in this catalogue.

This essay is dedicated to John and Charlotte Jones. They know why.

1. From conversations with the author, July 1996.
2. See Kathan Brown, *ink, paper, metal, wood: Painters and Sculptors at Crown Point Press* (San Francisco: Chronicle Books, 1996), p. 34. Wayne Thiebaud recounted the same story in conversations with the author, June 1996.
3. Quoted in Andrew Forge, *Rauschenberg* (New York: Harry N. Abrams, 1972), p. 227.
4. Quoted in Brown, p. 275, from a questionnaire that Diebenkorn completed in 1989 for Jade Dellinger, a printmaking student at the University of South Florida.
5. For Richard Diebenkorn's work in the general orbit of the *Ocean Park* theme, see Gerald Nordland, *Richard Diebenkorn* (New York: Rizzoli, 1987); Richard Newlin, *Richard Diebenkorn: Works on Paper* (Houston: Houston Fine Art Press, 1987); and Newlin *Richard Diebenkorn: Etchings and Drypoints 1949–1980* (Houston: Houston Fine Art Press, 1981).
6. On the history of the woodcut program at Crown Point Press, see Brown, chapters 16–18.
7. Quoted from Diebenkorn by Gerald Nordland, exh. cat. *Richard Diebenkorn: Graphics 1981–1988* (Billings, Montana: Yellowstone Art Center, 1989), pp. 15–16. Nordland noted that Diebenkorn "was delighted and interested in the way the process had changed the original work yet retained its spirit." The woodcut titled *Blue* from 1983 followed Diebenkorn's first woodcut print *Ochre* from earlier the same year, and used sixteen blocks for eleven colors. It is interesting to note that the visual evidence of working process that Diebenkorn retained in the print, such as over–layering and pentimenti, give the work that same heavily meditated quality that is so characteristic also of his contemporaneous, closely related paintings in the *Ocean Park* series.
8. Information on this project was supplied by Brown in conversations with the author in July 1996.

9. See, for example, Brown, figs. 130 and 133; and *Al Held Watercolors*, exh. cat. (New York: André Emmerich Gallery, 1988).

10. Brown related the history of the project in conversations with the author, July 1996. Both watercolors are illustrated in Lisa Lyons and Robert Storr, *Chuck Close* (New York: Rizzoli, 1987), p. 141.

11. For a selection of works with this looser handling, and the pulp paper portraits, see Lyons and Storr, pp. 110–12, 126–31, 136, 142–43.

12. On the development of Chuck Close's paintings from the 1980s onward, see Paul Gardner, "Chuck Close: 'Making the Impossible Possible,'" *ARTnews* 91:5 (May 1992) pp. 94–99, and John Guare, *Chuck Close: Life and Work 1988–1995* (London and New York: Thames and Hudson, 1995).

13. Quoted in Susan Tallman, *The Contemporary Print: from Pre-Pop to Postmodern* (London and New York: Thames and Hudson, 1996) p. 40, from the film *Hanafuda/Jasper Johns*, directed and produced by Katrina Martin, 1980.

14. See Brown, p. 92.

15. From excerpts of a conversation between Pat Steir and Juliane Willi on 7 February 1988, published in *Pat Steir: Gravures–Prints 1976–1988*, exh. cat. (Geneva: Musée d'art et d'histoire,1988), p. 9.

16. Willi, p. 9.

17. Brown, p. 96.

18. Conversations with the author, May 1996. Steir uses for these prints a soap ground which she can paint, drip, and splash, moving the printmaking technique particularly close to painting: "Not only are [the prints] made with water, they are pictures of water."

19. See Jeremy Lewison, *Brice Marden: Prints 1961–1991, a Catalogue Raisonné*, exh. cat. (London: Tate Gallery, 1992), cat. nos. 1–19.

20. Ibid, cat. nos. 20, 23, 28, 29.

21. See Robert Pincus-Witten, *Brice Marden: The Grove Group*, exh. cat. (New York: Gagosian Gallery, 1991).

22. Both of the preceding quotes from Brice Marden are reported by Lewison, p. 110.

23. This point was previously made by Lewison, p. 110.

24. The paintings are reproduced in *Brice Marden: Paintings Drawings and Prints 1975–80*, exh. cat. (London: Whitechapel Art Gallery, 1981), pp. 23–25; and Klaus Kertess, *Brice Marden: Paintings and Drawings* (New York: Harry N. Abrams, 1992), pp. 95, 96, 97. The influence of the prints on the paintings is discussed by Lewison, p. 37.

25. See *Brice Marden*, Whitechapel Art Gallery, pp. 27–31.

26. Interview by the author, May 1996.

27. See *Sol LeWitt: Prints 1970–1995*, exh. brochure (New York: Museum of Modern Art, 1996), figs. 52–53.

28. For other examples, see Brown, figs. 72–75, and *LeWitt*, Museum of Modern Art, fig. 58.

29. Discussions with the author, July 1996.

30. See also *LeWitt*, Museum of Modern Art, figs. 66–67.

31. Interview with the author, June 1996.

32. Interview with the author, June 1996.

33. For a selection of these paintings, see *Wayne Thiebaud at Allan Stone Gallery: Celebrating 33 Years Together*, exh. cat. (New York: Allan Stone Gallery, 1994), pp. [16–17].

34. The etching is illustrated in Brown, fig. 20; the lithograph, titled *Glasses*, is included in *Wayne Thiebaud: Graphics 1964–1971*, exh. cat. (New York: Parasol Press, 1971), fig. 41; the painting is illustrated in *Wayne Thiebaud at Allan Stone Gallery*, p. [5].

35. The drawing and painting are reproduced in *Wayne Thiebaud Cityscapes*, exh. cat. (San Francisco: Campbell-Thiebaud Gallery, 1993), pp. [15–16].

36. *Vision and Revision: Hand Colored Prints by Wayne Thiebaud*, exh. cat. (San Francisco: California Palace of the Legion of Honor, 1991), p. 59. Numerous other compositional sequences of this type can be cited. A perusal of Thiebaud's respective oeuvre in painting, drawing, and printmaking reveals instances of almost dizzying paths along which an image bounces from one medium to another. Just one such path can be traced from the drypoint *Ridge* of 1966 (*Wayne Thiebaud: Graphics*, Parasol Press, fig. 32), to a watercolor painted over the drypoint in 1968 (*Vision and*

FIG 12
Christopher Brown *The Birder's Log,* 1993, pastel on paper, 36 x 35 inches, private collection, courtesy of the Palo Alto Cultural Center

Revision, p. 66), to a large painting of essentially the same composition titled *Diagonal Ridge*, from 1968 (*Facing Eden: 100 Years of Landscape Art in the Bay Area*, exh. cat. (San Francisco: M. H. de Young Memorial Museum, 1995), fig. 20.

37. Interview with the author, June 1996.

38. Interview with the author, June 1996.

39. Interview with the author, June 1996.

40. Quoted from [Christopher] Brown by Karin Breuer in "The Proof Is In the Process," in *Christopher Brown: Works on Paper*, exh. cat. (Palo Alto, California: Palo Alto Cultural Center, 1995), p. 17. He added: "I wanted evidence of the process to show. I wanted [the viewer] to feel the work. This was the debate in my painted work at the time."

41. Ibid.

42. Other works in the series are illustrated in ibid., figs. 35–40.

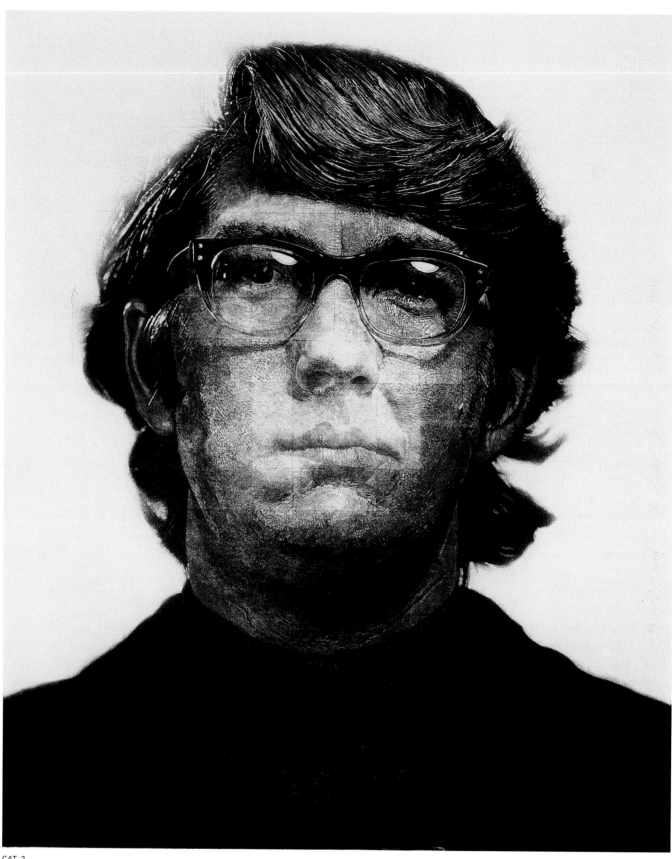

CAT. 2
Chuck Close Trial proof for *Keith,* 1972

I

Crown Point Press
Highlights from Thirty-Five Years

KATHAN BROWN speaks straightforwardly about her motivation for establishing Crown Point Press in 1962: "I liked printmaking and I wanted everybody else to like it too. I wanted to save etching, which seemed like a dying technique that serious artists weren't using and that nobody was doing anything to rescue."* Today, Brown is hailed as having revitalized the etching medium for contemporary artistic purposes. Her earliest Crown Point Press publications, particularly those from 1965 by Richard Diebenkorn and Wayne Thiebaud, were much admired. More than three decades later, her accomplishment is undiminished and Crown Point has become one of the leading fine art publishers in America with over 1200 editioned prints to its credit, most of them etchings.

The prints that were made in the early 1970s at Crown Point by Minimalist artists through an association with the New York City publisher Parasol Press brought immediate acclaim to Brown's efforts. These works—created by Brice Marden, Sol LeWitt, and Chuck Close, among others—were lauded for the clarity of the etching technique used, and Crown Point was recognized for its willingness to extend itself to accommodate varied artistic concerns.

When Crown Point resumed publishing on its own in 1977, Brown forged new ground by inviting artists who had never made prints to experiment with etching techniques. Over the years Brown initiated print projects by painters and sculptors, Conceptual artists, and performance artists. The uniqueness of these projects and their lack of a specific workshop "look" stems from Brown's belief that, in order to make great prints, artists must first understand the printmaking process they have chosen. They are encouraged to try both traditional and nontraditional methods, as their ideas direct. Printers are available to offer their skills, knowledge of materials, support, and open-mindedness. For any printmaking project at Crown Point, the artist's idea is always paramount.

In much the same way that she rescued etching by matching it with avant-garde ideas, Brown set an additional direction for Crown Point Press in 1982 by establishing a color woodcut program in Kyoto, Japan. It was a risky move (Brown could not be sure that contemporary artists would respond to the controlled and formal process of *Ukiyo-e* style woodblock printing in which the wood carving was done by a technician). Nevertheless, some of the most memorable color prints of the decade were produced there, among them works by Diebenkorn, Helen Frankenthaler, LeWitt, and Thiebaud. The popular appeal of those prints and their success in the marketplace inspired Brown to establish a similar program in 1987 in China.

Brown's sense of adventure allows for the scope and diversity in the roster of artists who have worked at the Press. She continues to publish artists whose printed work is untried in the marketplace; artists whose work is relatively unknown in America; artists who are skeptical about printmaking. Brown is unwavering in her belief that if an artist has good ideas, and if emphasis on those ideas is foremost, then successful prints will follow. K. BREUER

*Kathan Brown quoted by Kenneth Baker in "Crown Point Press 'Messianic' About Intaglio" (*ARTnews*, November 1996), p. 79

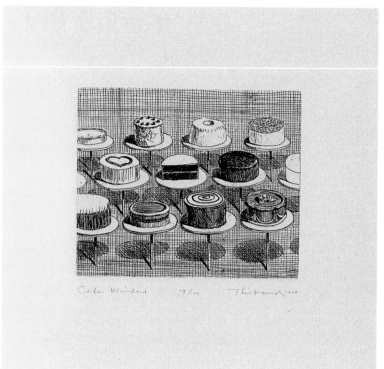

Wayne Thiebaud *Cake Window,* PL. 13, 1964

1

Wayne Thiebaud b. Mesa, Arizona 1920

Delights 1965

Book with 17 prints on Rives BFK paper

PL. 1 *Lunch,* hard ground etching, 128 x 171 mm (plate)
PL. 2 *Fish,* drypoint, 100 x 99 mm (plate)
PL. 3 *Banana Splits,* hard ground etching,
100 x 123 mm (plate)
PL. 4 *Cherry Stand,* hard ground etching,
146 x 175 mm (plate)
PL. 5 *Bacon and Eggs,* hard ground etching,
130 x 151 mm (plate)
PL. 6 *Double Deckers,* drypoint, 101 x 125 mm (plate)
PL. 7 *Lunch Counter,* hard ground etching,
175 x 199 mm (plate)
PL. 8 *Dispensers,* hard ground etching,
100 x 125 mm (plate)
PL. 9 *Gum Machine,* hard ground etching,
100 x 99 mm (plate)
PL. 10 *Lemon Meringue,* hard ground etching,
100 x 124 mm (plate)
PL. 11 *Suckers,* 1964, aquatint, 126 x 124 mm (plate)
PL. 12 *Candied Apples,* hard ground etching,
124 x 125 mm (plate)
PL. 13 *Cake Window,* hard ground etching, 127 x 151 mm (plate)
PL. 14 *Club Sandwich,* hard ground etching,
100 x 124 mm (plate)
PL. 15 *Pies,* hard ground etching and aquatint,
100 x 124 mm (plate)
PL. 16 *Delicatessen,* aquatint, 124 x 124 mm (plate)
PL. 17 *Olives,* aquatint, 74 x 100 mm (plate)

Page size for each is 328 x 274 mm

Published by Crown Point Press, Berkeley

Printed by Kathan Brown

Edition: 100 (50 bound and 50 boxed portfolio sets);
the FAMSF Archive has 1 from the bound edition (19/100)

Crown Point Press Archive, gift of Kathan Brown

1991.28.387–403

All of the plates for *Delights* were made by Thiebaud
in 1964 at Crown Point Press.

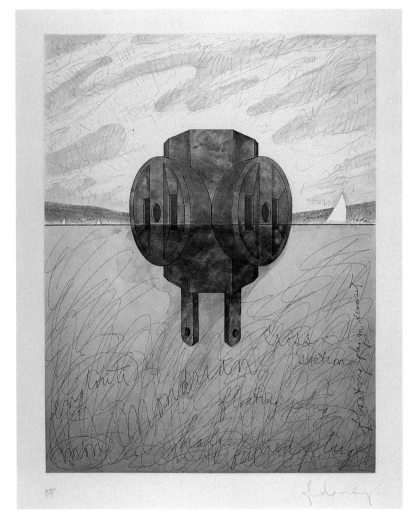

2 [see page 66]

Chuck Close b. Monroe, Washington 1940

Trial Proof for *Keith* 1972

Mezzotint with roulette on Rives BFK paper

1138 x 908 mm (plate); 1230 x 1073 mm (sheet)

Published by Parasol Press Ltd., New York

Printed by Kathan Brown at Crown Point Press, Oakland

Edition: 10, plus 4 Artist's Proofs, 4 Trial Proofs (also called "Studio Proofs"); the FAMSF Archive has 1 Trial Proof, 1 Working Proof for the full-size portrait; 2 Working Proofs from test plates for a small version of the portrait, and 6 Working Proofs from test plates for Keith's lips

Crown Point Press Archive, Museum purchase, bequest of Whitney Warren Jr. in memory of Mrs. Adolph B. Spreckels

1991.28.98

Because of its enormous size, the copper plate for *Keith* was not rocked in the traditional manner of mezzotint. Instead, through extensive trial and error, it was prepared with a process of photoetching. When Close scraped and burnished to create the image of *Keith*, more than fifty proofs were taken from the plate. This caused the plate to wear down, particularly in the areas around Keith's mouth. As a result, only ten prints were considered satisfactory for the edition. Kathan Brown wrote about this ambitious project in 1972 in a deluxe publication, *The Chuck Close Mezzotint "Keith" 1972/A Documentation with Ten Photographic Etchings of the Work in Progress* (Oakland, California: Crown Point Press, n.d.).

3

Claes Oldenburg b. Stockholm, Sweden 1929

Archive Proof for *Floating Three-Way Plug* 1976

Color spit bite aquatint, hard ground etching, and soft ground etching on Arches 88 paper

1073 x 825 mm (plate); 1248 x 976 mm (sheet)

Published by Multiples, Inc., New York

Printed by John Slivon at Crown Point Press, Oakland

Edition: 60, plus 15 Artist's Proofs, 3 Trial Proofs, 1 OKTP (called a BAT), 1 Archive Proof, and 2 (unsigned) Exhibition Proofs; the FAMSF Archive has 1 Archive Proof, 2 study drawings on tracing paper, 7 Working Proofs, and 1 Working Proof for a rejected (unpublished) plate

Axsom/Platzker 154

Crown Point Press Archive, gift of Kathan Brown

1991.28.97

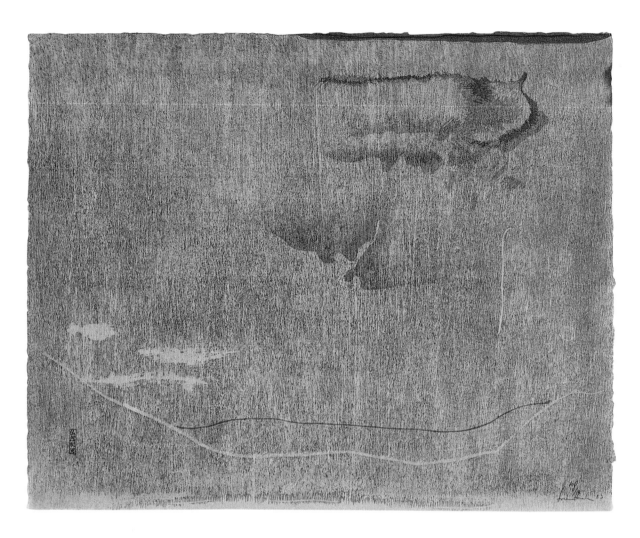

4 [see page 58]

Pat Steir b. Newark, New Jersey 1940

Abstraction, Belief, Desire 1981

Color aquatint, hard ground etching, soft ground etching, spit bite aquatint, and drypoint on Arches 88 paper

912 x 1403 mm (plate); 1078 x 1550 mm (sheet)

Published by Crown Point Press, Oakland

Printed by Hidekatsu Takada

Edition: 35, plus 10 Artist's Proofs, and 1 OKTP; the FAMSF Archive has 1 undesignated (signed) proof, 2 drawings, and 27 Working Proofs

Willi 15

Crown Point Press Archive, gift of Kathan Brown

1991.28.1358

5

Helen Frankenthaler b. New York, New York 1928

Cedar Hill 1983

Color woodcut on light pink Mingei Momo paper

512 x 635 mm (image and sheet)

Published by Crown Point Press, Oakland

Printed by Tadashi Toda at the Shiundo Print Shop, Kyoto, Japan

Edition: 75, plus 18 Artist's Proofs, 10 Trial Proofs, 51 Helen Frankenthaler Archive Proofs, and 2 Presentation Proofs; the FAMSF Archive has 1 Artist's Proof (AP 10)

Harrison 121

Crown Point Press Archive, gift of Crown Point Press

1992.167.986

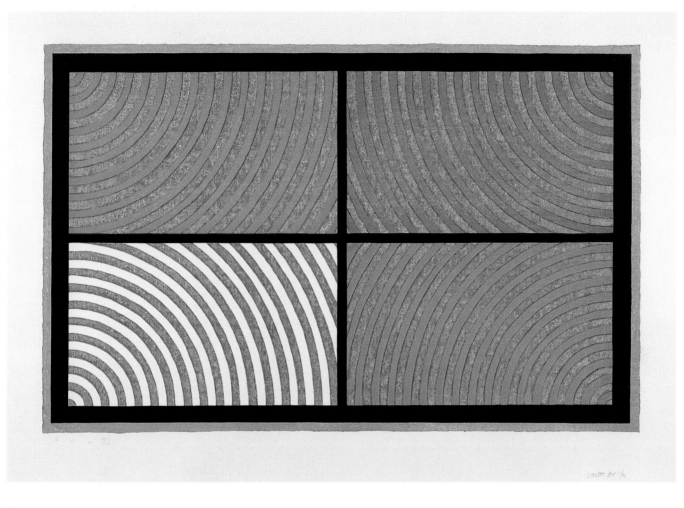

6

Sol LeWitt b. Hartford, Connecticut 1928

Arcs from Four Corners 1986

Color woodcut on Echizen Torinoko paper

471 x 723 mm (image); 587 x 828 mm (sheet)

Published by Crown Point Press, San Francisco

Printed by Tadashi Toda at the Shiundo Print Shop, Kyoto, Japan

Edition: 200, plus 20 Artist's Proofs and 9 Trial Proofs (including 1 OKTP); the FAMSF Archive has 1 Artist's Proof (AP 11)

Tate W4

Crown Point Press Archive, gift of Crown Point Press

1992.167.673

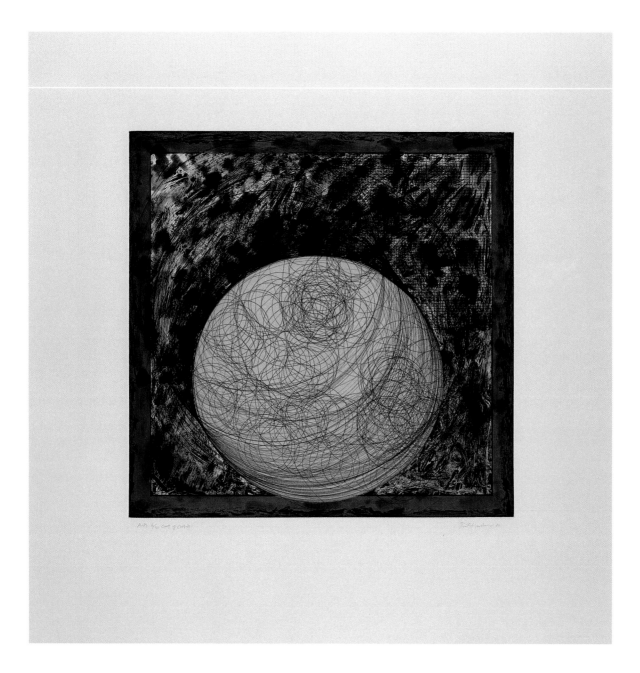

7*

Robert Hudson b. Salt Lake City, Utah 1938

Out of Orbit 1986

Color aquatint, hard ground etching, drypoint, and spit bite aquatint on Somerset Satin paper

455 x 454 mm (plate); 731 x 707 mm (sheet)

Published by Crown Point Press, Oakland

Printed by Lawrence Hamlin

Edition: 35, plus 10 Artist's Proofs and 7 Trial Proofs (including 1 OKTP); the FAMSF Archive has 1 Artist's Proof (AP 6)

Crown Point Press Archive, gift of Crown Point Press

1992.167.958

8 [right]

Richard Diebenkorn

b. Portland, Oregon 1922 — d. Berkeley, California 1993

Green 1986

Color aquatint, spit bite aquatint, soap ground aquatint, and drypoint on Somerset paper

1143 x 898 mm (plate); 1363 x 1935 mm (sheet)

Published by Crown Point Press, Oakland

Printed by Marcia Bartholme

Edition: 60, plus 10 Artist's Proofs, and 11 Trial Proofs (including 1 OKTP); the FAMSF Archive has 1 Artist's Proof (AP 6)

Crown Point Press Archive, gift of Crown Point Press

1992.28.1274

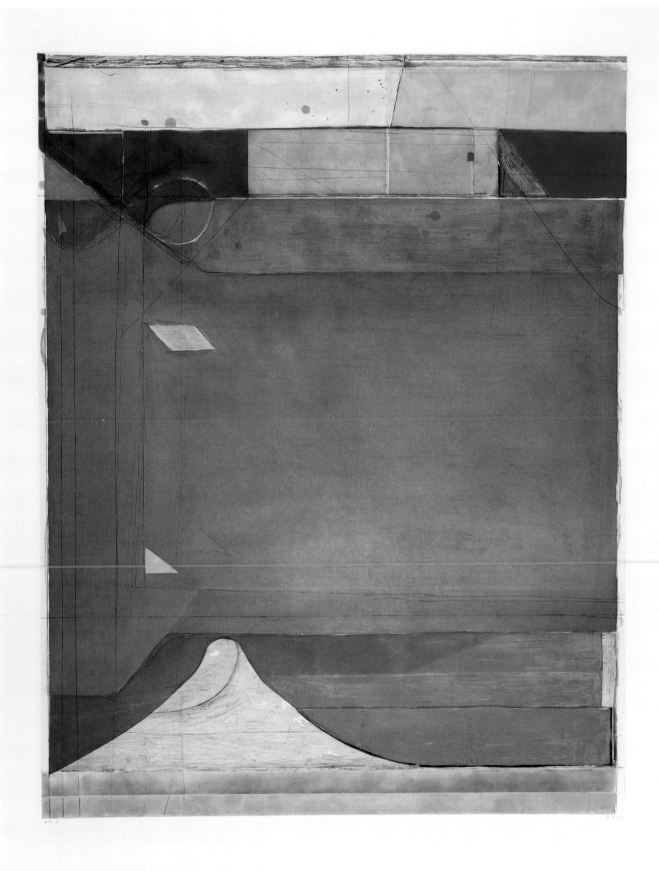

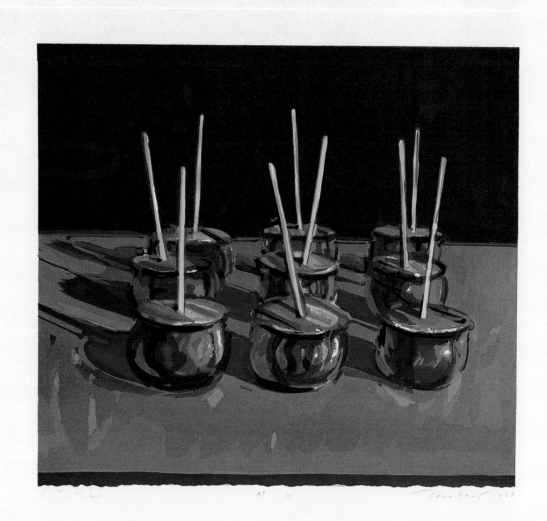

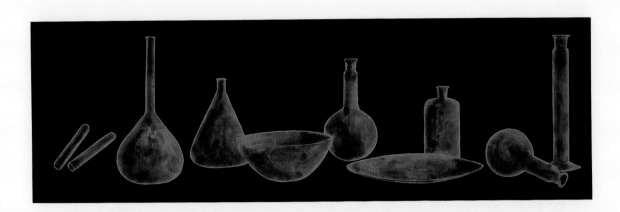

10

Tony Cragg b. Liverpool, England 1949

Laboratory Still Life No. 2, State 2 1988

Color spit bite aquatint and aquatint printed in black and light red on Somerset Textured paper

292 x 902 mm (plate); 532 x 1108 mm (sheet)

Published by Crown Point Press, San Francisco

Printed by Mark Callen

Edition: 30, plus 10 Artist's Proofs and 6 Trial Proofs (including 1 OKTP); the FAMSF Archive has 1 Artist's Proof (AP 6) and 2 Working Proofs

Crown Point Press Archive, gift of Crown Point Press

1992.167.131

9 [left]

Wayne Thiebaud b. Mesa, Arizona 1920

Candy Apples 1987

Color woodcut on Tosa Kozo paper

388 x 420 mm (image); 592 x 615 mm (sheet)

Published by Crown Point Press, San Francisco

Printed by Tadashi Toda at Shiundo Print Shop, Kyoto, Japan

Edition: 200, plus 20 Artist's Proofs and 12 Trial Proofs (including 1 OKTP); the FAMSF Archive has 1 Artist's Proof (AP 11)

Crown Point Press Archive, gift of Crown Point Press

1992.167.270

Candy Apples and *Hill Street* were the prints made in 1987 during Thiebaud's second engagement with Crown Point Press's Japanese woodcut program. Altogether, Thiebaud made three color woodcuts with Tadashi Toda in Japan.

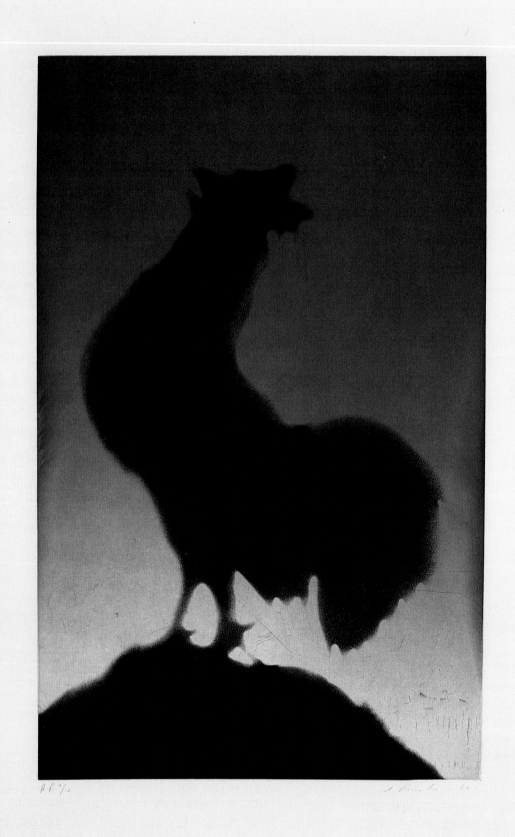

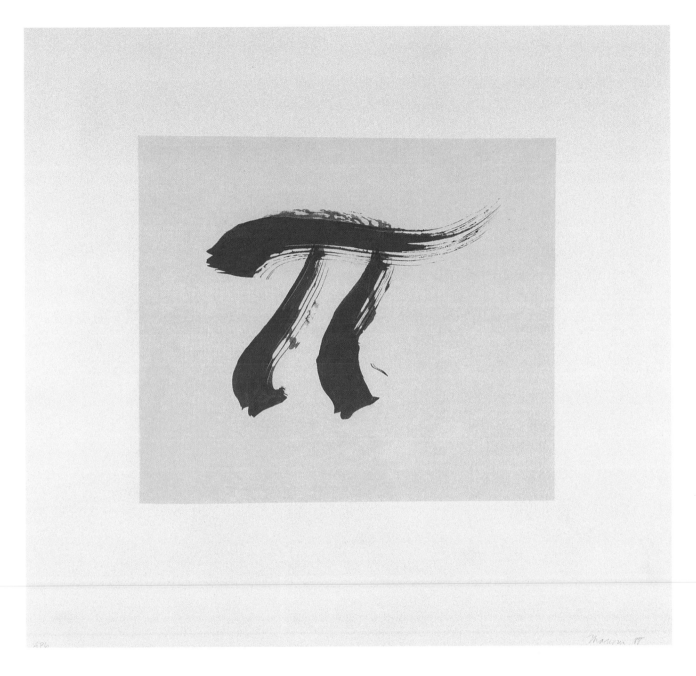

11 [left]

Ed Ruscha b. Omaha, Nebraska 1937

Rooster 1988

Color aquatint and hard ground etching on Somerset White paper

907 x 567 mm (plate); 1124 x 770 mm (sheet)

Published by Crown Point Press, San Francisco

Printed by Renée Bott

Edition: 50, including 10 Artist's Proofs and 4 Trial Proofs (including 1 OKTP); the FAMSF Archive has 1 Artist's Proof (AP 7)

Crown Point Press Archive, gift of Crown Point Press

1991.28.1093

12

Tom Marioni b. Cincinnati, Ohio 1937

Pi 1988

Woodcut printed in red on silk, mounted on Arches Cover Buff paper

330 x 376 mm (silk); 572 x 593 mm (paper)

Published by Crown Point Press, San Francisco

Printed by Yin She Xu, Hangzhou, People's Republic of China

Edition: 30, plus 10 Artist's Proofs and 7 Trial Proofs (including 1 OKTP); the FAMSF Archive has 1 Artist's Proof (AP 6) and 4 Working Proofs

Crown Point Press Archive, gift of Crown Point Press

1992.167.295

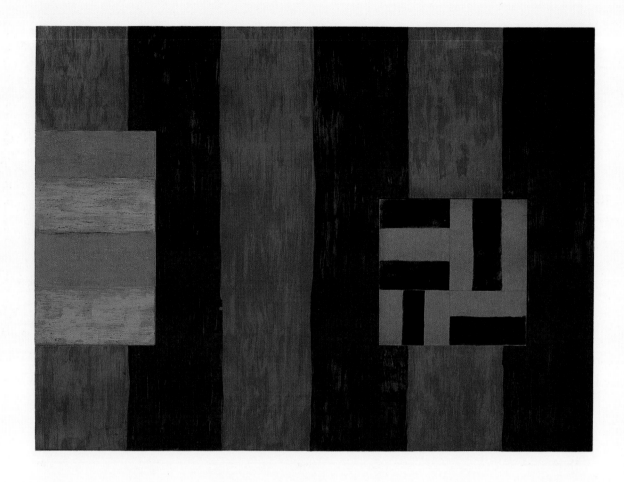

13

Sean Scully b. Dublin, Ireland 1945

Room 1988

Color soap ground aquatint, aquatint, spit bite aquatint, drypoint, and crayon resist on Somerset Textured White paper

802 x 1059 mm (plate); 1058 x 1290 mm (sheet)

Published by Crown Point Press, San Francisco

Printed by Brian Shure

Edition: 40, plus 10 Artist's Proofs and 5 Trial Proofs (including 1 OKTP); the FAMSF Archive has 1 Artist's Proof (AP 6) and 10 Working Proofs

Crown Point Press Archive, gift of Crown Point Press

1991.28.1404

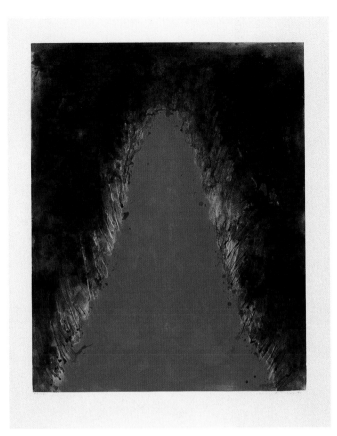

14

Anish Kapoor b. Bombay, India 1954

Untitled I 1988

Color spit bite aquatint printed on Arches Cover paper

1134 x 899 mm (plate); 1347 x 1070 mm (sheet)

Published by Crown Point Press, San Francisco

Printed by Lawrence Hamlin

Edition: 20, plus 10 Artist's Proofs and 6 Trial Proofs (including 1 OKTP); the FAMSF Archive has 1 Artist's Proof (AP 6) and 2 Working Proofs

Crown Point Press Archive, gift of Crown Point Press

1992.167.1047

15 [following page]

John Cage
b. Los Angeles, California 1912 — d. New York, New York 1992

75 Stones 1989

Color spit bite aquatint and sugar lift aquatint on smoked Somerset Textured White paper

1215 x 895 mm (plate); 1375 x 1047 mm (sheet)

Published by Crown Point Press, San Francisco

Printed by Pamela Paulson

Edition: 25, plus 10 Artist's Proofs and 5 Trial Proofs (including 1 OKTP); the FAMSF Archive has 1 Artist's Proof (AP 6) and 6 Working Proofs

Crown Point Press Archive, gift of Crown Point Press

1991.28.1336

The title of this print, *75 Stones*, refers to the seventy-five outlines of variously sized stones scattered across the paper. The colors used in the print were matched to colors that were observed in the stones. *75 Stones* was one of several print projects that used smoked paper. The printers smoked the paper by setting on fire several crumbled pieces of newspaper and then placing dampened paper on the fire to extinguish it. Because the paper was hand-smoked, each print has a different degree of background tone.

16

Al Held b. New York, New York 1928

Magenta 1990

Color aquatint and spit bite aquatint on Somerset White paper

909 x 1138 mm (plate); 1047 x 1373 mm (sheet)

Published by Crown Point Press, San Francisco

Printed by Renée Bott

Edition: 50, plus 10 Artist's Proofs and 5 Trial Proofs
(including 1 OKTP); the FAMSF Archive has 1 Artist's Proof (AP 6)
and 1 Working Proof

Crown Point Press Archive, gift of Crown Point Press

1993.51.282

CAT. 31
Dorothea Rockburne *Locus Series No. 6,* 1972–1975

II

The Press in the 1970s

IN 1970 KATHAN BROWN ACCEPTED the job of printing two large, color etchings by Wayne Thiebaud for a portfolio of his work to be published by Parasol Press. The resulting prints delighted Robert Feldman, director of Parasol, who was skeptical that etching could be a suitable medium for contemporary art. As he soon realized, etching was an effective vehicle for the Minimalist painters whom he also wanted to publish. The physicality of etching—that is, the dimensionality that could be created through subtle modulations of aquatint or the crisp lines created by hard ground etching—was a direct match for the Minimalist statement.

Through commissions from Parasol, Brice Marden, Robert Mangold, and Robert Ryman soon became actively involved in printmaking projects at Crown Point Press. Their prints made at the Press in the early 1970s were lauded for their finesse. Brown was credited with having provided these artists with the appropriate techniques so as not to complicate their Minimalist statement while allowing them to create works of great beauty.

The Parasol program did not publish prints by Minimalist artists exclusively. Chuck Close, Bryan Hunt, Sylvia Plimack Mangold, and Donald Sultan all made prints at Crown Point during the 1970s. For the most part, they were matched to the Press by Feldman.

Sol LeWitt, whose work is often identified with Minimalism because of his use of spare, simple lines and shapes, was also sent to Crown Point by Feldman. In theory and practice, LeWitt's art was more akin to the Conceptual standard in which an idea or concept was considered the most important aspect of the artwork. The form of the art that resulted used systems in its making (arcs in four corners, squares with a different line direction in each half square, etc.). Brown's successful first collaboration with LeWitt in 1971 resulted in numerous other print projects with him, many of which Crown Point itself published.

LeWitt's conceptualist theories influenced Brown to consider working with other artists who shared similar ideas. In 1974 she met Tom Marioni, a sculptor and Conceptual artist, and their first project together, *The Sun's Reception*, led her to develop a program of publishing with a Conceptual bent. By 1977 she had begun to phase out contract printing for other publishers, and by the end of the decade she had published 280 prints on her own, of which ninety-seven were by Conceptual artists.

K. BREUER

83

PL. 1

PL. 2

PL. 3

PL. 4

PL. 5

PL. 6

PL. 7

PL. 8

PL. 9

PL. 10

Bruce Conner
Dennis Hopper/
One Man Show/
Volume One,
PL. III, 1971

17–26 [left]

Sol LeWitt b. Hartford, Connecticut 1928

Squares with a Different Line Direction in Each Half Square 1971

Set of 10 hard ground etchings on Rives BFK paper

PL. 1 184 x 181 mm (plate)
PL. 2 179 x 189 mm (plate)
PL. 3 179 x 185 mm (plate)
PL. 4 184 x 182 mm (plate)
PL. 5 182 x 183 mm (plate)
PL. 6 184 x 180 mm (plate)
PL. 7 184 x 183 mm (plate)
PL. 8 184 x 181 mm (plate)
PL. 9 183 x 181 mm (plate)
PL. 10 183 x 180 mm (plate)

Sheet size for all is 370 x 368 mm

Published by Parasol Press, New York, and Wadsworth Atheneum, Hartford, Connecticut

Printed by Kathan Brown at Crown Point Press, Berkeley

Edition: 25 sets, plus 7 Artist's Proof sets and 3 Trial Proof sets; the FAMSF Archive has 1 Artist's Proof set (AP 6)

Tate E1

Crown Point Press Archive, Achenbach Foundation for Graphic Arts purchase

1991.28.805–814

Each of the prints in the set shows a version of the formula described in the title, except plate ten which presents nine additional versions in miniature.

27 [above]

Bruce Conner b. McPherson, Kansas 1933

Dennis Hopper/One Man Show/Volume One 1971

Book of 8 photoetchings printed on Rives BFK paper

PL. I 338 x 229 mm (plate)
PL. II 192 x 280 mm (plate)
PL. III 175 x 229 mm (plate)
PL. IV 218 x 161 mm (plate)
PL. V 163 x 134 mm (plate)
PL. VI 178 x 207 mm (plate)
PL. VII 144 x 255 mm (plate)
PL. VIII 311 x 230 mm (plate)

Page size for all is 466 x 377 mm

Published by Crown Point Press, Oakland

Printed by Kathan Brown

Edition: 10 books, and a small, but unknown number of Artist's Proof books and unbound Trial Proofs; the FAMSF Archive has 1 book from the edition (5/10)

Crown Point Press Archive, Museum purchase, gift of Mrs. Paul L. Wattis

1991.28.305–312

28

Robert Ryman b. Nashville, Tennessee 1930

Plate 1 of 7 from the portfolio *Seven Aquatints* 1972

Aquatint printed in lead white on Rives BFK paper

303 x 353 mm (overall, two plates); 612 x 615 mm (sheet);

Published by Parasol Press Ltd., New York

Printed by Kathan Brown at Crown Point Press, Oakland

Edition: 50 portfolios, plus 10 Artist's Proof portfolios, 3 Trial Proof portfolios, and an unknown quantity of single proofs; the FAMSF Archive has 1 Artist's Proof portfolio (AP 1)

Crown Point Press Archive, Museum purchase, gift of several donors

1991.28.1066

29

Robert Ryman

Plate 5 of 7 from the portfolio *Seven Aquatints* 1972

Aquatint printed in lead white on Rives BFK paper

352 x 349 mm (plate); 612 x 615 mm (sheet)

Published by Parasol Press Ltd., New York

Printed by Kathan Brown at Crown Point Press, Oakland

Edition: 50 portfolios, plus 10 Artist's Proof portfolios, 3 Trial Proof portfolios, and an unknown quantity of single proofs; the FAMSF Archive has 1 Artist's Proof portfolio (AP 1)

Crown Point Press Archive, Museum purchase, gift of several donors

1991.28.1064

30

Dorothea Rockburne
b. Verdun, Quebec, Canada 1934

Locus Series No. 1 1972–1975

Relief etching and aquatint printed in gray and white on folded Strathmore Bristol paper

No visible plate mark; 1010 x 764 mm (sheet)

Published by Parasol Press Ltd., New York

Printed by Jeryl Parker at Crown Point Press, Oakland

Edition: 42; the FAMSF Archive has 1 Artist's Proof (AP 2) and 1 Working Proof

Crown Point Press Archive, Museum purchase, gift of Mr. and Mrs. Gordon P. Getty

1991.28.231

The six *Locus* prints, which can be considered separately or as a series, were begun in 1972 and completed over a three-year period when Rockburne was working on a series of drawings that, she said, "make themselves." The paper was folded before it was run through the press so that embossed lines would be created from the edges and folds. The prints were sold in this state and had to be unfolded in order to be enjoyed.

31 [see page 82]

Dorothea Rockburne

Locus Series No. 6 1972–1975

Relief etching and aquatint printed in gray and white on folded Strathmore Bristol paper

No visible plate mark; 1010 x 764 mm (sheet)

Published by Parasol Press Ltd., New York

Printed by Jeryl Parker at Crown Point Press, Oakland

Edition: 42; the FAMSF Archive has 1 Artist's Proof (AP 2) and 1 Working Proof

Crown Point Press Archive, Museum purchase, gift of Mr. and Mrs. Gordon P. Getty

1991.28.236

32

Mel Bochner b. Pittsburgh, Pennsylvania 1940

Four + Three 1973

Aquatint printed on Rives BFK paper

271 x 353 mm (plate); 440 x 508 mm (sheet)

Published by Parasol Press Ltd., New York

Printed by Kathan Brown at Crown Point
Press, Oakland

Edition: 25; the FAMSF Archive has
1 Artist's Proof (AP 8)

Crown Point Press Archive, Museum purchase,
bequest of Whitney Warren Jr. in memory of
Mrs. Adolph Spreckels

1991.28.583

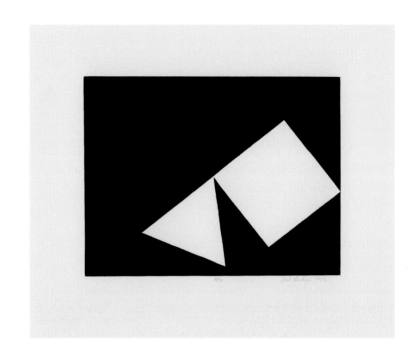

33

Mel Bochner

Five + Five 1973

Aquatint printed on Rives BFK paper

273 x 354 mm (plate); 465 x 534 mm (sheet)

Published by Parasol Press Ltd., New York

Printed by Kathan Brown at Crown Point
Press, Oakland

Edition: 25; the FAMSF Archive has
1 Artist's Proof (AP 8)

Crown Point Press Archive, Museum purchase,
bequest of Whitney Warren Jr. in memory of
Mrs. Adolph Spreckels

1991.28.584

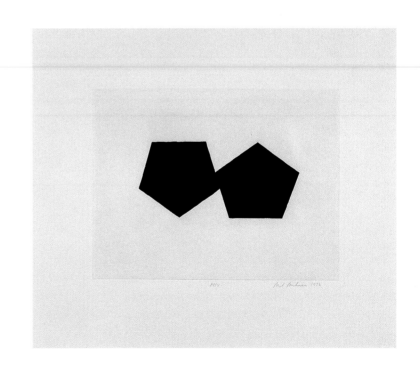

34–38 [see page 54]

Brice Marden b. Bronxville, New York 1938

Five Plates 1973

Portfolio of 5 prints on Rives BFK paper

Untitled (Image a), hard ground etching and aquatint, 708 x 499 mm (plate)
Untitled (Image b), hard ground etching and aquatint, 712 x 503 mm (plate) *
Untitled (Image c), hard ground etching and aquatint, 713 x 505 mm (plate) *
Untitled (Image d), hard ground etching and aquatint, 710 x 515 mm (plate)
Untitled (Image e), hard ground etching and aquatint, 713 x 503 mm (plate) *

All sheets measure 1015–1021 x 750–755 mm

Published by Parasol Press Ltd., New York

Printed by Patricia Branstead at Crown Point Press, Oakland

Edition: 50 portfolios, plus 15 Artist's Proof portfolios (identified by the
letters A–0), and a small but unknown number of Trial Proofs; the FAMSF
Archive has 1 portfolio set from the edition (44/50)

Lewison 23 a–e

Crown Point Press Archive, gift of Kathan Brown

1991.28.1023–1027

Marden wanted each of the five prints in this series to have a sense of physicality.
He accomplished this by building up layers of aquatint (just as he would build up
layers in a painting). The printers dragged the ink up to the surface of the plate in a
process called *retroussage*. They also inked the edges of each plate which had eroded
considerably due to numerous immersions in acid. In addition, they left a light film
of ink on blank areas of the plate to create tone so that after printing there was a
distinction between the white areas of the image and the margin of the paper. False
biting was allowed to remain in those areas, giving the image even more substance.

39 [upper right]

Edda Renouf b. Mexico City, Mexico 1943

Plate 1 of 8 from the portfolio *Clusters* 1976

Soft ground etching printed in brown on Rives BFK paper

183 x 181 mm (plate); 226 x 223 mm (sheet)

Published by Parasol Press, Ltd., New York

Printed by Doris Simmelink at Crown Point Press, Oakland

Edition: 25 portfolios, plus 10 Artist's Proof portfolios, and
4 Trial Proof portfolios; the FAMSF Archive has 1 Artist's Proof
portfolio (AP 3)

Crown Point Press Archive, Museum purchase, gift of Mr. and
Mrs. Gordon P. Getty

1991.28.130

40 [lower right]

Edda Renouf

Plate 7 of 8 from the portfolio *Clusters* 1976

Drypoint and aquatint printed in brown on Rives BFK paper

182 x 182 (plate); 222 x 225 mm (sheet)

Published by Parasol Press, Ltd., New York

Printed by Doris Simmelink at Crown Point Press, Oakland

Edition: 25 portfolios, plus 10 Artist's Proof portfolios, and
4 Trial Proof portfolios; the FAMSF Archive has 1 Artist's Proof
portfolio (AP 3)

Crown Point Press Archive, Museum purchase, gift of Mr. and
Mrs. Gordon P. Getty

1991.28.136

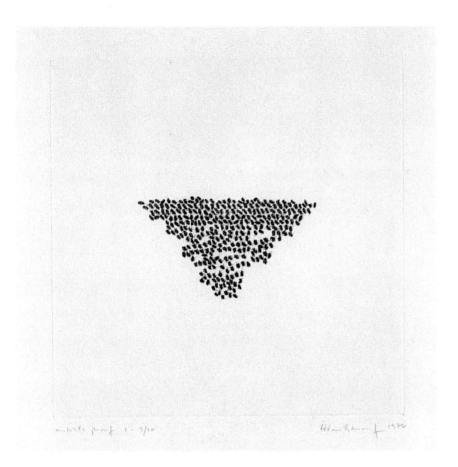

artist proof 1 - 3/10 Adam Reising 1976

artist proof 2 - 3/10 Adam Reising 1976

41*

Tom Marioni b. Cincinnati, Ohio 1937

The Sun's Reception 1974

Drypoint printed in blue on Rives BFK paper

918 x 1141 mm (plate); 1028 x 1243 mm (sheet)

Published by Crown Point Press, Oakland

Printed by Kathan Brown

Edition: 6, plus 1 Artist's Proof and 2 Trial Proofs; the FAMSF Archive has 1 from the edition (4/6) and 1 Working Proof

Crown Point Press Archive, Museum purchase, gift of the Erika Meyerovich Gallery

1991.28.99

The Sun's Reception was created as an art "action" at the home of David and Mary Robinson in Sausalito, California. Outdoors near the swimming pool, Marioni drew around the sun's image reflected on a copper plate, using an electric grinder. The sounds of his making the print were amplified for the audience. A book documenting the activity was published to accompany the print.

42–46 [right]

Robert Mangold b. North Tonawanda, New York 1937

5 Aquatints 1975

Portfolio of 5 prints on Rives BFK paper

PL. A color aquatint and soft ground etching, 226 x 226 (plate and sheet)
PL. B color aquatint and soft ground etching, 226 x 226 (plate and sheet)
PL. C color aquatint and soft ground etching, 226 x 226 (plate and sheet)
PL. D color aquatint and soft ground etching, 226 x 226 (plate and sheet)
PL. E color aquatint and soft ground etching, 226 x 226 (plate and sheet)

Published by Parasol Press, Ltd., New York

Printed by Patrick Foy at Crown Point Press, Oakland

Edition: 50 portfolios, plus 15 Artist's Proof portfolios (identified by the letters A–O); the FAMSF Archive has 1 Artist's Proof portfolio (AP L)

Crown Point Press Archive, Achenbach Foundation for Graphic Arts purchase

1991.28.125–129

47

Sylvia Plimack Mangold b. New York, New York 1938

Paper Under Tape, Paint Over Paper 1977

Color aquatint and hard ground etching on Rives BFK paper

478 x 650 mm (plate); 557 x 767 mm (sheet)

Published by Parasol Press, Ltd., New York

Printed by Patrick Foy at Crown Point Press, Oakland

Edition: 50, plus 15 Artist's Proofs; the FAMSF Archive
has 1 Artist's Proof (AP 10)

D'Oench/Faberman 5

Crown Point Press Archive, Achenbach Foundation
for Graphic Arts purchase

1991.28.1071

TITLE PAGE

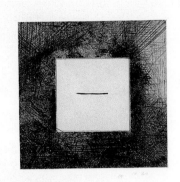

PL. a

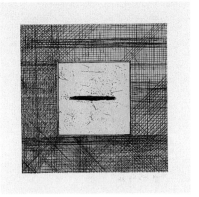

PL. b

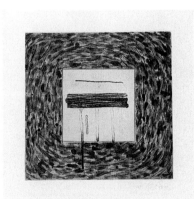

PL. c

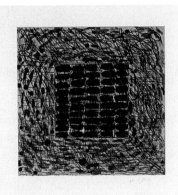

PL. d

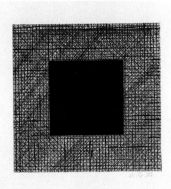

PL. e

PL. f

48–54*

Pat Steir b. Newark, New Jersey 1938

Drawing Lesson. Part I. Line. 1978

Portfolio of 7 prints on Arches Satiné paper

Title page (self-portrait), drypoint printed in brown,
 144 x 143 mm (plate)
Untitled (image a), color aquatint and drypoint,
 302 x 302 mm (plate)
Untitled (image b), color aquatint, hard ground etching,
 and drypoint, 303 x 301 mm (plate)
Untitled (image c), color aquatint, spite bite aquatint,
 soft ground etching, and drypoint, 303 x 302 mm (plate)
Untitled (image d), color aquatint, spit bite aquatint, soft ground
 etching, drypoint, and sugar lift aquatint, 302 x 301 mm (plate)
Untitled (image e), color aquatint, hard ground etching, and
 drypoint, 301 x 303 mm (plate)

Untitled (image f), color aquatint and hard ground etching,
 302 x 304 mm (plate)

All sheets measure 407–406 x 405–409 mm

Published by Crown Point Press, Oakland

Printed by John Slivon

Edition: 25 portfolios, plus 10 Artist's Proof portfolios and
1 Trial Proof portfolio; the FAMSF Archive has one
Artist's Proof portfolio (AP 2)

Willi 5

Crown Point Press Archive, gift of Kathan Brown

1991.28.485–491

55*

Bryan Hunt b. Terra Haute, Indiana 1947

Straight Falls 1979

Hard ground etching, sugar lift aquatint, soap ground aquatint, and drypoint printed on Rives BFK paper

2360 x 457 mm (overall 2 sheets)

Published by Parasol Press, Ltd., New York

Printed by David Kelso at Crown Point Press, Oakland

Edition: 10, plus 10 Artist's Proofs and 5 Trial Proofs; the FAMSF Archive has 1 Artist's Proof (AP 1) and 1 Working Proof

Crown Point Press Archive, Museum purchase, bequest of Sheldon G. Cooper in memory of Patricia Tobin Cooper

1991.28.216 a–b

56*

Bryan Hunt

Falls with Bend 1979

Hard ground etching, sugar lift aquatint, soap ground aquatint, and drypoint printed on Rives BFK paper

2384 x 455 mm (overall 2 sheets)

Published by Parasol Press, Ltd., New York

Printed by David Kelso at Crown Point Press, Oakland

Edition: 10, plus 10 Artist's Proofs and 5 Trial Proofs; the FAMSF Archive has 1 Artist's Proof (AP III) and 1 Working Proof

Crown Point Press Archive, Museum purchase, bequest of Sheldon G. Cooper in memory of Patricia Tobin Cooper

1991.28.217 a–b

57*

Donald Sultan b. Asheville, North Carolina, 1951

March 22, 1979, plate 5 of 8 from the portfolio
Water Under the Bridge 1979

Aquatint, drypoint, and soft ground etching with scraping and burnishing on Rives BFK paper

303 x 302 mm (plate); 463 x 460 mm (sheet)

Published by Parasol Press Ltd., New York

Printed by David Kelso at Crown Point Press, Oakland

Edition: 45 portfolios, plus 10 Artist's Proof portfolios, 3 Trial Proof portfolios, and 1 RTP portfolio; the FAMSF Archive has 1 Artist's Proof portfolio (AP 8)

Crown Point Press Archive, Museum Purchase, gift of Mr. and Mrs. Robert J. Bransten

1991.28.454

58*

Donald Sultan

March 28, 1979, plate 8 of 8 from the portfolio
Water Under the Bridge 1979

Etching and aquatint with scraping and burnishing printed on Rives BFK paper

303 x 302 mm (plate); 460 x 458 mm (sheet)

Published by Parasol Press Ltd., New York

Printed by David Kelso at Crown Point Press, Oakland

Edition: 45 portfolios, plus 10 Artist's Proof portfolios, 3 Trial Proof portfolios, and 1 RTP portfolio; the FAMSF Archive has 1 Artist's Proof portfolio (AP 8)

Crown Point Press Archive, Museum Purchase, gift of Mr. and Mrs. Robert J. Bransten

1991.28.457

The cigarette/smokestack image in this print became the subject of *Smokers,* three large-scale aquatints made by Sultan at Crown Point Press the following year.

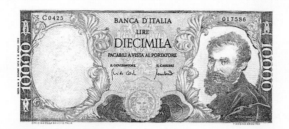

A.P. Diecimila *Chris Burden 1977*

RECTO

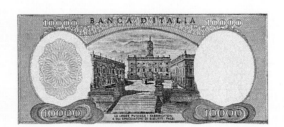

A.P. Diecimila *Chris Burden 1977*

CAT. 60 VERSO
Chris Burden *Diecimila,* 1977

III Conceptual Art and Its Affinities

KATHAN BROWN HAS WRITTEN extensively about her early commitment to publish prints by Conceptual artists. She identified Conceptual art as the characteristic art of the 1970s, the primary concerns of which were not the creation of an art object, but rather the creation of a concept in the mind of the viewer.

Brown understood the Conceptual stance as antimaterialistic in its rejection of the preciousness of works of art. From her point of view, that credo fit well with the traditional understanding of the print as a democratic art form. Prints by Conceptual artists, especially those involved with activity or performance, could be seen as portable evidence of their work. Brown also believed that Conceptual artists took a big step away from art of the recent past by not identifying themselves with a single material, as painters had done with paint or photographers with photographs. She realized that the flexible working environment of the Crown Point Press studio would be ideal for Conceptual artists. She tailored each project to the individual, making the medium of etching stretch and bend according to the working concept.

These were ambitious undertakings because the materials the artists wanted to use to make prints were often untraditional. For example, in 1971 Chris Burden wanted (literally) to make money. Robert Barry wanted to use language. Daniel Buren wanted to make something that would cause people to become aware of an art installation as a problem, not as a habit. Hamish Fulton, an artist who takes

walks, wanted to make a human-sized record of a journey in the California wilderness. Tim Rollins, an artist whose medium is education, wanted to make art in collaboration with five teenagers from the South Bronx.

In each case, Brown's ideas about art and printmaking were stimulated by the fact that the working methods of the Conceptual artists were diverse and unusual. The projects were not always successful from a financial point of view (many of the artists had no proven marketability with prints) but Crown Point gained a reputation in international art circles for its adventurousness with acclaimed avant-garde artists. Throughout the 1980s and 1990s, Brown continued working with Conceptual artists such as John Baldessari and Joel Fisher, and also with artists Sherrie Levine, Bertrand Lavier, and José Maria Sicilia, whose work was influenced by Conceptualist ideas.

K. BREUER

99

59*

Jim Melchert b. New Bremen, Ohio, 1930

A Scratch on the Negative 1974

Book with 7 photoetchings, 1 blind embossing,
and 1 drypoint on Rives BFK paper

PL. 1 photoetching, 152 x 269 mm (plate)
PL. 2 photoetching, 154 x 271 mm (plate)
PL. 3 photoetching, 152 x 438 mm (plate)
PL. 4 photoetching, 151 x 440 mm (plate)
PL. 5 photoetching, 150 x 440 mm (plate)
PL. 6 photoetching, 151 x 440 mm (plate)
PL. 7 blind embossing, 154 x 272 mm (plate)
PL. 8 drypoint, 150 x 268 mm (plate)
PL. 9 photoetching, 161 x 440 mm (plate)

Page size for each is 334 x 444 mm

Published by Crown Point Press, Oakland

Printed by Patricia Branstead. Photographic plates
made by Ron Greenberg.

Edition: 15 books, plus 10 Artist's Proof books; the
FAMSF Archive has 1 Artist's Proof book (AP 1)

Crown Point Press Archive, Museum purchase,
gift of Mr. and Mrs. Douglas W. Grigg

1991.28.476–484

The first plate in the book is a photograph of baseball
players from a sports magazine. Five subsequent plates
focus closely on an area of the photograph which
includes a scratch. A blank page and a blank plate
indicate that a reversal will occur. Then a drypoint
scratch appears alone on the next plate. The last plate
is a photograph of the universe that resembles the
grainy texture of the details of the baseball photograph.

60 [see page 98]

Chris Burden b. Boston, Massachusetts 1946

Diecimila 1977

Color photoetching printed on both sides of handmade
Don Farnsworth paper, with colored pencil additions by
the artist and printers

79 x 162 mm (each plate); 260 x 356 mm (sheet)

Published by Crown Point Press, Oakland

Printed by John Slivon

Edition: 35, plus 10 Artist's Proofs, 5 Trial Proofs, and
1 annotated proof used as a guide for coloring; the FAMSF
Archive has 1 Artist's Proof (AP 1) and 4 Working Proofs

Crown Point Press Archive, Museum purchase, bequest of
Whitney Warren Jr. in memory of Mrs. Adolph B. Spreckels

1991.28.221 r–v

THE ATOMIC ALPHABET

A for ATOMIC 原子
B for BOMB 爆弾
C for COMBAT 戦闘
D for DUMB 馬鹿
E for ENERGY 原動力
F for FALLOUT 原子灰
G for GUERRILLA 奇襲隊
H for HOLOCAUST 大焼尽
I for IGNITE 発火
J for JUNGLE 密林地帯
K for KILL 殺害
L for LIFE 生命
M for MUTANT 突然変異体
N for NUCLEAR 原子核
O for OBLITERATE 抹殺
P for PANIC 恐慌
Q for QUAKE 地震
R for RUBBLE 粉砕
S for STRIKE 奇襲
T for TARGET 標的
U for URANIUM 重金属元素
V for VICTORY 勝利
W for WAR 戦争
X for RAY 照射線
Y for YELLER 腰抜け
Z for ZERO 零

61*

Chris Burden

b. Boston, Massachusetts 1946

The Atomic Alphabet 1980

Photoetching, soft ground etching, and watercolor (applied by Tony Morse) on Arches 88 paper

1365 x 903 mm (plate);
1457 x 997 mm (sheet)

Published by Crown Point Press, Oakland

Printed by Hidekatsu Takada. Illustrations by Tony Morse. Calligraphy by Hidekatsu Takada.

Edition: 20, plus 9 Artist's Proofs and 2 Trial Proofs; the FAMSF Archive has 1 Artist's Proof (AP 1) and 1 Working Proof

Crown Point Press Archive, gift of Crown Point Press

1991.28.1332

Burden wanted to create a print that looked like a children's alphabet, but his own drawing style was not appropriate. He interviewed several illustrators to find one whose style would fit his concept. Tony Morse, a professional illustrator, was chosen and Burden worked closely with him as each word picture was developed. Morse additionally hand-colored each etching after printing. Hidekatsu Takada, the printer for the project, supplied the Japanese calligraphy.

62*

Terry Fox b. Seattle,Washington 1943

Pendulum Spit Bite 1977

Spit bite aquatint on Rives BFK paper

913 x 1143 mm (plate); 1014 x 1243 mm (sheet)

Published by Crown Point Press, Oakland

Printed by Stephen Thomas

Edition: 25, plus 10 Artist's Proofs, and 1 Trial Proof;
the FAMSF Archive has 1 Artist's Proof (AP 6)

Crown Point Press Archive, gift of Kathan Brown

1991.28.88

The title of this print refers to a pendulum apparatus
that Fox constructed to make the print. The pendulum,
constructed from plastic tubing and a lead weight,
dripped the acid onto the copper plate as it swung
around. Fox signed *Pendulum Spit Bite* on each of the
four edges to indicate that the print could be read
from any orientation.

ARE THE RICH A MENACE?

Some people think they are, so let's look at the record.

 Suppose you inherit, win or otherwise acquire a million dollars net after taxes. That would make you rich, wouldn't it? Now, what's the first thing you'd do? Invest it, wouldn't you?— in stocks, bonds or in a savings bank.

 So, what does that mean? It means that you have furnished the capital required to put about 30 people to work.

 How is that? National statistics show that for every person graduating from school or college, at least thirty thousand dollars of capital must be found for bricks, fixtures, machinery, inventory, etc. to put each one to work.

 Now, on your million dollar investments you will receive an income of sixty thousand, eighty thousand, or more dollars a year. This you will spend for food, clothing, shelter, taxes, education, entertainment and other expenses. And this will help support people like policemen, firemen, store clerks, factory workers, doctors, teachers, and others. Even congressmen.

 So, in other words, Mr. Rich Man, you would be supporting (wholly or partially) perhaps more than 100 people.

 Now, how about that? Are you a menace? No, you are not.

TIFFANY & CO.

FIFTH AVENUE & 57TH STREET
NEW YORK

Advertisement in The New York Times, June 6, 1977

The 9,240,000 Unemployed in The United States of America Demand The Immediate Creation of More Millionaires

63

Hans Haacke b. Cologne, Germany 1936

Tiffany Cares 1978

Photoetching on Twinrocker paper, handmade to the artist's specifications

420 x 877 mm (overall, two plates); 750 x 1053 mm (irreg. sheet)

Published by Crown Point Press, Oakland

Printed by Stephen Thomas

Edition: 35, plus 10 Artist's Proofs and 3 Trial Proofs; the FAMSF Archive has 1 Artist's Proof (AP 6)

Crown Point Press Archive, gift of Kathan Brown

1991.28.1206

The Tiffany's editorial advertisement that appeared in the *New York Times* in 1977 was written by Walter Hoving, Chairman of the Board of Tiffany & Co. On reading the newspaper, Haacke was immediately intrigued by the extraordinary statement in defense of the rich. That same year, he used it as the basis for an art object that incorporated the ad text and his own response (a wooden box, lined with satin with a copy of the ad engraved on silverplated copper). This etching from the following year also incorporates the ad text and Haacke's statement.

 Haacke, as a matter of policy, never signs his work. In the case of *Tiffany Cares*, he looked at the prints and approved each one by stamping on the reverse, with a rubber stamp in black ink (along with the printer's and publisher's information), "Designed and Approved by Hans Haacke."

64*

Robert Barry b. New York, New York 1936

Untitled 1978

Hard ground etching printed in gray on Arches Satiné paper

608 x 794 mm (plate); 663 x 853 mm (sheet)

Published by Crown Point Press, Oakland

Printed by John Slivon

Edition: 10, plus 10 Artist's Proofs; the FAMSF Archive has 1 Artist's Proof (AP 6)

Crown Point Press Archive, gift of Kathan Brown

1991.28.591

The prints Barry made at Crown Point in 1978 were his first efforts in the medium; he is a language Conceptual artist who performs sound works, and makes word projections, books, and drawings. Barry chooses his words from lists that he keeps, then arranges the words on pages dealing with the spatial dictates that each word presents. The words "CONSIDER," "ABSENT," "UNCERTAIN," "BEFORE," "ENDURE," "DISTANT," "IRRELEVANT," "HOW," "AGAINST," "LOST," "WILLING," and "DENY" were scratched by Barry through the wax ground on the plate in the traditional manner, letterforms backwards.

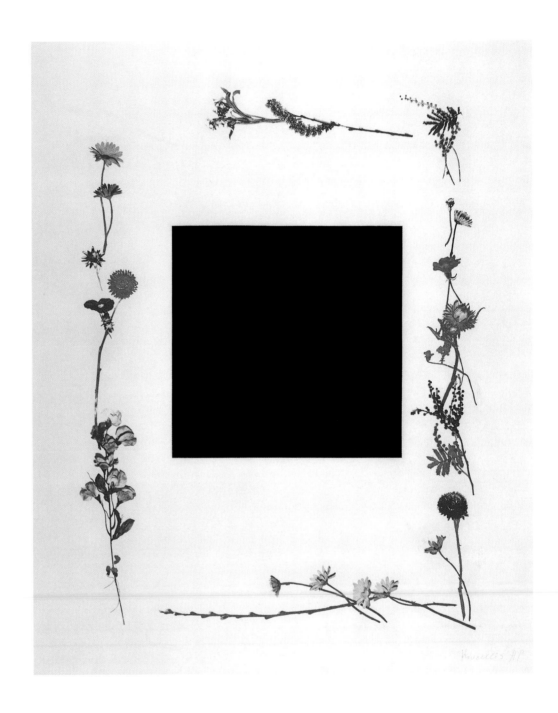

65

Jannis Kounellis b. Piraeus, Greece 1936

Untitled 1979

Photoetching and aquatint printed in black and blue
on Rives BFK paper

No visible plate mark; 1136 x 914 mm (sheet)

Published by Crown Point Press, Oakland

Printed by Stephen Thomas

Edition: 21, plus 10 Artist's Proofs and 1 OKTP;
the FAMSF Archive has 1 Artist's Proof

Crown Point Press Archive, gift of Kathan Brown

1991.28.89

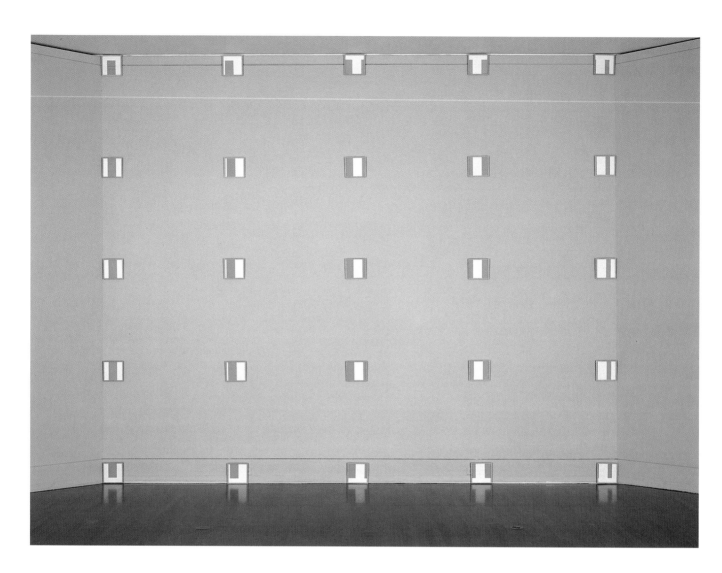

66

Daniel Buren b. Boulogne-Billancourt, France 1938

Framed/Exploded/Defaced 1979

25 framed aquatints (cut from a single aquatint) printed in Cadmium Yellow-Red on Rives BFK paper

203 x 203 mm (each framed fragment); 914 x 914 mm (plate, before cutting); 1016 x 1016 mm (sheet, before cutting)

Published by Crown Point Press, Oakland

Printed by Lilah Toland

Edition: 46 unique color variations, ranging from pure Cadmium Yellow (#1) to pure Cadmium Red (#46) each cut into 25 fragments and framed in ash wood frames; the FAMSF Archive has #7 (39 parts yellow, 16 parts red) and a set of color swatches assembled from strips that were removed from the prints (so the size of the collected framed objects would be the same as that of the original aquatint).

Crown Point Press Archive, gift of Kathan Brown

1991.28.1451 a–y

Buren conceived an artwork in which forty-six large (40 x 40 in.), unique aquatints would each "explode" into twenty-five fragments. The forty-six sets of fragments should then be installed in forty-six different locations according to his specifications. Because each installation of the twenty-five fragments is a fundamental part of the work, the artist considers the work neither completed nor authentic if it is not installed correctly. The general principle of the installation is that the 40 x 40 inch block of twenty-five framed fragments should expand to fit whatever wall has been chosen. The bottom edge of five frames must touch the floor where it meets the wall; the top edges of five frames must touch the ceiling. Buren accounts for existing windows, doors, etc., as "interference." Fragments are eliminated from the installation if it appears that they will come into contact with an "interference."

67*

Joan Jonas b. New York, New York 1936

Rainbow, pl. 1 of 5 from the portfolio
Hurricane Series 1979

Aquatint printed on Rives BFK paper

No visible plate mark; 596 x 905 mm (sheet)

Published by Crown Point Press, Oakland

Printed by Lilah Toland

Edition: 25 portfolios, plus 10 Artist's Proof portfolios, and
4 Trial Proof portfolios (including 1 OKTP); the FAMSF Archive
has 1 Artist's Proof portfolio

Crown Point Press Archive, gift of Kathan Brown

1991.28.280

Rainbow, and the four other images in the portfolio, *Sun,
Heart, Hurricane*, and *Reflection*, originated as white chalk
drawings in Jonas's 1976 performance piece, *Mirage*.

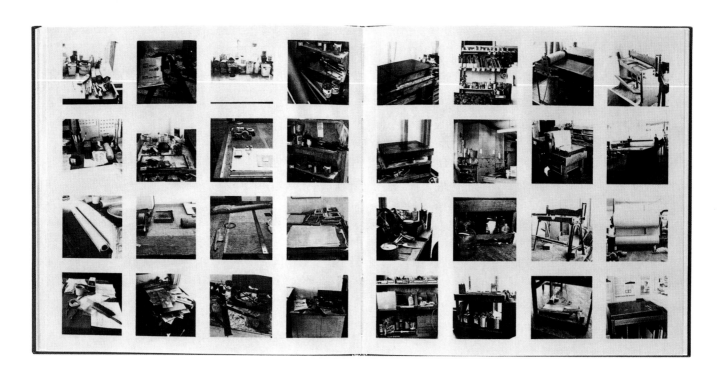

68*

Sol LeWitt b. Hartford, Connecticut 1928

CrownPoint 1980

Book of 19 photoetchings printed on Somerset Satin
heavyweight paper in 42 leaves

No visible plate mark; 280 x 560 mm (sheet, double page)

Published by Crown Point Press, Oakland

Printed by Kevin Parker

Edition: 25 books, plus 10 Artist's Proof books, 2 Trial
Proof books (one unbound), and 3 unbound sheets;
the FAMSF Archive has 1 Artist's Proof book (AP 6)

Tate E27

Crown Point Press Archive, gift of Crown Point Press

1992.167.1181.1–19

LeWitt wanted to record the way Crown Point
Press looked at the time he was in residence
there, 4–18 March 1980. Kevin Parker took
photographs of different areas throughout the
studio on instructions from LeWitt as to what
the subject matter and general composition
of the photographic images should be. LeWitt
then arranged 608 images onto nineteen
sensitized zinc plates, thirty-two images per
plate. The resulting prints were bound as page
spreads in the book.

69 [right]

Vito Acconci b. New York, New York 1940

3 Flags for 1 Space and 6 Regions 1979–1981

Color photoetching and aquatint printed on 6 sheets of
Rives BFK paper

Eighteen various plate sizes; 1786 x 1576 mm (overall, six sheets)

Published by Crown Point Press, Oakland

Printed by Nancy Anello

Edition: 25, plus 10 Artist's Proofs and 2 Trial Proofs (including
1 OKTP); the FAMSF Archive has 1 Artist's Proof (AP 9)

Crown Point Press Archive, gift of Kathan Brown

1991.28.4 a–f

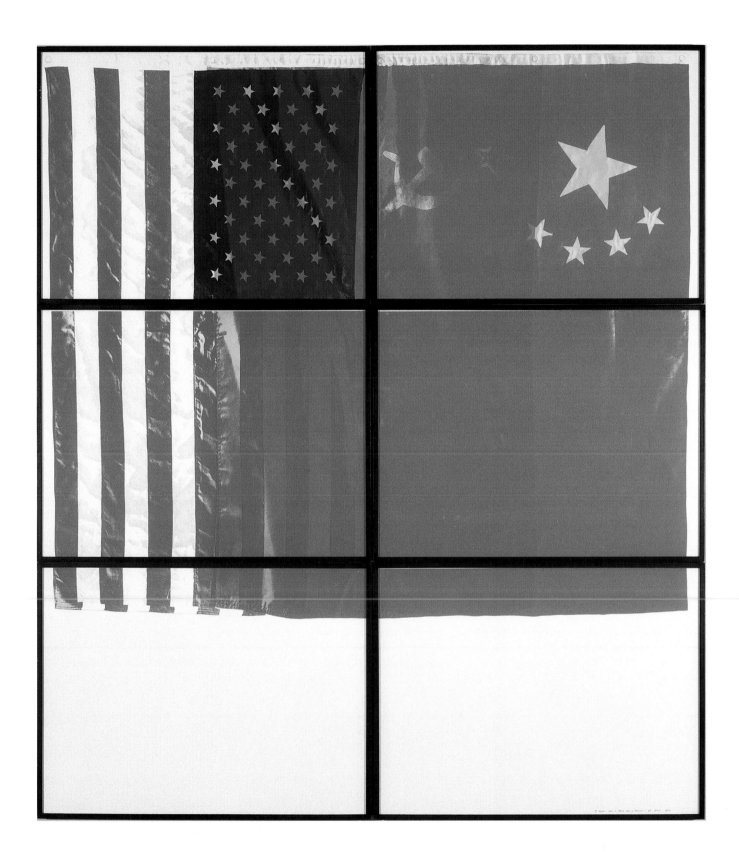

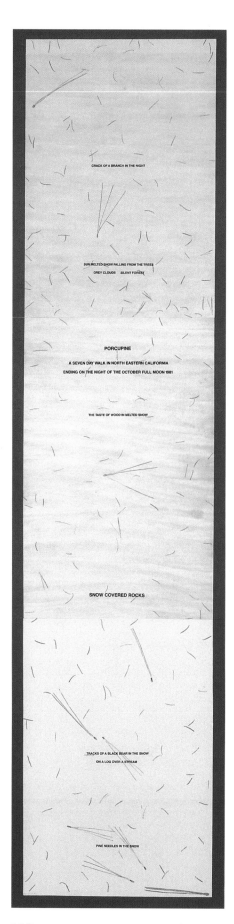

CRACK OF A BRANCH IN THE NIGHT

SUN MELTED SNOW FALLING FROM THE TREES
GREY CLOUDS SILENT FOREST

PORCUPINE

A SEVEN DAY WALK IN NORTH EASTERN CALIFORNIA

ENDING ON THE NIGHT OF THE OCTOBER FULL MOON 1981

THE TASTE OF WOOD IN MELTED SNOW

SNOW COVERED ROCKS

TRACKS OF A BLACK BEAR IN THE SNOW
ON A LOG OVER A STREAM

PINE NEEDLES IN THE SNOW

70

Hamish Fulton b. London, England 1946

Porcupine 1982

Color aquatint, photo aquatint, spit bite aquatint, and soft ground etching printed on 3 sheets of Somerset Textured White paper

No visible plate mark; 2373 x 580 mm (overall, 3 sheets)

Published by Crown Point Press, Oakland

Printed by Paul Singdahlsen

Edition: 25, plus 11 Artist's Proofs and 3 Trial Proofs (including 1 OKTP); the FAMSF Archive has 1 Artist's Proof (AP 8)

Crown Point Press Archive, gift of Crown Point Press

1992.167.999 a–c

During the week of 7–13 October 1981, Fulton took a walk in Shasta County in Northern California. The etching is a result of that walk, including the pine needles that he gathered and brought back to use in the soft ground for three of the plates in the print.

71* [right]

Ed Ruscha b. Omaha, Nebraska 1937

Metro, Petro, Neuro, Psycho 1982

Color soft ground etching printed on Somerset Satin paper

371 x 388 mm (plate); 620 x 570 mm (sheet)

Published by Crown Point Press, Oakland

Printed by Peter Pettengill

Edition: 25, plus 10 Artist's Proofs and 5 Trial Proofs (including 1 OKTP); the FAMSF Archive has 1 Artist's Proof (AP 2)

Crown Point Press Archive, gift of Crown Point Press

1991.28.1104

METRO=
NEURO=
PSYCHO=
PETRO=
POLITAN
MULTICELLULAR
CHEMICAL
LOGICAL
CENTER
TEMPER
COMPLEX
FRENZY

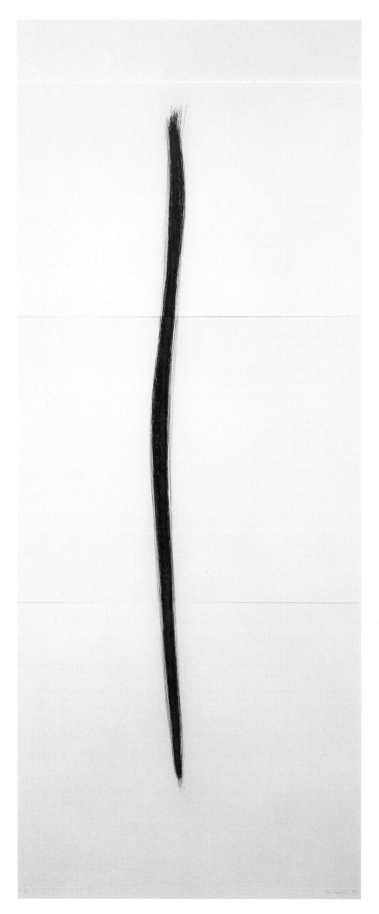

Tom Marioni b. Cincinnati, Ohio 1937

*Drawing A Line As Far
As I Can Reach* 1984

Hard ground etching and aquatint printed in
brown on 3 sheets of Somerset paper

Partial plate mark on 2 sheets, not measurable;
1916 x 761 mm (overall, 3 sheets)

Published by Crown Point Press, Oakland

Printed by Hidekatsu Takada

Edition: 5, plus 3 Artist's Proofs and 1 Trial Proof;
the FAMSF Archive has 1 Artist's Proof (AP 1)

Crown Point Press Archive, gift of Crown Point Press

1992.167.306 a–c

This print is one of several by Marioni that
consciously explored body movement and gesture.
In the studio at Crown Point Press, Marioni sat
on the floor with the plate propped on the wall in
front of him, and reached upward with a tool,
marking the plate over and over the length of
his reach.

73–77

Sherrie Levine b. Hazleton, Pennsylvania, 1947

Barcham Green Portfolio 1986

Set of 5 prints on Barcham Green Robin Cover Brown paper

No. 1 (profile of Abraham Lincoln), color aquatint, (no visible plate mark)
No. 2* (vertical stripes), color aquatint, 476 x 377 mm (plate)
No. 3* (tilted square), color aquatint, 372 x 383 mm (plate)
No. 4* (woodgrain), photogravure and color aquatint, 482 x 380 mm (plate)
No. 5* (Walker Evans photo), photogravure and aquatint, 485 x 381 mm (plate)

Sheet sizes for all are 793–797 x 582–585 mm

Published by Crown Point Press, Oakland

Printed by Hidekatsu Takada

Edition: 25 sets, plus 10 Artist's Proof sets and 4–5 Trial Proofs (including 1 OKTP) for each print; the FAMSF Archive has 1 Artist's Proof set (AP6)

Crown Point Press Archive, gift of Crown Point Press

1992.167.707–711

Sherrie Levine is an appropriation artist who uses reproduction of existing images and makes it into her own art. In the five plates in this portfolio, she has appropriated the art of the designer of the Lincoln penny, a generic Minimalist artist, the Russian artist Kasimir Malevich, a piece of plywood, and the American photographer Walker Evans.

78*

Bertrand Lavier b. Chatillon-sur-Seine, France 1949

Untitled Modern Painting #2 1987

Color aquatint and sugar lift aquatint printed on Somerset
Soft White paper

302 x 1138 mm (plate); 484 x 1265 mm (sheet)

Published by Crown Point Press, San Francisco

Printed by Mark Callen

Edition: 25, plus 10 Artist's Proofs and 6 Trial Proofs
(including 1 OKTP); the FAMSF Archive has 1 Artist's Proof
and 2 Working Proofs

Crown Point Press Archive, gift of Crown Point Press

1991.28.1316

In this print, Lavier bases his imagery on something he saw
in a comic book: a modern painting envisioned in a Disney
cartoon character's visit to a museum of modern art.

79

José Maria Sicilia b. Madrid, Spain 1954

Fleur Rouge VI 1988

Color spit bite aquatint, soap ground aquatint, and aquatint on (Japanese Gampi) chine collé, mounted on Somerset Textured White paper

1141 x 469 mm (plate); 1411 x 622 mm (sheet)

Published by Crown Point Press, San Francisco

Printed by Renée Bott

Edition: 24, plus 10 Artist's Proofs and 5 Trial Proofs, (including 1 OKTP); the FAMSF Archive has 1 Artist's Proof (AP 6)

Crown Point Press Archive, gift of Crown Point Press

1991.28.1271

80–93 [right]

Tim Rollins (b. Pittsfield, Maine, 1955) + **K. O. S.**

The Temptation of Saint Antony I–XIV 1989

Portfolio of 14 prints printed on (Rives Lightweight White) chine collé, mounted on Lana Gravure White paper

PL. I* spit bite aquatint with steel wool burnishing on Xerograph
PL. II spit bite aquatint on Xerograph
PL. III* spit bite aquatint on Xerograph
PL. IV* aquatint and Xerox toner on Xerograph
PL. V* spit bite aquatint on Xerograph
PL. VI* spit bite aquatint on Xerograph
PL. VII* aquatint and Xerox toner on Xerograph
PL. VIII aquatint and Xerox toner on Xerograph
PL. IX* spit bite aquatint with steel wool burnishing on Xerograph
PL. X* aquatint and Xerox toner on Xerograph
PL. XI spit bite aquatint with steel wool burnishing on Xerograph
PL. XII aquatint and Xerox toner on Xerograph
PL. XIII* spit bite aquatint with steel wool burnishing on Xerograph
PL. XIV* aquatint and Xerox toner on Xerograph

214 x 136 mm (each plate);
565–568 x 378–380 mm (each sheet)

Published by Crown Point Press, San Francisco

Printed by Brian Shure

Edition: 30 for each print, plus 10 Artist's Proofs and 6–9 Trial Proofs (varies for each print, including 1 OKTP); the FAMSF Archive has 1 Artist's Proof portfolio (AP 6) and 40 Working Proofs

Crown Point Press Archive, gift of Crown Point Press

1992.167.820–833

K. O. S. is an acronym for "Kids of Survival," a group of teenagers from a public junior high school in the South Bronx. For this project, the "Kids" were Richard Cruz (b. 1970), George Garces (b. 1972), Carlos Rivera (b. 1971), and Nelson Savinon (b. 1972)

94 [see page 118]

Joel Fisher b. Salem, Ohio 1947

Tree 1990

Color aquatint printed on 4 sheets of Somerset Textured White paper

68 x 68 mm (each plate); 2189 x 1649 mm (overall 4 sheets)

Published by Crown Point Press, San Francisco

Printed by Pamela Paulson

Edition: 7, plus 6 Artist's Proofs 1 Trial Proof (inscribed BAT); the FAMSF Archive has 1 Artist's Proof (AP 4), and 1 preparatory drawing

Crown Point Press Archive, gift of Crown Point Press

1991.28.1279 a–d

The concept for this print was derived from a digitized, pixelated image of Fisher's own tree sculpture. The image area is composed of 452 squares, printed from 119 individual plates, each measuring 68 x 68 mm.

95* [see page 119]

John Baldessari b. National City, California 1931

To Insert: Person and Ladder (red)/Hose/ Smoke; Flowers and Plates (Blue Hope) 1991

Color aquatint and photogravure printed on Somerset White paper

706 x 433–487 mm (irreg. plate); 938 x 637–687 mm (irreg. sheet)

Published by Crown Point Press, San Francisco

Printed by Lothar Osterburg

Edition: 25, plus 10 Artist's Proofs and 5 Trial Proofs (including 1 OKTP); the FAMSF Archive has 1 Artist's Proof (AP 6) and 1 Working Proof

Crown Point Press Archive, gift of Crown Point Press

1993.51.179

A.P.6 JH-DESSARI 91

CAT. 99
Francesco Clemente
Telemone #1, 1981

IV Figuration and Its Meaning

SINCE 1977 CROWN POINT PRESS has always had a gallery as part of its operation where visitors could view and purchase the Press's publications. The gallery installations are sometimes provocative and often illustrative of Kathan Brown's thoughts about art. In 1982, Crown Point presented the exhibition *Representing Reality: Fragments from the Image Field* with a brochure in which Brown discussed the artistic explorations of Günter Brus, Francesco Clemente, Joel Fisher, Robert Kushner, Pat Steir, and William T. Wiley, all of whom had just made prints at Crown Point and almost all of whom worked in a figurative vein at the time.

Whether or not these artists were identified with the contemporary trend of "new image" or "new figuration" painting, Brown saw their work as new art that could not be interpreted on visual or stylistic grounds alone, as had been done with figurative art in the past. These artists had dispensed with traditional notions of figure/object/background and, instead, considered the representational images in their art as fields for meaning. The meaning might be social, intellectual, emotional, or simply decorative, depending on the motivation of the artist.

Brown had worked with figurative artists since the establishment of Crown Point Press, and she spoke with some authority on the changes in the meaning of figurative work. Early on she had sponsored weekly sessions with a model in the Crown Point Press studio, which enabled interested artists to draw from life directly on the etching plate. Her first publications (*41 Etchings* by Richard Diebenkorn, *Delights* by Wayne Thiebaud, *The Nude Man* by Beth Van Hoesen, and *Beulah Land* by Fred Martin) were by artists known for their figurative work. However, Brown has not consciously allied herself with figurative artists, nor is she particularly concerned with issues surrounding abstraction and representation in the work of the artists she has invited to work at Crown Point Press. The different ways in which artists treat figuration are simply a source of interest to her and part of the process she uses to choose her artists: "I try to make sense of what artists in general are doing and what ideas in particular the artist I'm considering seems to be exploring."*

K. BREUER

*Kathan Brown in *ink, paper, metal, wood: Painters and Sculptors at Crown Point Press* (San Francisco: Chronicle Books, 1996), p. 47

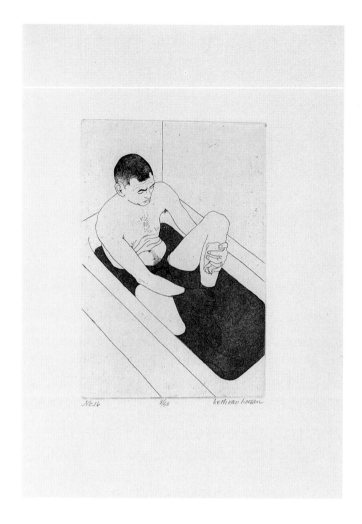

Beth Van Hoesen *Bath,* PL. 16, 1965

96*

Beth Van Hoesen b. Boise, Idaho 1926

The Nude Man 1965

Book of 25 prints printed on Japanese paper

PL. 1 *Seated,* hard ground etching, 174 x 133 mm (plate)
PL. 2 *Chest patterns,* hard ground etching and drypoint, 82 x 107 mm (plate)
PL. 3 *W. seated,* hard ground etching and drypoint, 205 x 101 mm (plate)
PL. 4 *Three plates,* hard ground etching and drypoint, l–r: 96 x 51 mm, 96 x 57 mm, 96 x 48 mm (plate)
PL. 5 *E. seated,* hard ground etching and aquatint, 150 x 132 mm (plate)
PL. 6 *P. standing,* drypoint, 125 x 67 mm (plate)
PL. 7 *Reclining,* hard ground etching, 111 x 187 mm (plate)
PL. 8 *Father and son,* drypoint, 177 x 119 mm (plate)
PL. 9 *H. Seated,* hard ground etching and aquatint, 136 x 87 mm (plate)
PL. 10 *M. profile,* hard ground etching, 232 x 81 mm (plate)
PL. 11 *Sun tan,* hard ground etching and aquatint, 115 x 75 mm (plate)
PL. 12 *Reclining II,* hard ground etching, 125 x 155 mm (plate)
PL. 13 *Two figures,* hard ground etching and aquatint, 124 x 132 mm (plate)
PL. 14 *Model,* hard ground etching, 250 x 153 mm (plate)
PL. 15 *J. seated,* drypoint, 117 x 105 mm (plate)

PL. 16 *Bath,* hard ground etching and aquatint, 214 x 143 mm (plate)
PL. 17 *Chest patterns II,* hard ground etching and drypoint, 152 x 128 mm (plate)
PL. 18 *Back,* engraving, 220 x 101 mm (plate)
PL. 19 *Arms over knees,* hard ground etching with roulette, 114 x 68 mm (plate)
PL. 20 *W. standing,* drypoint, 182 x 128 mm (plate)
PL. 21 *M. standing,* hard ground etching, 255 x 81 mm (plate)
PL. 22 *Chest patterns III,* hard ground etching and aquatint, 114 x 97 mm (plate)
PL. 23 *Tattoo,* hard ground etching and drypoint printed in black and blue, 150 x 177 mm (plate)
PL. 24 *Foreshortened,* hard ground etching, 58 x 58 mm (plate)
PL. 25 *W. profile,* hard ground etching and drypoint, 179 x 98 mm (plate)

Page size for each is 382 x 282 mm

Published by Crown Point Press, Berkeley

Printed by Kathan Brown

Edition: 50 (25 bound and 25 boxed portfolio sets); the FAMSF Archive has 1 from the bound edition (8/50)

Crown Point Press Archive, Museum purchase, gift of Mr. and Mrs. George M. Marcus

1991.28.404–428

97*

Fred Martin b. San Francisco, California 1927

Beulah Land 1966

Book of 15 etchings (11 plates, a vignette for the cover,
and illustrations for the title page, dedication page, and
contents page)

PL. 1 *East of the Sun and West of the Moon,* hard ground
etching with watercolor, 448 x 302 mm (overall, two plates)

PL. 2 *Old Lumber,* hard ground etching, 448 x 301 mm (overall,
two plates)

PL. 3 *Wreathed Gate,* hard ground etching with watercolor,
455 x 301 mm (plate)

PL. 4 *Pomegranates,* hard ground etching with watercolor,
457 x 300 mm (plate)

PL. 5 *Historical Relics,* hard ground etching,
456 x 298 mm (plate)

PL. 6 *From Western Workshops,* hard ground etching with
watercolor, 446 x 300 mm (overall, two plates)

PL. 7 *Waving Grain,* hard ground etching, 445 x 300 mm
(overall, two plates)

PL. 8 *Stone Barn,* hard ground etching with watercolor,
445 x 300 mm (overall, two plates)

PL. 9 *Homestead,* hard ground etching with watercolor,
445 x 300 mm (overall, two plates)

PL. 10 *Source,* hard ground hard ground etching with watercolor,
452 x 298 mm (plate)

PL. 11 *Entrance,* hard ground etching, 452 x 300 mm (plate)

Page size for each is 485 x 328 mm

Printed by Kathan Brown

Published by Crown Point Press, Berkeley

Edition: 25 books; the FAMSF Archive has 1 bound book from
the edition (9/25), 15 Artist's Proofs from an unbound set of the
book, 2 Working Proofs for the title page, and 3 Working Proofs
for rejected (unpublished) illustrations

Crown Point Press Archive, Museum purchase, gift of
Mr. and Mrs. Douglas W. Grigg

1991.28.934.1–15

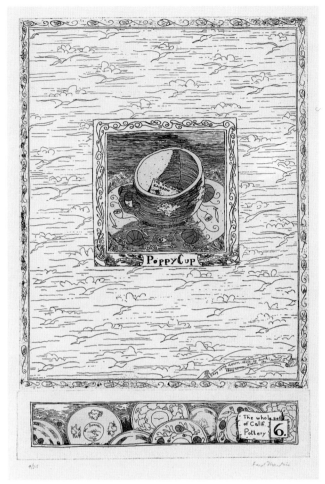

Fred Martin *From Western Workshops,* PL. 6, 1966

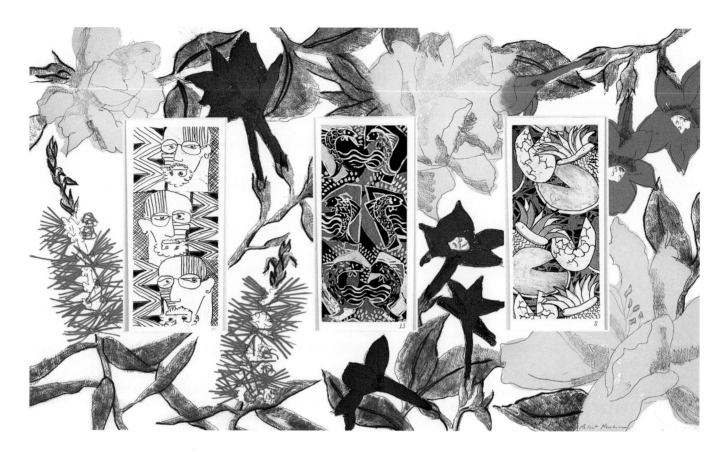

98

Robert Kushner b. Pasadena, California 1949

Henri, Jumping Fish, and Victoria Regina,
from the portfolio of 20 prints *Joy of Ornament* 1980

Henri, pl. 18, aquatint and hard ground etching,
 231 x 100 mm (plate)

Jumping Fish, pl. 13, aquatint, 229 x 101 mm (plate)

Victoria Regina, pl. 8, hard ground etching and aquatint,
 225 x 102 mm (plate)

Sheet sizes for all are 292 x 152 mm, Arches Satiné
Heavyweight paper

The three prints are mounted in the *Flowered Mat for the Joy of
Ornament,* 1982, color aquatint, drypoint, and soft ground etching.

No visible plate mark; 472 x 780 (sheet/mat)

Published by Crown Point Press, Oakland

Portfolio printed by Stephen Thomas; *Flowered Mat* printed
by Peter Pettengill

Edition for the prints: 35 portfolios, plus 10 Artist's Proof
portfolios, 3 Trial Proof portfolios, and 24 individual prints;
the FAMSF Archive has 1 Artist's Proof portfolio (AP 3)

Edition for the mat : 40 were printed and signed in 1982, but
not in a limited edition and with the possibility of more being
printed in the future. The artist stipulates that the number of
mats to be printed should be determined by the number of
Joy of Ornament prints requiring them; FAMSF Archive has
one from the edition (#37)

Crown Point Press Archive, gift of Crown Point Press

1992.167.801 (*Henri*); 1992.167.796 (*Jumping Fish*);
1992.167.791 (*Victoria Regina*); 1992.167.623 (mat)

Kushner, who is interested in decoration in art, intended
this portfolio to look like a pattern book. There are
references to patterns used throughout history, and in
this selection, a reference to Victorian era patterns
and Henri Matisse's use of pattern in his art. Kushner
conceived that the twenty prints in the portfolio could
variously be inserted into the windows of the *Flowered
Mat,* creating endless designs and patterns.

99 [see page 120]

Francesco Clemente b. Naples, Italy 1952

Telemone #1 1981

Hard ground etching, aquatint, drypoint, and soft ground etching on (Don Farnsworth handmade) chine collé mounted on Arches 88 paper

1545 x 487 mm (overall); 1595 x 612 mm (sheet)

Published by Crown Point Press, Oakland

Printed by Hidekatsu Takada

Edition: 25, plus 10 Artist's Proofs and 4 Trial Proofs (including 1 OKTP); the FAMSF has 1 Artist's Proof (AP 2)

Crown Point Press Archive, gift of Crown Point Press

1991.28.1410

100

Francesco Clemente

Telemone #2 1981

Hard ground etching, aquatint, drypoint, and soft ground etching printed in black and silver on (Don Farnsworth handmade) chine collé mounted on Arches 88 paper

1589 x 485 mm (overall); 1595 x 613 mm (sheet)

Published by Crown Point Press, Oakland

Printed by Hidekatsu Takada

Edition: 25, plus 10 Artist's Proofs, and 6 Trial Proofs (including 1 OKTP); the FAMSF has 1 Artist's Proof (AP 1)

Crown Point Press Archive, gift of Crown Point Press

1991.28.1411

In both *Telemone #1* and *#2* the central image of the top section, the "Japanese Garden," was drawn directly on the plate when the artist was in Japan. The rest of the print was made at Crown Point Press in Oakland.

The *Telemone* are male caryatids who support symbols of ongoing life. They expose their hidden sensual organs — the spinal cord and the heart.

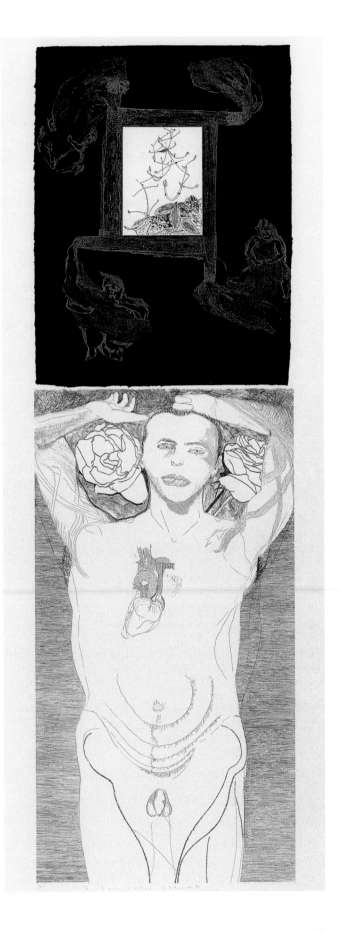

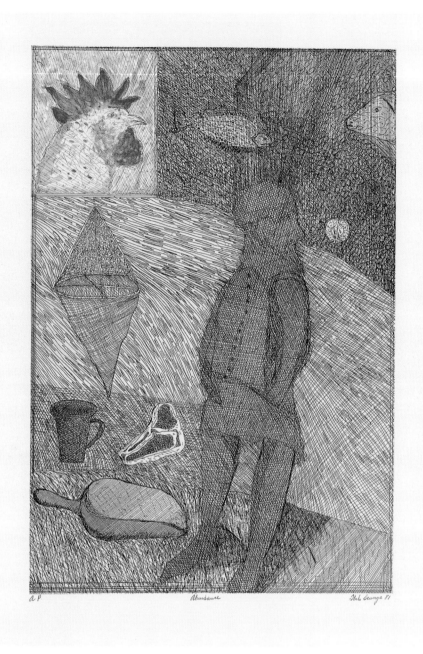

101

Italo Scanga b. Lago, Calabria, Italy 1932

Abundance 1981

Hard ground etching and spit bite aquatint printed
in black and red on Arches Cover Buff paper

908 x 609 mm (plate); 1068 x 757 mm (sheet)

Published by Crown Point Press, Oakland

Printed by Nancy Anello

Edition: 25, plus 10 Artist's Proofs, and 3 Trial Proofs (including
1 OKTP); the FAMSF Archive has 1 Artist's Proof (AP 1)

Crown Point Press Archive, gift of Crown Point Press

1991.28.1149

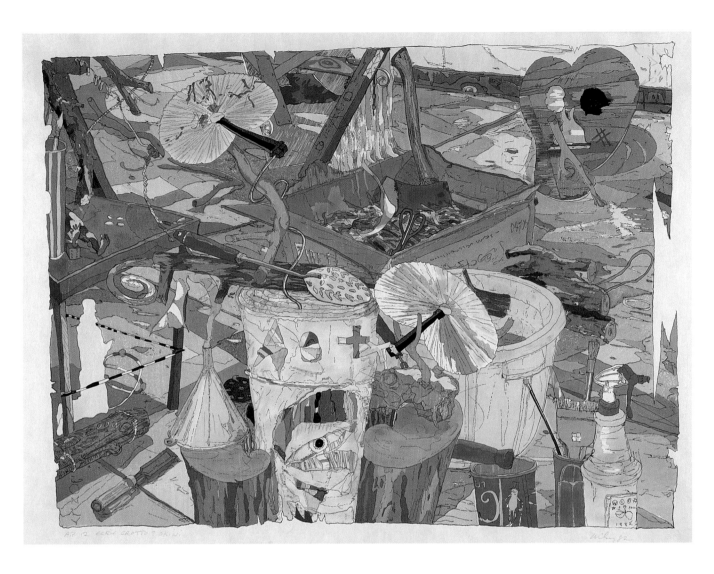

102

William T. Wiley b. Bedford, Indiana 1937

Eeerie Grotto? Okini 1982

Color woodcut printed on Echizen Hosho paper

530 x 690 mm (image); 578 x 748 mm (sheet)

Published by Crown Point Press, Oakland

Printed by Tadashi Toda at the Shiundo Print Shop, Kyoto, Japan

Edition: 200, plus 20 Artist's Proofs and 8 Trial Proofs (including 1 OKTP); the FAMSF Archive has 1 Artist's Proof (AP 12)

Crown Point Press Archive, gift of Crown Point Press

1992.167.529

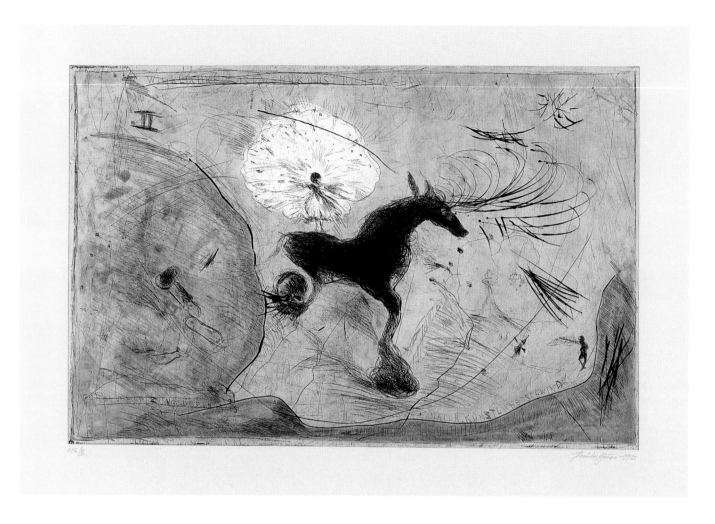

103*

Günter Brus b. Ardning, Austria 1938

Grosse Erdangst III 1982

Spit bite aquatint, hard ground etching, and drypoint on Somerset Satin White paper

607 x 913 mm (plate); 784 x 1118 mm (sheet)

Published by Crown Point Press, Oakland

Printed by Lilah Toland

Edition: 15, plus 10 Artist's Proofs and 4 Trial Proofs (including 1 OKTP); the FAMSF Archive has 1 Artist's Proof (AP 6) and 1 Working Proof

Crown Point Press Archive, gift of Crown Point Press

1992.167.201

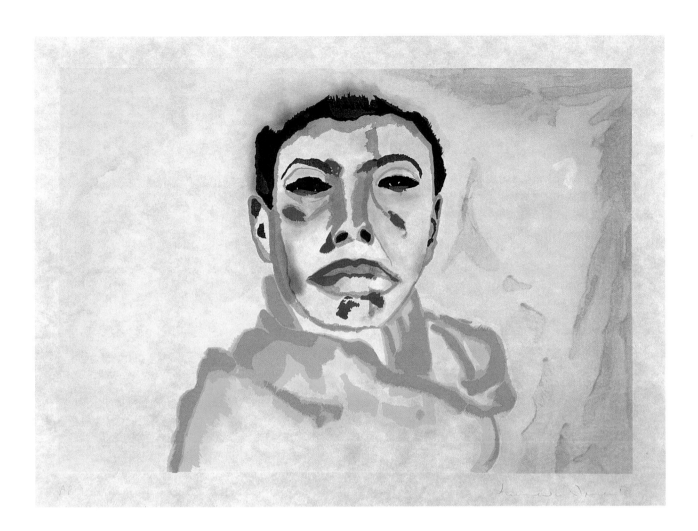

104

Francesco Clemente b. Naples, Italy 1952

I 1982

Color woodcut on Kozo paper

360 x 511 mm (image); 428 x 572 mm (sheet)

Published by Crown Point Press, Oakland

Printed by Tadashi Toda at the Shiundo Print Shop, Kyoto, Japan

Edition: 100, plus 10 Artist's Proofs and 6 Trial Proofs;
the FAMSF Archive has 1 Artist's Proof (AP 9)

Crown Point Press Archive, gift of Crown Point Press

1992.167.87

105

Wayne Thiebaud b. Mesa, Arizona 1920

Dark Cake 1983

Color woodcut on handmade Tosa Kozo paper

383 x 446 mm (image); 519 x 569 mm (sheet)

Published by Crown Point Press, Oakland

Printed by Tadashi Toda at the Shiundo Print Shop, Kyoto, Japan

Edition: 200, plus 20 Artist's Proofs and 6 Trial Proofs (including
1 OKTP); the FAMSF Archive has 1 Artist's Proof (AP 16)

Crown Point Press Archive, gift of Crown Point Press

1992.167.269

106*

Elaine de Kooning

b. New York, New York 1920 – d. New York, New York 1989

Torchlight Cave Drawing II, from the portfolio of 8
Torchlight Cave Drawings 1985

Aquatint printed on Richard de Bas paper

303 x 376 mm (plate); 519 x 666 mm (sheet)

Published by Crown Point Press, Oakland

Printed by Peter Pettengill

Edition: 25 portfolios, plus 10 Artist's Proof portfolios,
and 11 Trial Proof sets (including 1 set of OKTPs);
the FAMSF Archive has 1 Artist's Proof portfolio (AP 6)

Crown Point Press Archive, gift of Crown Point Press

1992.167.1110

107

Alex Katz b. New York, New York 1927

The Green Cap 1985

Color woodcut printed on handmade Tosa Kozo paper

310 x 455 mm (image); 455 x 613 mm (sheet)

Published by Crown Point Press, Oakland

Printed by Tadashi Toda at the Shiundo Print Shop, Kyoto, Japan

Edition: 200, plus 20 Artist's Proofs and 6 Trial Proofs (including 1 OKTP); the FAMSF Archive has 1 Artist's Proof (AP 14) and 9 Working Proofs

Crown Point Press Archive, gift of Crown Point Press

1992.167.691

The following four working proofs have been selected from the nine proofs in the Archive to demonstrate Katz's involvement in the creation of *The Green Cap*.

108*

Working Proof 2 for *The Green Cap* 1985

Color woodcut with graphite inscriptions by the artist and printer

310 x 455 mm (image); 450 x 613 (sheet)

Crown Point Press Archive, gift of Crown Point Press

1992.167.689

For each of the Crown Point Press woodcut projects in Japan, a drawing by the artist was sent to Tadashi Toda in Kyoto. Toda, working with a professional block carver, painstakingly translated the drawing into a color woodcut proof and awaited the arrival of the artist, who made changes and adjustments. This proof is probably one of the first presented to Katz, whose pencil notations "lighter" and "softer" indicate that color adjustments are in order, and areas of color transition must be made less noticeable.

109*

Working Proof 5 for *The Green Cap* 1985

Color woodcut with graphite additions by the artist

309 x 455 mm (image); 452 x 615 mm (sheet)

Crown Point Press Archive, gift of Crown Point Press

1992.167.686

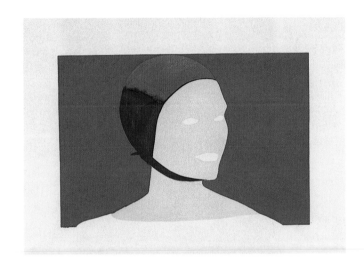

It is common practice in the proofing stages of printmaking to isolate parts of the composition to allow the artist to focus more easily on specific areas. In this case the green bathing cap was the focus. Toda reprinted the colors, but Katz indicated that he wanted the dark green area of the cap to blend more smoothly with the light green area.

110*

Working Proof 6 for *The Green Cap* 1985

Color woodcut

310 x 381 mm (irreg. image); 450 x 614 mm (sheet)

Crown Point Press Archive, gift of Crown Point Press

1992.167.685

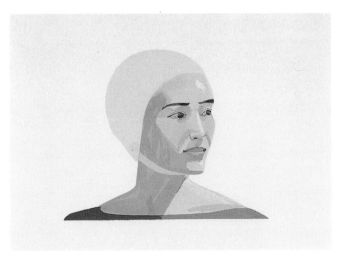

The focus in this proof was on the face, neck, and shoulders. Toda made one major change from *Working Proof 2* by emphasizing the white highlight areas on the forehead, nose, and shoulder. Otherwise, none of the suggestions from *Working Proof 2* were implemented.

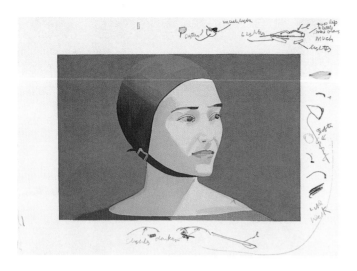

111*

Working Proof 9 for *The Green Cap* 1985

Color woodcut with graphite inscriptions by the artist and added collage element

310 x 456 mm (image); 450 x 616 mm (sheet)

Crown Point Press Archive, gift of Crown Point Press

1992.167.682

Changes between *Working Proof 6* and *9* have been significant as seen in areas on the swimmer's face where brushstroke-like areas were eliminated in favor of broader patches of color. Katz's focus was on the lips. He cut out a pair of lips from another proof, pasted them in the margin, and made a small drawing with notations to demonstrate exactly what he wanted.

112 [see page 57]

Chuck Close b. Monroe, Washington 1940

Leslie 1986

Color woodcut printed on Echizen Kozo Nimai-Zuki paper

628 x 546 mm (image); 807 x 643 mm (sheet)

Published by Crown Point Press, Oakland

Printed by Tadashi Toda at the Shiundo Print Shop, Kyoto, Japan

Edition: 150, plus 20 Artist's Proofs, and 11 Trial Proofs (including 1 OKTP); the FAMSF Archive has 1 Artist's Proof (AP 11) and 4 Working Proofs

Crown Point Press Archive, gift of Crown Point Press

1992.167.998

This was the artist's first color print.

113 [right]

Wayne Thiebaud b. Mesa, Arizona 1920

Eight Lipsticks 1988

Color drypoint printed on Somerset Satin paper

176 x 150 mm (plate); 356 x 304 mm (sheet)

Published by Crown Point Press, San Francisco

Printed by Lawrence Hamlin

Edition: 60, plus 10 Artist's Proofs, and 7 Trial Proofs (including 1 OKTP); the FAMSF Archive has 1 Artist's Proof and 6 Working Proofs

Crown Point Press Archive, gift of Crown Point Press

1992.167.218

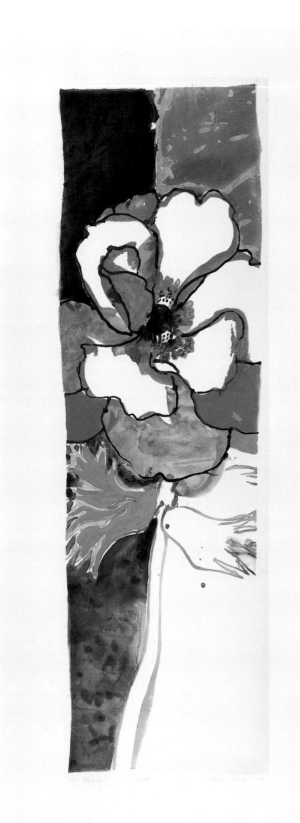

114

Robert Kushner b. Pasadena, California 1949

Red Anemone 1989

Color woodcut on silk mounted on Somerset Textured White paper

869 x 271 mm (silk); 1054 x 426 mm (sheet)

Published by Crown Point Press, San Francisco

Printed by Zhuo Guang Ling at the Duo Yun Xuan Studio, Shanghai, People's Republic of China

Edition: 75, including 10 Artist's Proofs and 15 Trial Proofs (including 1 OKTP); the FAMSF Archive has 1 Artist's Proof (AP 6)

Crown Point Press Archive, gift of Crown Point Press

1992.167.635

115 [right]

William T. Wiley b. Bedford, Indiana 1937

Now Who's Got the Blueprints 1989

Color hard ground etching and soft ground etching with scraping and burnishing on Somerset paper

1136 x 906 mm (plate); 1330 x 1037 mm (sheet)

Published by Crown Point Press, San Francisco

Printed by Lawrence Hamlin

Edition: 25, plus 10 Artist's Proofs and 9 Trial Proofs; the FAMSF Archive has 1 Artist's Proof (AP 6) and 8 Working Proofs

Crown Point Press Archive, gift of Crown Point Press

1992.167.1065

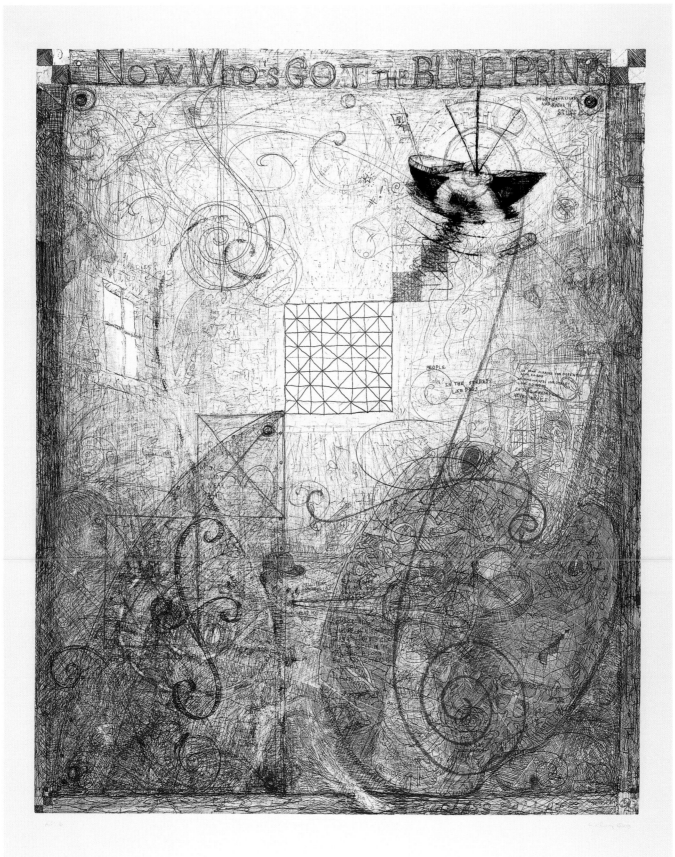

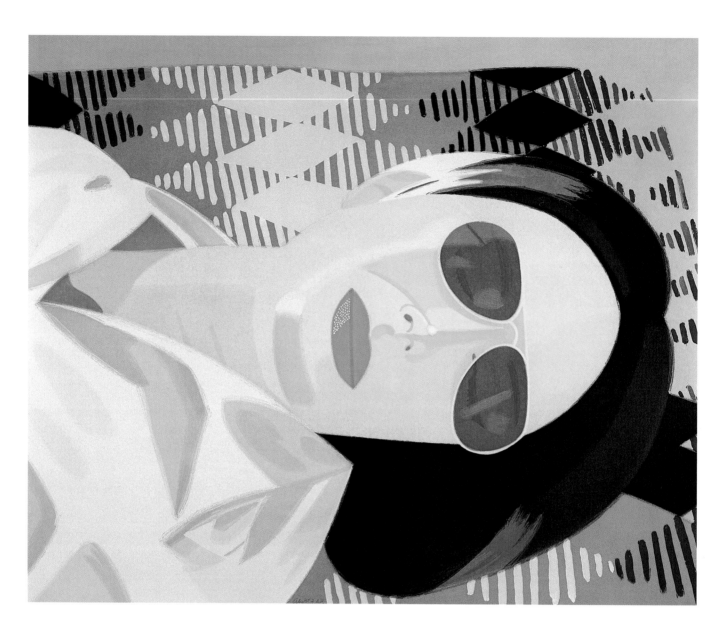

116

Alex Katz b. New York, New York, 1927

Reclining Figure 1987

Color aquatint on Somerset Satin paper

No visible plate mark; 900 x 1057 mm (sheet)

Published by Crown Point Press, San Francisco

Printed by Doris Simmelink

Edition: 60, plus 12 Artist's Proofs and 9 Trial Proofs (including 1 OKTP); the FAMSF Archive has 1 Artist's Proof (AP 7)

Crown Point Press Archive, gift of Crown Point Press

1992.167.1180

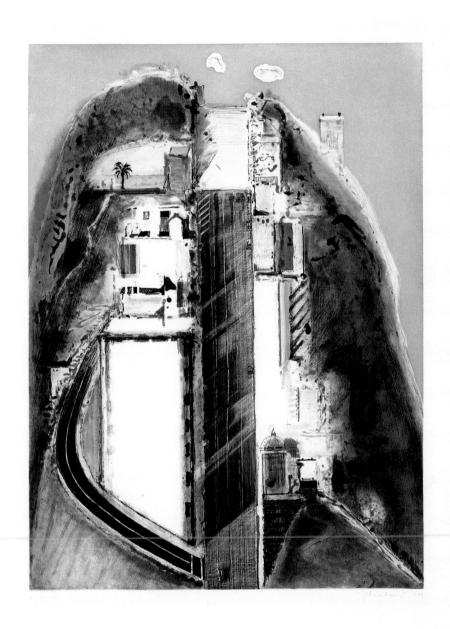

117

Wayne Thiebaud b. Mesa, Arizona 1920

Steep Street 1989

Color hard ground etching, drypoint, aquatint, and spit bite aquatint with scraping and burnishing on Somerset Textured paper

760 x 551 mm (plate); 990 x 776 mm (sheet)

Published by Crown Point Press, San Francisco

Printed by Lawrence Hamlin

Edition: 50, plus 10 Artist's Proofs and 7 Trial Proofs (including 1 OKTP); the FAMSF Archive has 1 Artist's Proof and 28 Working Proofs

Crown Point Press Archive, gift of Crown Point Press

1991.28.6

Five working proofs have been selected from among the twenty-eight in the FAMSF Archive to demonstrate Thiebaud's creative process in printmaking.

118*

Working Proof 2 for *Steep Street*

Spit bite aquatint

755 x 552 mm (plate); 864 x 658 mm (sheet)

Crown Point Press Archive, gift of Crown Point Press

1991.28.6.2

In many print projects at Crown Point, a plate is printed in black first, even though it will be printed in another color in the final editioning. This is done so that the artist can clearly see certain densely composed areas and details. The plate used to make this proof was entirely composed in spit bite aquatint and eventually was printed in yellow.

119*

Working Proof 19 for *Steep Street*

Color spit bite aquatint and aquatint

756 x 551 mm (plate); 862 x 657 mm (sheet)

Crown Point Press Archive, gift of Crown Point Press

1991.28.6.19

There are four plates (an aquatint plate and three spit bite aquatint plates) involved in this proof which was an early color experiment. It is an excellent demonstration that a print evolves plate by plate in color and in image complexity. Notable are solid aquatint areas that Thiebaud altered later with scraping and burnishing techniques.

120*

Working Proof 24 for *Steep Street*

Color spit bite aquatint, aquatint and drypoint
with scraping and burnishing

756 x 550 (plate); 890 x 662 mm (sheet)

Crown Point Press Archive, gift of Crown Point Press

1991.28.6.24

This proof involved five plates. Thiebaud began to
scrape certain areas, especially the four-lane street.
New drypoint was added on several plates creating
several building outlines and a domed building. The
aquatint plate of the sky was printed in blue, a color
that remained unchanged in successive proofs until
it was printed darker blue, then finally pink.

121*

Working Proof 14 for *Steep Street*

Spit bite aquatint, aquatint, and drypoint
with scraping and burnishing

754 x 549 mm (plate); 860 x 653 mm (sheet)

Crown Point Press Archive, gift of Crown Point Press

1991.28.6.14

This is a proof of the final version of the plate that was
printed in black in the edition. The "black plate," as
it was called, was perhaps the most complicated of all
the plates. In this proof, new drypoint details (notably,
the palm tree) were added. The addition of spit bite
aquatint to the domed building demonstrates how
Thiebaud continually honed the image.

122*

Working Proof 27 for *Steep Street*

Color spit bite aquatint, aquatint, and drypoint
with scraping and burnishing

756 x 550 mm (plate); 904 x 664 mm (sheet)

Crown Point Press Archive, gift of Crown Point Press

1991.28.6.27

This is the first working proof from Thiebaud's third
and final work session to complete the print. It shows
a dramatic change from the light blue sky to a very
dark blue, almost nocturnal sky. Thiebaud eventually
reverted to a lighter sky in the final edition print.

123 [right]

Robert Bechtle b. San Francisco, California 1932

Albany Monte Carlo 1990

Color woodcut on silk mounted on Xuan Zhi paper,
mounted on a larger sheet of Arches Cover paper

255 x 372 mm (silk); 662 x 658 mm (paper sheet)

Published by Crown Point Press, San Francisco

Printed by Zhi Jin Gu with Zhu Di Wang, and carved by
Tang Hong at the Tao Hua Wu studio, Suzhou, People's
Republic of China

Edition: 50, plus 10 Artist's Proofs and 4 Trial Proofs
(including 1 OKTP); the FAMSF Archive has
1 Artist's Proof (AP 6) and 3 Working Proofs

Crown Point Press Archive, gift of Crown Point Press

1995.75.3

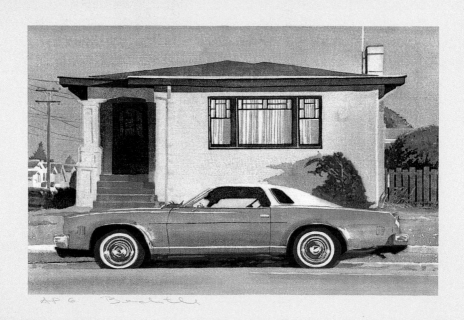

AP 6. Bechtle

124

Pat Steir

b. Newark, New Jersey 1940

Long Vertical Falls #1, from the series *Long Vertical Falls*

1991

Spit bite aquatint and soap ground aquatint printed on Somerset Textured Soft White paper

1138 x 580 mm (plate); 1354 x 774 mm (sheet)

Published by Crown Point Press, San Francisco

Printed by Brian Shure

Edition: 20, plus 10 Artist's Proofs and 6 Trial Proofs (including 1 OKTP); the FAMSF Archive has 1 Artist's Proof (AP 6) and 5 Working Proofs (test prints)

Crown Point Press Archive, gift of Crown Point Press

1992.167.1062

There are four prints in the series *Long Vertical Falls.*

125

Pat Steir

b. Newark, New Jersey 1940

Long Vertical Falls #3, from the series *Long Vertical Falls*

1991

Spit bite aquatint and soap ground aquatint printed on Somerset Textured Soft White paper

1140 x 580 mm (plate); 1350 x 776 mm (sheet)

Published by Crown Point Press, San Francisco

Printed by Brian Shure

Edition: 20, plus 10 Artist's Proofs and 6 Trial Proofs (including 1 OKTP); the FAMSF Archive has 1 Artist's Proof (AP 6) and 5 Working Proofs (test prints)

Crown Point Press Archive, gift of Crown Point Press

1992.167.1060

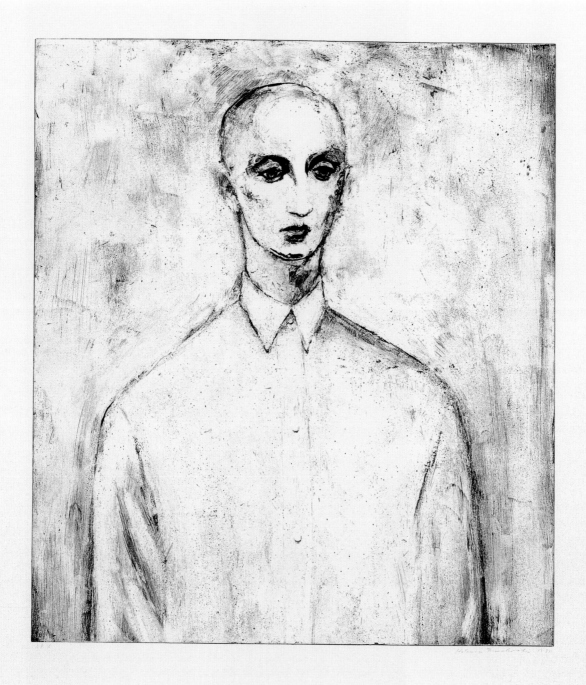

CAT. 128
Katsura Funakoshi *Dream of the Bird,* 1990

V Crown Point Press in the 1990s

THE LOMA PRIETA EARTHQUAKE of 1989 severely damaged Crown Point's San Francisco studio and gallery. Within a year Brown had purchased a building nearby: a 40,000 square-foot space that she renovated extensively to feature an architecturally designed gallery and three studios. In October of 1990 Crown Point Press opened the new building with a gala celebration and the announcement that a new era had begun for the Press. However, it was not to be a continuation of the exuberance of the 1980s that had allowed Crown Point and other fine art publishers to expand and thrive. The economic difficulties of the 1990s that affected the print market in the form of a "crash" soon caused Brown to scale back Crown Point's operations and rethink its ambitious program. Crown Point's woodcut program in Japan closed in 1991 because the cost of working in Japan had skyrocketed, and the program in China, beset by problems of continuity caused by that country's internal problems, was closed in 1994.

Despite these setbacks and undeterred by the weak marketplace, Brown continued her practice of seeking out new artists to work at the Press. Per Kirkeby and Nathan Oliveira, both accomplished printmakers, came to work at Crown Point for the first time. William Bailey, who hadn't made prints at Crown Point since his 1974 project with Parasol Press, revisited the Press in 1994 and 1996. Christopher Brown, a young Bay Area painter, made his first visit to the Press in 1990 and returned regularly to make elaborate color aquatints.

A new direction for the Press presented itself in 1991 after a fortuitous project with the French artist Christian Boltanski. The twenty-four photogravures created for Boltanski's portfolio *Gymnasium Chases* led to the establishment of a photogravure program that has become an important one for Crown Point. Photogravure, a nineteenth-century process in which an engraved image is photographically put onto a plate, uses nontoxic chemicals, making it safer than photo-etching which Crown Point had utilized in the past. Markus Raetz and John Baldessari used the technique in their innovative prints published by the Press in 1991. They convinced Brown that photogravure could provide a new area for artistic exploration at Crown Point. In 1995 she published a portfolio of six photogravures by four artists, Christopher Brown, Tom Marioni, Gay Outlaw, and Ed Ruscha. Publishing a portfolio of different artists was a first for Crown Point, and a first for Brown who had chosen the artists as a match for the technique.

Brown's philosophy for Crown Point's future remains optimistic and she often invokes the Zen-like wisdom of John Cage when asked about her plans: "As you keep going, which you will do, the way to proceed will become apparent."*

K. BREUER

*John Cage's advice to Brown in 1989 as quoted in *ink, paper, metal, wood*, pp. 261-263

126*

Gary Stephan b. Brooklyn, New York 1942

1990 IIII 1990

Color aquatint and spit bite aquatint on
Somerset Textured Soft White paper

1036 x 756 mm (paper); 1377 x 1044 (sheet)

Published by Crown Point Press, San Francisco

Printed by Daria Sywulak

Edition: 25, plus 10 Artist's Proofs and 6 Trial Proofs
(including 1 OKTP); the FAMSF Archive has
1 Artist's Proof (AP 6) and 1 Working Proof

Crown Point Press Archive, gift of Crown Point Press

1991.28.1266

127*

William Brice b. New York, New York 1921

Untitled #12 1990

Color aquatint, spit bite aquatint, and soap ground aquatint on Somerset Satin paper

289 x 272 mm (plate); 517 x 483 mm (sheet)

Published by Crown Point Press, San Francisco

Printed by Pamela Paulson

Edition: 15, plus 10 Artist's Proofs and 5 Trial Proofs (including 1 OKTP); the FAMSF Archive has 1 Artist's Proof (AP 6)

Acton 53

Crown Point Press Archive, gift of Crown Point Press

1992.167.180

128 [see page 146]

Katsura Funakoshi b. Morioka City, Iwate, Japan, 1951

Dream of the Bird 1990

Soap ground aquatint and drypoint on Somerset Textured White paper

922 x 804 mm (plate); 1368 x 1030 mm (sheet)

Published by Crown Point Press, San Francisco

Printed by Daria Sywulak

Edition: 30, plus 10 Artist's Proofs and 5 Trial Proofs (including 1 OKTP); the FAMSF Archive has 1 Artist's Proof (AP 6) and 3 Working Proofs

Crown Point Press Archive, gift of Crown Point Press

1991.28.1397

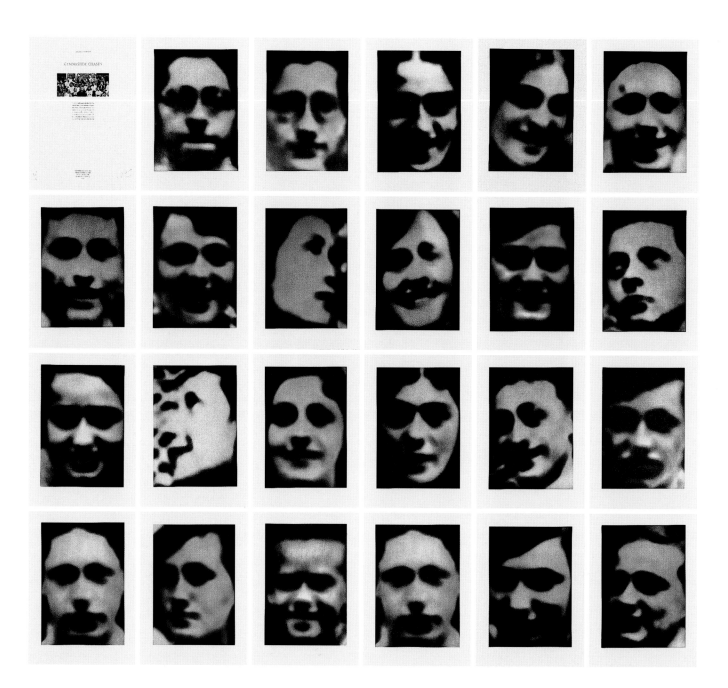

129–152

Christian Boltanski b. Paris, France 1944

Gymnasium Chases 1991

Portfolio of 24 photogravures on Somerset Satin White paper

Title page image: 87 x 198 mm (plate); 594 x 420 mm (sheet)

Each plate: 462 x 316 mm (plate); 594 x 420 (sheet)

Published by Crown Point Press, San Francisco

Printed by Daria Sywulak

Edition: 15 portfolios, plus 10 Artist's Proof portfolios and 5 Trial Proof portfolios (including 1 OKTP); the FAMSF Archive has 1 Artist's Proof portfolio (AP 6)

Crown Point Press Archive, gift of Crown Point Press

1992.167.1135–1158

The statement in French by Boltanski on the title page reveals something more about the subject of this portfolio: "They are assembled for the last time. It is the end of the year, they are students at the Gymnasium Chases, a Jewish high school in Vienna, the year is 1931. What became of them after all these years, what kind of lives have they had? One among them is identified in this photograph, he escaped the horror and lives today in New York, of the others I know nothing."

153 [see page 61]

Sol LeWitt b. Hartford, Connecticut 1928

Color and Black #3 (24 x 24) 1991

Color spit bite aquatint on Somerset Textured White paper

305 x 304 mm (plate); 622 x 609 mm (sheet)

Published by Crown Point Press, San Francisco

Printed by Lawrence Hamlin

Edition: 25, plus 10 Artist's Proofs and 5 Trial Proofs (including 1 OKTP); the FAMSF Archive has 1 Artist's Proof (AP 6)

Crown Point Press Archive, gift of Crown Point Press

1993.51.196

154

Markus Raetz b. Büren an der Aare, Switzerland 1941

Schatten (Shadows) 1991

Color aquatint and photogram-gravure printed in blue and black on Somerset Textured White paper

1386 x 312 mm (overall plates); 1770 x 673 mm (sheet)

Published by Crown Point Press, San Francisco

Printed by Lothar Osterburg

Edition: 35, plus 10 Artist's Proofs and 5 Trial Proofs (including 1 OKTP); the FAMSF Archive has 1 Artist's Proof (AP 6) and 7 Working Proofs

Mason/Willi-Cosandier 266

Crown Point Press Archive, gift of Crown Point Press

1993.51.324

To make this print, Raetz twisted a single length of wire into a form. The printers prepared six small plates for photogravure, and then Raetz placed the form against each plate in turn so a different shadow image was made. The shadow images were exposed to the sun from the studio skylight, then etched in photogravure using aquatint grounds. Two additional plates were printed as backgrounds in pale turquoise blue.

155

Shoichi Ida b. Kyoto, Japan, 1941

No. 5, from the series *Falling Landscape –
Between Air and Water* 1992

Color soft ground etching, spit bite aquatint, and drypoint on
(Gampi) chine collé mounted on Somerset Textured White paper

497 x 417 mm (overall plates); 801 x 681 mm (sheet)

Published by Crown Point Press, San Francisco

Printed by Paul Mullowney

Edition: 10, plus 10 Artist's Proofs and 7 Trial Proofs, including
1 OKTP; the FAMSF Archive has 1 Artist's Proof (AP 6)

Crown Point Press Archive, gift of Crown Point Press

1993.51.213

The *Falling Landscape* series contains a total of twelve
images numbered sequentially. Some of the plates used
in this print were also used in *Falling Landscape – Between
Air and Water No.'s 9, 10, 11,* and *12.*

156

Judy Pfaff b. London, England 1946

Del fumio è polvera, from the series
Half a Dozen of the Other 1992

Color sugar lift aquatint, spit bite aquatint, aquatint, hard
ground etching, and drypoint with scraping and burnishing,
and relief printing (for the ellipses) on Hosho paper

914 x 1135 mm (plate); 1088 x 1288 mm (sheet)

Published by Crown Point Press, San Francisco

Printed by Lawrence Hamlin

Edition: 20, plus 10 Artist's Proofs and 6 Trial Proofs
(including 1 OKTP); the FAMSF Archive has
1 Artist's Proof (AP 6)

Crown Point Press Archive, gift of Crown Point Press

1993.51.272

The title, translated from the old Italian, means "of
smoke and dust" and it came from Pfaff's interest in
Leonardo da Vinci's writings and drawings. For the
relief printing in this print, coated stock paper was
rolled with ink and used as a plate for printing.

157

Per Kirkeby b. Copenhagen, Denmark 1938

Plate 6 of 18 from the portfolio *Inventory* 1993

Drypoint and hard ground etching with scraping
on Somerset Textured White paper

129 x 179 mm (plate); 265 x 330 mm (sheet)

Published by Crown Point Press, San Francisco

Printed by Renée Bott

Edition: 25 portfolios, plus 10 Artist's Proof portfolios and
5 Trial Proof portfolios (including 1 OKTP); the FAMSF Archive
has 1 Artist's Proof portfolio (AP 6)

Crown Point Press Archive, gift of Kathan Brown

1995.131.14.6

158

Per Kirkeby

Plate 9 of 18 from the portfolio *Inventory* 1993

Drypoint, hard ground etching, and sugarlift aquatint with
scraping on Somerset Textured White paper

152 x 228 mm (plate); 265 x 331 mm (sheet)

Published by Crown Point Press, San Francisco

Printed by Renée Bott

Edition: 25 portfolios, plus 10 Artist's Proof portfolios and
5 Trial Proof portfolios, (including 1 OKTP); the FAMSF Archive
has 1 Artist's Proof portfolio (AP 6)

Crown Point Press Archive, gift of Kathan Brown

1995.131.14.9

159

Per Kirkeby

Plate 15 of 18 from the portfolio *Inventory* 1993

Drypoint, aquatint, and crayon-resist flat bite etching on Somerset Textured White paper

152 x 226 mm (plate); 263 x 328 mm (sheet)

Published by Crown Point Press, San Francisco

Printed by Renée Bott

Edition: 25 portfolios, plus 10 Artist's Proof portfolios and 5 Trial Proof portfolios, (including 1 OKTP); the FAMSF Archive has 1 Artist's Proof portfolio (AP 6)

Crown Point Press Archive, gift of Kathan Brown

1995.131.14.15

160

Per Kirkeby

Plate 17 of 18 from the portfolio *Inventory* 1993

Aquatint, crayon-resist flat bite etching, and drypoint on Somerset Textured White paper

152 x 229 mm (plate); 266 x 330 mm (sheet)

Published by Crown Point Press, San Francisco

Printed by Renée Bott

Edition: 25 portfolios, plus 10 Artist's Proof portfolios and 5 Trial Proof portfolios, (including 1 OKTP); the FAMSF Archive has 1 Artist's Proof portfolio (AP 6)

Crown Point Press Archive, gift of Kathan Brown

1995.131.14.17

161

Richard Tuttle b. Rahway, New Jersey, 1941

Plate 2 of 7 from the portfolio *Galisteo Paintings* 1993

Color woodcut with acrylic paint border on Xuan Zhi paper

262 x 363 mm (image); 306 x 406 mm (sheet)

Published by Crown Point Press, San Francisco

Printed by Gui Lin Yee at the Duo Yun Xuan Studio, Shanghai

Edition: 30 portfolios, plus 10 Artist's Proof portfolios and
7 Trial Proof portfolios (including 1 OKTP); the FAMSF Archive
has 1 Artist's Proof portfolio (AP 6)

Crown Point Press Archive, gift of Kathan Brown

1995.131.32.2

The woodcuts in the *Galisteo* portfolio were based on a
series of watercolor paintings done by Tuttle in Galisteo,
New Mexico. Tuttle suggests that, although these are
prints, they remain paintings in a sense because of the
delicate way in which the Chinese printer hand-painted
each block before printing.

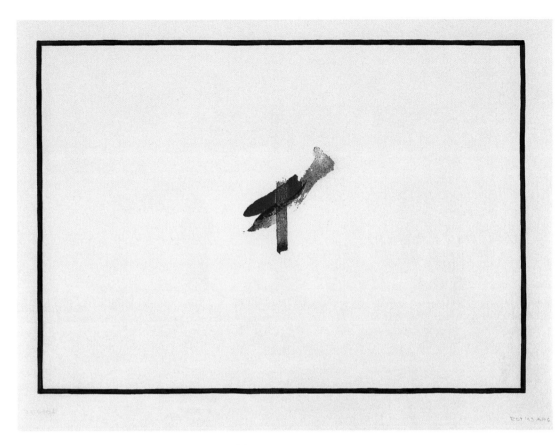

162

Richard Tuttle

Plate 3 of 7 from the portfolio *Galisteo Paintings* 1993

Color woodcut with acrylic paint border on Xuan Zhi paper

262 x 363 mm (image); 306 x 406 mm (sheet)

Published by Crown Point Press, San Francisco

Printed by Gui Lin Yee at the Duo Yun Xuan Studio, Shanghai

Edition: 30 portfolios, plus 10 Artist's Proof portfolios and
7 Trial Proof portfolios (including 1 OKTP); the FAMSF Archive
has 1 Artist's Proof portfolio (AP 6)

Crown Point Press Archive, gift of Kathan Brown

1995.131.32.3

163

Christopher Brown b. Camp Lejeune, North Carolina 1951

Station 1993

Color soft ground etching and spit bite aquatint on Somerset Textured Soft White paper

503 x 505 mm (plate); 778 x 760 mm (sheet)

Published by Crown Point Press, San Francisco

Printed by Pamela Paulson

Edition: 65, plus 10 Artist's Proofs and 10 Trial Proofs (including 1 OKTP); the FAMSF Archive has 1 Artist's Proof (AP 6)

Crown Point Press Archive, gift of Kathan Brown

1995.131.5

164 [right]

Nathan Oliveira b. Oakland, California 1928

Dog Man 1994

Color soap ground aquatint, spit bite aquatint, aquatint, and drypoint with scraping and burnishing on Somerset Soft White paper

761 x 607 mm (plate); 1022 x 839 mm (sheet)

Published by Crown Point Press, San Francisco

Printed by Daria Sywulak

Edition: 35, plus 10 Artist's Proofs and 5 Trial Proofs (including 1 OKTP); the FAMSF Archive has 1 Artist's Proof (AP 6)

Crown Point Press Archive, gift of Crown Point Press

1995.75.110

165*

Janis Provisor b. Brooklyn, New York 1946

Jumu 1994

Four color woodcuts on silk mounted together on
Xuan Zhi paper, and mounted on a larger sheet of
Somerset Textured Soft White paper

316 x 313 mm (overall); 521 x 521 mm (sheet)

Published by Crown Point Press, San Francisco

Printed by Qin Yun Hu at the Crown Point Press Workshop,
Hangzhou, People's Republic of China

Edition: 50, plus 10 Artist's Proofs and 5 Trial Proofs, (including
1 OKTP); the FAMSF Archive has 1 Artist's Proof (AP 6)

Crown Point Press Archive, gift of Crown Point Press

1995.75.116

Jumu and *Zitan* are two Chinese names for wood.

166*

Janis Provisor

Zitan 1994

Four color woodcuts on silk mounted together on
Xuan Zhi paper, and mounted on a larger sheet of
Somerset Textured Soft White paper

315 x 315 mm (overall); 523 x 523 mm (sheet)

Published by Crown Point Press, San Francisco

Printed by Qin Yun Hu at the Crown Point Press Workshop,
Hangzhou, People's Republic of China

Edition: 50, plus 10 Artist's Proofs and 5 Trial Proofs (including
1 OKTP); the FAMSF Archive has 1 Artist's Proof (AP 6)

Crown Point Press Archive, gift of Crown Point Press

1995.75.117

AP6 James M. Nelson '95

AP 6

Clyfe Brown 1995

168*

Christopher Brown b. Camp Lejeune, North Carolina 1951

Between the Eyes, from the portfolio
Gravure Group 1995

Photogravure, color aquatint, and soft ground etching
on Somerset paper

231 x 349 mm (plate); 408 x 510 mm (sheet)

Published by Crown Point Press, San Francisco

Printed by Daria Sywulak

Edition: 45, of which 25 are in portfolio, plus 10 Artist's Proofs
and 12 Trial Proofs (including 1 OKTP); the FAMSF Archive has
1 Artist's Proof portfolio (AP 6)

Crown Point Press Archive, gift of Crown Point Press

1996.55.2.1

167 [left]

Joan Nelson b. Torrance, California 1958

Untitled (#1) 1995

Color aquatint, hard ground etching, soft ground etching,
and drypoint on Somerset Textured White paper

302 x 303 mm (plate); 535 x 510 mm (sheet)

Published by Crown Point Press, San Francisco

Printed by Renée Bott

Edition: 60, plus 10 Artist's Proofs and 6 Trial Proofs (including
1 OKTP); the FAMSF Archive has 1 Artist's Proof (AP 6)

Crown Point Press Archive, gift of Crown Point Press

1995.75.108

AP 6 Marioni 95

169*

Tom Marioni b. Cincinnati, Ohio 1937

The Hand of the Artist, from the portfolio
Gravure Group 1995

Photogravure printed in ochre, color aquatint, and fingerprints
applied by the artist on Somerset paper

268 x 172 mm (plate); 510 x 408 mm (sheet)

Published by Crown Point Press, San Francisco

Printed by Daria Sywulak

Edition: 45, of which 25 are in portfolio, plus 10 Artist's Proofs
and 12 Trial Proofs (including 1 OKTP); the FAMSF Archive has
1 Artist's Proof portfolio (AP 6)

Crown Point Press Archive, gift of Crown Point Press

1996.55.2.2

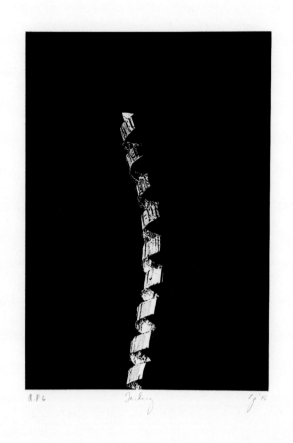

170*

Gay Outlaw b. Mobile, Alabama 1959

Tailing, from the portfolio *Gravure Group* 1995

Photogravure on Somerset paper

352 x 242 mm (plate); 510 x 408 mm (sheet)

Published by Crown Point Press, San Francisco

Printed by Daria Sywulak

Edition: 45, of which 25 are in portfolio, plus 10 Artist's Proofs and 12 Trial Proofs (including 1 OKTP); the FAMSF Archive has 1 Artist's Proof portfolio (AP 6)

Crown Point Press Archive, gift of Crown Point Press

1996.55.2.4

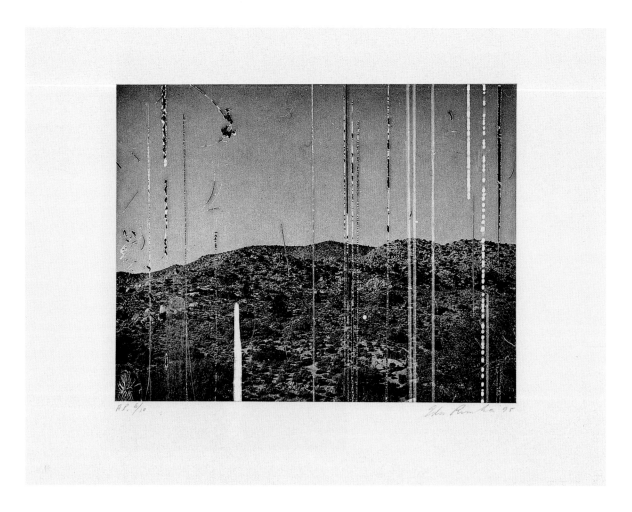

171*

Ed Ruscha b. Omaha, Nebraska 1937

Section 22, from the portfolio

Gravure Group 1995

Photogravure on Somerset paper

276 x 347 mm (plate); 408 x 510 mm (sheet)

Published by Crown Point Press, San Francisco

Printed by Daria Sywulak

Edition: 45, of which 25 are in portfolio, plus 10 Artist's Proofs
and 12 Trial Proofs (including 1 OKTP); the FAMSF Archive has
1 Artist's Proof portfolio (AP 6)

Crown Point Press Archive, gift of Crown Point Press

1996.55.2.6

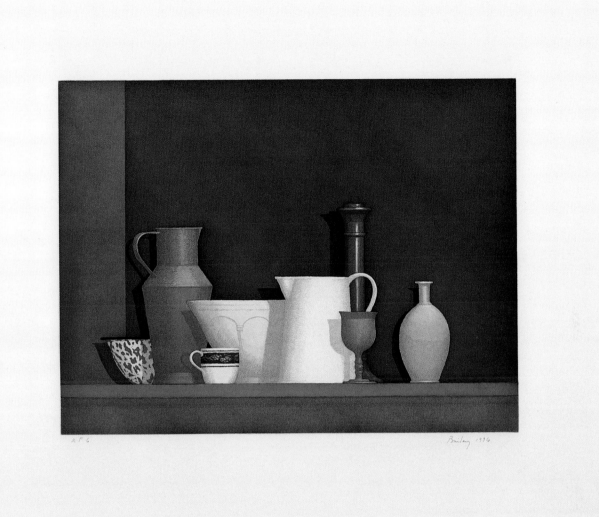

172

William Bailey b. Council Bluffs, Iowa

Umbria Verde 1996

Color aquatint and hard ground etching with scraping and
burnishing on Somerset Satin White paper

355 x 455 mm (image); 615 x 687 mm (sheet)

Published by Crown Point Press, San Francisco

Printed by Daria Sywulak

Edition: 50, plus 10 Artist's Proofs and 5 Trial Proofs, including
1 OKTP; the FAMSF Archive has 1 Artist's Proof (AP 6)

Crown Point Press Archive, gift of Crown Point Press

1996.55.1

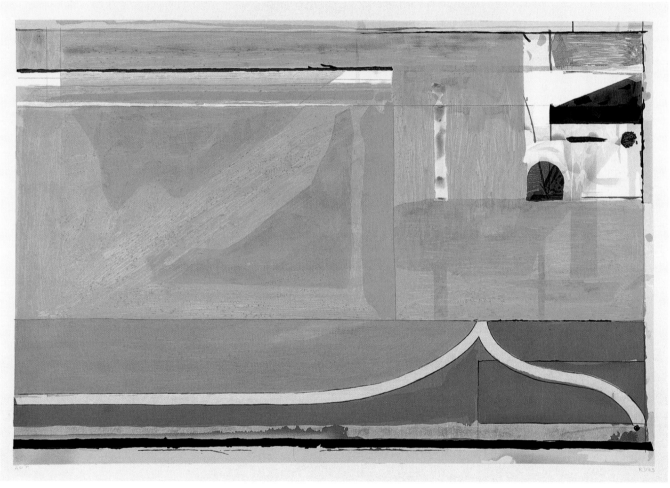

CAT. 181
Richard Diebenkorn *Ochre,* 1983

VI Tribute to Richard Diebenkorn and John Cage

NO TWO ARTISTS appear to be more different in terms of background, motivation, method, and style than Richard Diebenkorn and John Cage. Diebenkorn was a painter, based in the West, known both for his achievements in the Bay Area Figurative style and his later abstract work. He was also known for an impressive body of printmaking, spanning the years 1961 to 1992. John Cage, although he traveled extensively, lived primarily in New York City. Cage was best known for his avant-garde musical compositions that defied conventional rules of harmony and were composed using what he called "chance operations." He also created visual work beginning with graphic scores, then added printmaking, drawing, and watercolor. His influence on composers and artists was far-reaching.

What Diebenkorn and Cage had in common, were personal and professional relationships with Kathan Brown that helped shape the direction of Crown Point Press. Their deaths in 1992 (Cage) and 1993 (Diebenkorn) were a great personal loss to her.

Diebenkorn's words to Brown in 1963, "What I want is to be doing something, not making something"* have become a maxim for her in the emphasis on *doing* (art processes) over *making* (the mechanical aspects or manufacturing). Diebenkorn worked at Crown Point in the mid-1960s and almost every year after 1977 producing 106 editions. His first prints were made with a simple drypoint tool, but over many years Brown successfully convinced him to try more complex printmaking. The early etchings and drypoints were reflective of his figurative painting, and later work possessed a framework similar to his *Ocean Park* paintings. The *Clubs and Spades* series of the early 1980s featured experimental forms, which appeared in his painting only rarely or in fragmented ways. They were created in lush and complex color, a hallmark of his prints from the 1980s and 1990s. The subtle beauty of Diebenkorn's color aquatints appears effortless, but it was the product of days of changing, correcting, and redoing—which was the only way he worked.

Cage's Zen-based attitude that art and life are ever-changing led him to perceive printmaking as a viable new field of activity that could influence his music. He began making etchings, his first, at Crown Point in January of 1978. He continued to work at the press for two weeks almost every year until his death.

Cage's penchant for using chance operations created visually varied work that nevertheless is identifiable as his own. He always relied on methodically organized systems of provoking chance (such as are offered by the *I Ching*) to dictate the details of each print project. That, and the fact that he often incorporated unorthodox methods (for example, fire, smoke, brands, the bottoms of hot teapots) in his prints, secured his place as an inventive contributor to the history of printmaking. He left behind a significant body of visual art, including 274 editioned etchings and six monotype series, as an addition to his life's activities.

K. BREUER

*Richard Diebenkorn quoted in *ink, paper, metal, wood*, p. 21

173

Richard Diebenkorn

b. Portland, Oregon 1922—d. Berkeley, California 1993

41 Etchings Drypoints

Assembled and published in 1965

Portfolio of 41 prints on Rives BFK paper

PL. 1 1964, drypoint, 146 x 243 mm (plate)
PL. 2 1964, hard ground etching, 206 x 246 mm (plate)
PL. 3 1965, soft ground etching, 247 x 179 mm (plate)
PL. 4 1965, soft ground etching, 199 x 313 mm (plate)
PL. 5 1965, aquatint and hard ground etching,
 240 x 172 mm (plate)
PL. 6 1964, drypoint, 194 x 138 mm (plate)
PL. 7 1965, soft ground etching, 207 x 198 mm (plate)
PL. 8 1965, aquatint and soft ground etching,
 149 x 210 mm (plate)
PL. 9 1964, hard ground etching, 162 x 175 mm (plate)
PL. 10 1965, drypoint, 279 x 170 mm (plate)
PL. 11 1965, aquatint and hard ground etching,
 239 x 200 mm (plate)
PL. 12 1965, drypoint, 284 x 228 mm (plate)
PL. 13 1965, drypoint, 301 x 186 mm (plate)
PL. 14 1965, hard ground etching and drypoint,
 301 x 226 mm (plate)
PL. 15 1965, hard ground etching, 301 x 235 mm (plate)
PL. 16 1964, hard ground etching, 338 x 248 mm (plate)
PL. 17 1964, aquatint, drypoint, and hard ground etching,
 321 x 224 mm (plate)
PL. 18 1965, drypoint, 201 x 241 mm (plate)
PL. 19 1963, drypoint, 198 x 170 mm (plate)
PL. 20 1965, hard ground etching, 119 x 119 mm (plate)
PL. 21 1965, soft ground etching, 214 x 147 mm (plate)
PL. 22 1965, hard ground etching, 202 x 157 mm (plate)
PL. 23 1965, hard ground etching, 211 x 170 mm (plate)
PL. 24 1965, soft ground etching, 327 x 249 mm (plate)
PL. 25 1965, hard ground etching, 222 x 182 mm (plate)
PL. 26 1964, aquatint, drypoint, and hard ground etching,
 277 x 212 mm (plate)
PL. 27 1964, drypoint, 187 x 303 mm (plate)

PL. 28 1964, drypoint, 330 x 181 mm (plate)
PL. 29 1965, drypoint and hard ground etching
 with scraping, 236 x 179 mm (plate)
PL. 30 1965, soft ground etching and drypoint,
 176 x 148 mm (plate)
PL. 31 1965, aquatint and hard ground etching,
 259 x 202 mm (plate)
PL. 32 1965, hard ground etching, 198 x 289 mm (plate)
PL. 33 1965, aquatint, hard ground etching, and drypoint,
 301 x 247 mm (plate)
PL. 34 1964, hard ground etching, 176 x 159 mm (plate)
PL. 35 1964, drypoint, 213 x 277 mm (plate)
PL. 36 1964, hard ground etching, 214 x 293 mm (plate)
PL. 37 1965, drypoint and hard ground etching,
 277 x 250 mm (plate)
PL. 38 1965, hard ground etching, 212 x 198 mm (plate)
PL. 39 1963, drypoint, 330 x 248 mm (plate)
PL. 40 1965, drypoint, 125 x 106 mm (plate)
PL. 41 1963, drypoint and hard ground etching,
 195 x 158 mm (plate)

Page size is 457 x 374 mm for each

Published by Crown Point Press, Berkeley

Printed by Kathan Brown

Edition: 25, (13 bound and 12 in portfolio) plus 10 Artist's Proofs (4 bound, 2 in portfolio, 4 loose); the FAMSF Archive has 1 Artist's Proof bound book (AP 6), 1 Artist's Proof (AP 6) for plate 18 (unbound), 2 Working Proofs for plate 18, 2 State proofs for another version of plate 18, 2 State Proofs for another version of plate 33, and a drawing after plate 38

Guillemin p. 116 – 121

Crown Point Press Archive, Museum purchase, Earthquake Fund

1991.28.332–372

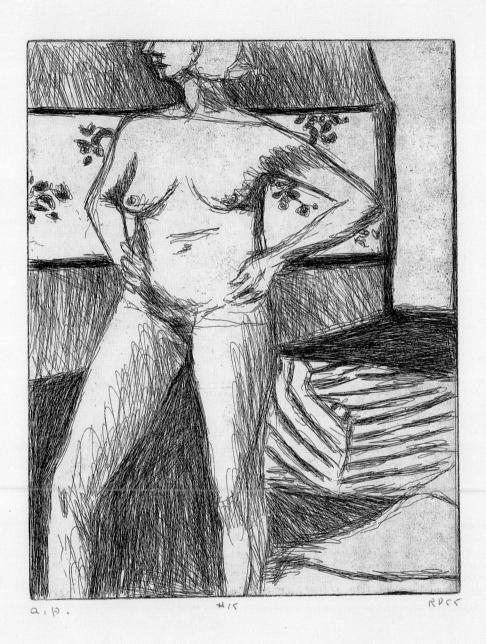

Richard Diebenkorn *41 Etchings Drypoints,* PL. 15, 1965

174

Richard Diebenkorn

#3, from the portfolio *Nine Drypoints and Etchings* 1977

Drypoint and hard ground etching with scraping and burnishing on German Etching paper

607 x 456 mm (plate); 764 x 569 mm (sheet)

Published by Crown Point Press, Oakland

Printed by John Slivon

Edition: 25 portfolios, plus 10 Artist's Proof portfolios, 2 Trial Proof portfolios, and 1 individual Trial Proof; the FAMSF Archive has 1 portfolio from the edition (13/25)

Guillemin, p. 114

Crown Point Press Archive, gift of Kathan Brown

1991.28.287

175

Richard Diebenkorn

#4, from the portfolio *Nine Drypoints and Etchings* 1977

Drypoint and hard ground etching with scraping and burnishing on German Etching paper

457 x 300 mm (plate); 761 x 567 mm (sheet)

Published by Crown Point Press, Oakland

Printed by John Slivon

Edition: 25 portfolios, plus 10 Artist's Proof portfolios, 4 Trial Proof portfolios, and 3 individual Trial Proofs; the FAMSF Archive has 1 portfolio from the edition (13/25)

Guillemin, p. 114

Crown Point Press Archive, gift of Kathan Brown

1991.28.288

176*

Richard Diebenkorn

#5, from the portfolio *Nine Drypoints and Etchings* 1977

Drypoint and hard ground etching with scraping and burnishing on German Etching paper

179 x 275 mm (plate); 751 x 567 mm (sheet)

Published by Crown Point Press, Oakland

Printed by John Slivon

Edition: 25 portfolios, plus 10 Artist's Proof portfolios, 5 Trial Proof portfolios, and 4 individual Trial Proofs; the FAMSF Archive has 1 portfolio from the edition (13/25)

Guillemin, p. 114

Crown Point Press Archive, gift of Kathan Brown

1991.28.289

177*

Richard Diebenkorn

#6, from the portfolio *Nine Drypoints and Etchings* 1977

Hard ground etching with scraping and burnishing on German Etching paper

201 x 278 mm (plate); 757 x 569 mm (sheet)

Published by Crown Point Press, Oakland

Printed by John Slivon

Edition: 25 portfolios, plus 10 Artist's Proof portfolios, 2 Trial Proof portfolios, and 1 individual Trial Proof; the FAMSF Archive has 1 portfolio from the edition (13/25)

Guillemin, p. 114

Crown Point Press Archive, gift of Kathan Brown

1991.28.290

178

Richard Diebenkorn

Large Light Blue 1980

Color spit bite aquatint and soft ground etching
on Rives Heavyweight paper

609 x 360 mm (plate); 1018 x 670 mm (sheet)

Published by Crown Point Press, Oakland

Printed by Lilah Toland

Edition: 35, plus 10 Artist's Proofs and 9 Trial Proofs (designated
A – I), plus 1 OKTP; the FAMSF Archive has 1 Artist's Proof (AP 7)

Guillemin, p. 111

Crown Point Press Archive, gift of Crown Point Press

1991.28.656

This is one in a series of eight color etchings, the first
that Diebenkorn made in color. The title is descriptive
and was assigned by the publisher with the artist's
approval. *Large Light Blue* contains a "ghost" image from
another etching in this series, *Large Bright Blue*. After the
bright blue print had been pulled, the "key" plate was
inked again only in the area around the small violet
rectangle. When this plate was printed, the ink that
remained in the plate from the *Large Bright Blue* printing
was transferred to the paper along with the fresh ink. To
complete the print, additional plates were inked and
printed in ochre, green, and red. These resemble plates
used for *Large Bright Blue* but are not the same. The
impressions of *Large Light Blue* vary slightly from one
another because the exact shape of the dark area around
the violet rectangle is not defined in the plate.

179* [see page 42]

Richard Diebenkorn

Spreading Spade 1981

Color aquatint, spit bite aquatint, and drypoint
on Arches Satiné paper

457 x 484 mm (plate); 925 x 783 mm (sheet)

Published by Crown Point Press, Oakland

Printed by Nancy Anello

Edition: 35, plus 11 Artist's Proofs and 9 Trial Proofs
(4 designated A – D, 4 undesignated, and 1 OKTP); the FAMSF
Archive has one from the edition (7/35) and 4 Working Proofs

Crown Point Press Archive, gift of Crown Point Press

1991.28.672

180 [see page 38]

Richard Diebenkorn

Clubs Blue Ground 1982

Color hard ground etching, spit bite aquatint, and drypoint
on Rives Heavyweight White paper

508 x 480 mm (plate); 839 x 673 mm (sheet)

Published by Crown Point Press, Oakland

Printed by Lilah Toland

Edition: 35, plus 11 Artist's Proofs and 9 Trial Proofs
(designated A – H, and 1 OKTP); the FAMSF Archive has
2 Working Proofs and 1 drawing

Crown Point Press Archive, gift of Crown Point Press

1991.28.77

181 [see page 168]

Richard Diebenkorn

Ochre 1983

Color woodcut on Mitsumata paper

636 x 697 mm (image); 910 x 973 mm (sheet)

Published by Crown Point Press, Oakland

Printed by Tadashi Toda at the Shiundo Print Shop, Kyoto, Japan

Edition: 200, plus 20 Artist's Proofs and 14 Trial Proofs (designated A – M, including 1 OKTP)

Crown Point Press Archive, gift of Crown Point Press

1991.28.675

In her documentation of this print Kathan Brown relates that on this, Diebenkorn's first woodcut project with Crown Point in Japan, he likened himself to an orchestra conductor. He was at the Shiundo Print Shop to guide and adjust, choose, and change, using the skills of the woodcarver Reizo Monjyu and the printer Tadashi Toda to adapt their centuries-old technique to his ends.

182 [above]

Richard Diebenkorn

Flotsam 1991

Aquatint and drypoint with scraping and burnishing on Rives Heavyweight Buff paper

608 x 457 mm (plate); 864 x 677 mm (sheet)

Published by Crown Point Press, San Francisco

Printed by Renée Bott

Edition: 85, plus 10 Artist's Proofs and 9 Trial Proofs (including 1 OKTP); the FAMSF Archive has 1 Artist's Proof (AP 6)

Crown Point Press Archive, gift of Crown Point Press

1993.51.205

Scattered around the plate, almost as if they were collage elements, are many of the shapes and figures Diebenkorn used in his work over thirty years—scissors, arrows, and spades, among others.

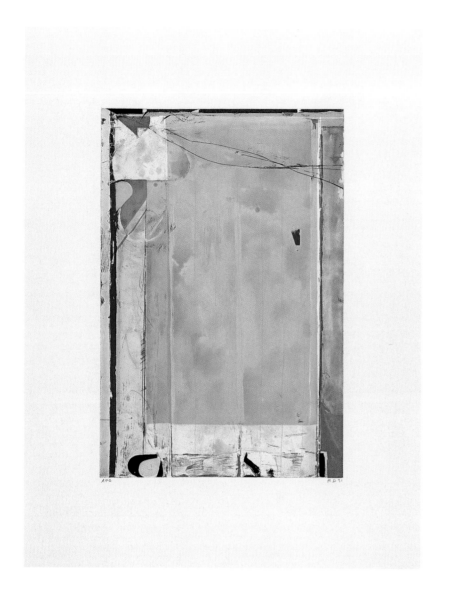

183

Richard Diebenkorn

Touched Red 1991

Color soft ground etching, aquatint, spit bite aquatint, and drypoint, with scraping and burnishing on Rives Heavyweight White paper

610 x 408 mm (plate); 910 x 677 mm (sheet)

Published by Crown Point Press, San Francisco

Printed by Renée Bott

Edition: 85, plus 10 Artist's Proofs and 9 Trial Proofs (including 1 OKTP); the FAMSF Archive has 1 Artist's Proof (AP 6)

Crown Point Press Archive, gift of Crown Point Press

1993.51.204

184 [right]

Richard Diebenkorn

High Green Version I 1992

Color aquatint, spit bite aquatint, soft ground etching, hard ground etching, soap ground aquatint, sugar lift aquatint, and drypoint with scraping and burnishing on Somerset Soft White paper

1015 x 583 mm (plate); 1344 x 863 mm (sheet)

Published by Crown Point Press, San Francisco

Printed by Renée Bott

Edition: 65, plus 10 Artist's Proofs and 17 Trial Proofs (including 1 OKTP); the FAMSF Archive has 1 Artist's Proof (AP 6)

Crown Point Press Archive, gift of Crown Point Press

1993.51.333

Another version of this image was published in 1992 in an edition of sixty-five and titled *High Green Version II*. It differed subtly in color and plate wiping, but used the same plates as *Version I*.

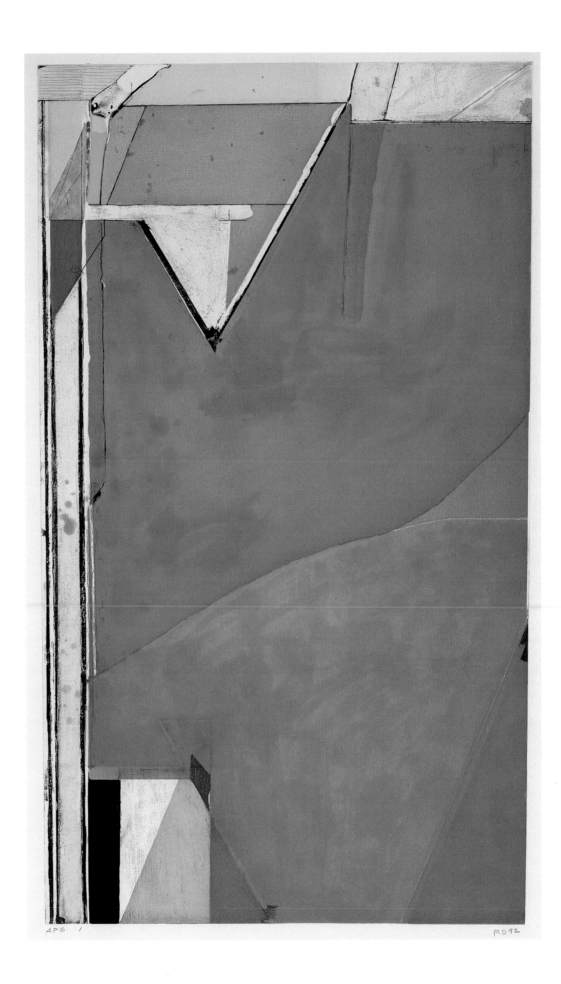

APG 1 RD92

185–191

John Cage

b. Los Angeles, California 1912 – d. New York, New York 1992

Seven Day Diary (Not Knowing) 1978

Portfolio of 7 prints on Rives Heavyweight Buff paper

Day One, hard ground etching and drypoint, 31 x 68 mm (plate)

Day Two, hard ground etching, drypoint, and soft ground etching, 29 x 105 mm (plate)

Day Three, hard ground etching, drypoint, soft ground etching, and sugar lift aquatint, 179 x 51 mm (plate)

Day Four, hard ground etching, drypoint, soft ground etching, sugar lift aquatint, and photoetching, 253 x 18 mm (plate)

Day Five, hard ground etching, drypoint, soft ground etching, sugar lift aquatint, photoetching, and impressions of inked objects, 36 x 167 mm (plate)

Day Six, color sugar lift aquatint, hard ground etching, drypoint, soft ground etching, photoetching, and impressions of inked objects, 180 x 145 mm (plate)

Day Seven, color sugar lift aquatint, drypoint, hard ground etching, photoetching, and impressions of inked objects, 126 x 77 mm (plate)

Sheet sizes for each are 305–307 x 427–430 mm, Rives Heavyweight Buff paper

Published by Crown Point Press, Oakland

Printed by Stephen Thomas

Edition: 25 portfolios, plus 10 Artist's Proof portfolios, 2 Trial Proof portfolios, 1 OKTP portfolio, and single Trial Proof impressions of *Day One* and *Day Six*; the FAMSF Archive has 1 Trial Proof portfolio (TP A)

Crown Point Press Archive, gift of Kathan Brown

1991.28.298–304

Cage's essay on the frontispiece of the portfolio describes this project, the first etchings he made:

> *Having accepted Kathan Brown's invitation to make etchings though I'd never made them before, I initiated a seven-day program to use the available techniques, an activity that would be characterized by my not knowing what I was doing.*
>
> *Towards the end of the first day, I Ching chance operations were used with respect to two techniques, hard ground and drypoint, determining the tool to be used and the number of marks on a copper plate to be made with it. When, through chance operations, the use of a tool previously used was indicated, that fact concluded the use of that particular technique. All marks were made without looking at the plate on which I was working. Lilah Toland [one of the printers] kept count since I sometimes missed the plate. On subsequent days a distinction between short, medium, and long marks was made and chance-determined. On each day a new technique, soft ground, sugar lift, the transfer of a photographic image, the impression under appropriate pressure of a found object, color, was added to the first, so that on the sixth day all seven were used in combination. For the last day (the work was actually done on the sixth day) which of these techniques were to be used and which were to be omitted was determined by chance operations. These operations also determined the orientation of a print in the space, and its position on the page. The size of the page is a twelve-inch square with two and one-half inch margins to the left and to the right.*

DAY TWO

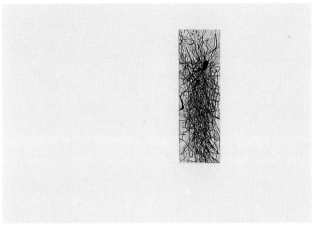

DAY THREE

DAY FOUR

DAY FIVE

DAY SIX

DAY SEVEN

192

John Cage

\# 35 from the series of 35

Changes and Disappearances 1979–1982

Color engraving, drypoint, and photoetching
on Twinrocker Gray-Green Laid paper

Various plate marks from 36 plates; 286 x 542 mm (sheet)

Published by Crown Point Press, Oakland

Printed by Lilah Toland

Edition: 2 sets, plus 11 individual Artist's Proofs; the
FAMSF Archive has one print (#35) from the "broken" set

Crown Point Press Archive, gift of Kathan Brown

1991.28.294

There are thirty-five related prints in this series, two
impressions made of each. One set of thirty-five
impressions was broken up for individual sale, the
second set was unbroken, and kept together as thirty-five
prints. Each of the prints has a unique palette of colors,
all mixed with some percentage (minimum 10%) of blue.
The number of plates used in any one of the etchings
was chance-determined, to a maximum of sixty-six. As
the project progressed and the plates were selected by
the *I Ching*, they accumulated lines and images of three
types: curved lines engraved by the artist; straight dry-
point lines drawn by the artist; and photographic images
of drawings from the journals of Henry David Thoreau.

193*

John Cage

2R + 13·14 (Where R = Ryoanji) 1983

Drypoint on J. Whatman Antique paper

178 x 538 mm (plate); 234 x 591 mm (sheet)

Published by Crown Point Press, Oakland

Printed by Lilah Toland

Edition: 25, plus 10 Artist's Proofs and 9 Trial Proofs (including 1 OKTP); the FAMSF Archive has 1 Artist's Proof (AP 6)

Crown Point Press Archive, gift of Crown Point Press

1992.167.52

When Cage arrived at the press to begin this project, he brought with him sixteen rocks he had picked up in various places around the world. He had the idea to do some work based on the Ryoanji rock garden in Kyoto, Japan. There are fifteen rocks in the Ryoanji garden, but Cage brought sixteen so that he could select fifteen for each print by chance operations. In the title of each work in the project, "R" stands for fifteen rocks and is squared or cubed. Cage found the position of each individual rock on the plate then drew around the rock with a light drypoint line, repeating this over and over, each time finding a new position by consulting his computer printed *I Ching* tables of chance operations. Because the Ryoanji garden is contained in a narrow space, Cage saw his printing plate as a contained space and would not allow any rock to cross the edge of the plate. He would swivel each rock, placing its flattest edge against an interior (non printing) grid line.

In this first print in the group, *2R + 13·14*, Cage drew around two rocks each fifteen times, then drew thirteen rocks each fourteen times. Cage originally intended to have in each print the possibility of eliminating some of the rocks through chance determination, but he changed his mind after the first print and used fifteen rocks in each of the successive prints.

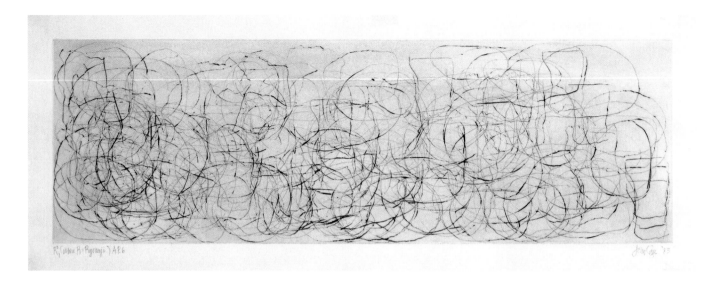

194*

John Cage

R²1 (Where R = Ryoanji) 1983

Drypoint on J. Whatman Antique paper

176 x 538 mm (plate); 239 x 597 mm (sheet)

Published by Crown Point Press, Oakland

Printed by Lilah Toland

Edition: 25, plus 10 Artist's Proofs and 8 Trial Proofs (including 1 OKTP); the FAMSF Archive has 1 Artist's Proof (AP 6)

Crown Point Press Archive, gift of Crown Point Press

1992.167.54

The next three prints he did were R^2, in versions *1*, *2*, and *3*, with *225* drawings on each plate. In each version, Cage varied the pressure he used in drawing, and, of course, the use of chance operations in placing the rocks assures that each of the three versions is quite different.

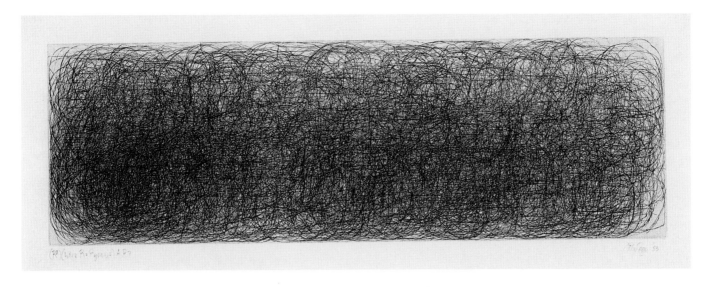

195*

John Cage

(R³) (Where R = Ryoanji) 1983

Drypoint on J. Whatman Antique paper

176 x 531 mm (plate); 234 x 592 mm (sheet)

Published by Crown Point Press, Oakland

Printed by Lilah Toland

Edition: 25, plus 10 Artist's Proofs and 8 Trial Proofs
(including 1 OKTP); the FAMSF Archive has
1 Artist's Proof (AP 7)

Crown Point Press Archive, gift of Crown Point Press

1992.167.57

Having completed R^2, Cage went on to the third
power. This entailed 3,375 rock drawings for each print.
Cage completed this and named it *(R³)* using parentheses
to indicate the closed-in quality that comes from the
containment of all the drawings within the plate.

196 [following page]

John Cage

Eninka 1 1986

Burned, smoked, and branded Gampi paper mounted on
Don Farnsworth handmade paper (unique impression)

No plate mark; 632 x 480 mm (sheet)

Published by Crown Point Press, Oakland

Printed by Marcia Bartholme

Edition: 50 unique impressions numbered 1–50, including
10 Artist's Proofs; the FAMSF Archive has impression #1

Crown Point Press Archive, gift of Crown Point Press

1992.167.47

Eninka means "Circle, Stamp, Fire" in Japanese.
The *Eninka* prints were created by igniting a chance-
determined number of newspaper sheets, then laying a
piece of Japanese Gampi paper on top and running it
through the press. The burned Gampi was then mounted
to a piece of Farnsworth handmade paper. Then the
images were branded with an iron ring. The placement
of the ring on the print and its temperature (which
controlled the strength of its mark) were also determined
by chance operations.

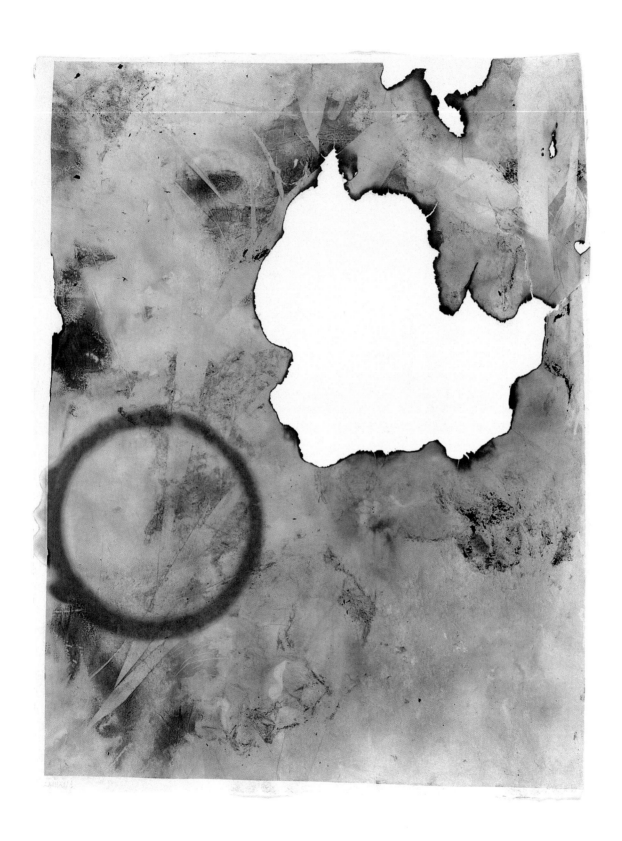

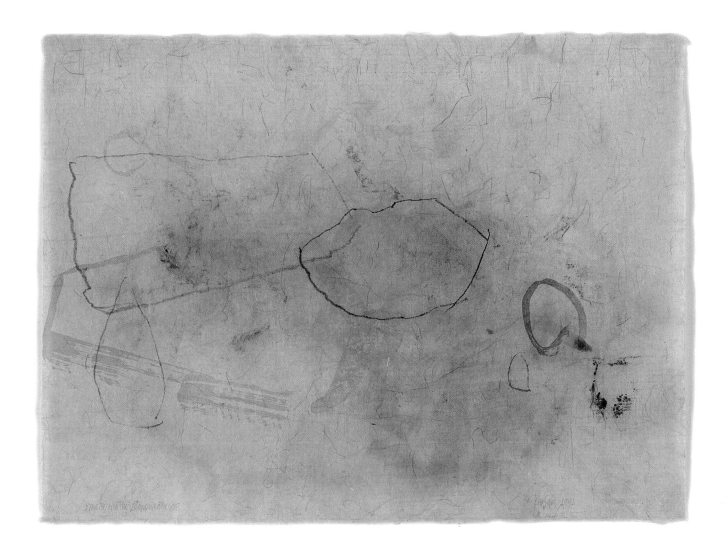

197

John Cage

Smoke Weather Stone Weather 28 1991

Color spit bite aquatint and soft ground etching
on smoked Okinawa paper

No visible plate mark; 383 x 503 mm (sheet)

Published by Crown Point Press, San Francisco

Printed by Paul Mullowney

Edition: 37 unique impressions (numbered 1–37), including
10 Artist's Proofs; the FAMSF Archive has impression #28

Crown Point Press Archive, gift of Crown Point Press

1992.167.49

The Crown Point Press printers smoked the paper by setting on fire several crumbled pieces of newspaper and then placing dampened paper on the fire to extinguish it. The smoke and occasional burn marks are recorded differently on each sheet. Next, Cage traced the outlines of forty-five stones onto fifteen metal plates using soft ground etching, spit bite aquatint or sugar lift aquatint. The methods of mark making, the placement of tracings, and the color used were selected by chance. The impressions were always printed singularly, and no stone tracings appear twice in one print.

198

John Cage

HV2 19c 1990

Color aquatint with foul biting on Betty Friedman handmade (natural Acaba) paper

Nineteen variously sized plate marks; 303 x 372 mm (sheet)

Published by Crown Point Press, San Francisco

Printed by Pamela Paulson

Edition: 45 (15 unique impressions in editions of 3 each), including 10 Artist's Proofs and 5 Trial Proofs; the FAMSF Archive has 19c

Crown Point Press Archive, gift of Crown Point Press

1993.51.355

For the fifteen images that comprise *HV2*, Cage arranged small copper plates in an improvisatory way, either in a horizontal or vertical direction so that they fit tightly together. The deckle-edge, handmade paper was laid inside the block made by the plates, so there is no peripheral plate mark. All of the plates were fragments that Cage found around the studio, many of them bearing marks of wear, an occasional registration mark from a previous project, and sometimes grease or tarnish. All of these imperfections were retained and valued by Cage. The choice of color in each print was determined by chance operation based on the *I Ching* charts that Cage used for much of his decision making.

199

John Cage
Without Horizon 15 1992

Sugar lift aquatint, spit bite aquatint, and drypoint on
Betty Friedman handmade (tinted natural Acaba) paper

Two partial plate marks; 185 x 225 mm (sheet)

Published by Crown Point Press, San Francisco

Printed by Pamela Paulson

Edition: 57 unique impressions (numbered 1–57), including
10 Artist's Proofs; the FAMSF Archive has #15

Crown Point Press Archive, gift of Crown Point Press

1993.51.99

The title, *Without Horizon*, comes from a mesostic—an
acrostic-like poem written by Cage. In this print, the
artist chose fifty-seven edges of thirteen stones to use as
templates. Using five etching techniques and traditional
or improvised drawing tools, he drew along the edges of
the stones directly on a series of plates. The technique,
tool, and particular stone edge were all chosen by chance
operations for the creation of each image. Then the
images were assembled together by chance operations
with one, three, four, or five images in each print.

Catalogue Note

All prints reproduced in the exhibition catalogue are from the collection of the Crown Point Press Archive at the Fine Arts Museums of San Francisco. Works marked by an asterisk are not included in the showing in Washington, D.C., at the National Gallery of Art. Of the 124 works on view in the exhibition in Washington, 91 are from the collection of the National Gallery of Art.

Measurements are given in millimeters, height preceding width. Plate size refers to the plate mark on the sheet. Image size refers to the printed image on the sheet when there is no plate mark, as in a woodcut. For prints made with multiple plates, the overall plate/image size is indicated.

Information on the edition size, number of proofs, and some commentary has been taken from the Crown Point Press documentation sheets. This documentation often does not exist for prints published by Parasol Press, or other publishers, or by Crown Point Press prior to 1977. Consequently, some information has been taken from printer's notes in project files at Crown Point Press. Although there may have been many printers involved in a given project, the printer in charge of the project is listed.

Published catalogues raisonnés are shown in abbreviated form at the end of the documentation of a print. The catalogues used in this checklist are:

Acton, David. *William Brice Works on Paper 1982–1992*, catalogue raisonné in the exhibition catalogue. Los Angeles: Grunwald Center for the Graphic Arts/University of California Los Angeles, 1993.

Axom, Richard H., and David Platzker. *Printed Stuff: Prints, Posters and Ephemera by Claes Oldenburg, A Catalogue Raisonné, 1958–1996*. New York: Hudson Hills Press, 1997.

D'Oench, Ellen G., and Hilarie Faberman. *Sylvia Plimack Mangold Works on Paper 1968–1991*, catalogue raisonné in the exhibition catalogue. Middletown, Connecticut: Davison Art Center, Wesleyan University; and Ann Arbor, Michigan: University of Michigan Museum of Art, 1992.

Guillemin, Chantal. *Richard Diebenkorn Etchings and Drypoints 1949–1980*, catalogue raisonné in the exhibition catalogue. Houston: Houston Fine Art Press, 1981.

Harrison, Pegram. *Frankenthaler, A Catalogue Raisonné, Prints 1961–1994*. New York: Harry N. Abrams, 1996.

Lewison, Jeremy. *Brice Marden Prints 1961–1991: A Catalogue Raisonné*, catalogue raisonné in the exhibition catalogue. London: The Tate Gallery, 1992.

Mason, Rainer Michael, and Juliane Willi-Cosandier. *Markus Raetz: les estampes/die druckgraphik/the prints 1958–1991*, catalogue raisonné in the exhibition catalogue. Geneva: Cabinet des estampes, Musée d'art et d'histoire; Berne: Kunstmuseum; Zurich: Galerie & Edition Stähli, 1991.

Sol LeWitt: Prints 1970–1986, catalogue raisonné in the exhibition catalogue. London: The Tate Gallery, 1992.

Willi, Juliane. *Pat Steir: Gravures. Prints. 1976–1988*, catalogue raisonné in the exhibition catalogue. Geneva: Cabinet des estampes, Musée d'art et d'histoire; and London: The Tate Gallery, 1988–1989.

Crown Point Press Roster

Crown Point Press Artists Published by the Press

Vito Acconci 1977, 1979, 1981
Anne Appleby 1994
William Bailey 1994, 1996
John Baldessari 1991
Robert Barry 1978
Iain Baxter 1979
Robert Bechtle 1982, 1983, 1987, 1990, 1993
Christian Boltanski 1991
William Brice 1985, 1987, 1990
Christopher Brown 1991, 1993, 1994, 1995
Kathan Brown 1964, 1967, 1972, 1975, 1982
Günter Brus 1982
Chris Burden 1977, 1980
Daniel Buren 1979
John Cage 1978, 1979, 1980, 1981, 1982, 1983, 1985, 1986, 1987, 1989, 1991, 1992
Francesco Clemente 1981, 1982, 1984, 1985, 1987, 1989, 1990
Chuck Close 1986
Bruce Conner 1971, 1972, 1973
Tony Cragg 1988, 1990
Brad Davis 1994
Richard Diebenkorn 1962–65, 1977, 1978, 1980, 1981, 1982, 1983, 1984, 1985, 1986, 1987, 1989, 1990, 1991, 1992
Rackstraw Downes 1984, 1986
Eric Fischl 1988
Joel Fisher 1980, 1990
Dan Flavin 1978
Terry Fox 1977
Helen Frankenthaler 1983
Hamish Fulton 1982
Katsura Funakoshi 1990, 1993
April Gornik 1988
Hans Haacke 1978, 1982
Al Held 1985, 1986, 1987, 1989, 1990, 1992, 1994
Tom Holland 1984, 1986
Robert Hudson 1986
Bryan Hunt 1986, 1988, 1991, 1992
Shoichi Ida 1984, 1986, 1987, 1989, 1992
Yvonne Jacquette 1987
Joan Jonas 1979, 1982
Anish Kapoor 1988, 1990, 1991
Alex Katz 1985, 1986, 1987, 1989, 1990
Per Kirkeby 1993
Elaine de Kooning 1985
Jannis Kounellis 1979
Joyce Kozloff 1981
Robert Kushner 1980, 1982, 1985, 1987, 1989, 1990, 1991, 1994
Bertrand Lavier 1987
Li Lin Lee 1989, 1990

Sherrie Levine 1986
Sol LeWitt 1980, 1983, 1986, 1991, 1997
Markus Lüpertz 1988
Robert Mangold 1978, 1985
Sylvia Plimack Mangold 1985
Brice Marden 1979
Tom Marioni 1974, 1977, 1979, 1980, 1981, 1982, 1984, 1986, 1987, 1988, 1990, 1991, 1992, 1994, 1995, 1996
Fred Martin 1966, 1969
Jim Melchert 1974
Robert Moskowitz 1988
Joan Nelson 1995
Nathan Oliveira 1994
Gay Outlaw 1995
Judy Pfaff 1984, 1987, 1992
Janis Provisor 1989, 1991, 1994
Markus Raetz 1991
Rammellzee 1984
Steve Reich 1978
Tim Rollins + K. O. S. 1989, 1990
Ed Ruscha 1982, 1988, 1995
David Salle 1987
Italo Scanga 1981
Sean Scully 1988
José Maria Sicilia 1988, 1989, 1990
Richard Smith 1985
Susana Solano 1991
Pat Steir 1977, 1978, 1980, 1981, 1982, 1984, 1985, 1986, 1987, 1988, 1989, 1990, 1991, 1992, 1993, 1996
Gary Stephan 1990
Wayne Thiebaud 1964–65, 1982, 1983, 1984, 1985, 1987, 1988, 1989, 1990, 1991, 1993, 1994, 1995
David True 1983, 1985, 1987, 1989
Richard Tuttle 1993
Beth Van Hoesen 1972
William T. Wiley 1978, 1979, 1982, 1983, 1989, 1996
Yutaka Yoshinga 1996

Crown Point Press Artists Published Elsewhere

William Bailey Parasol Press, Ltd., New York City, 1974
Jack Barth John Doyle Gallery, Chicago/Paris, 1974
Joel Bass John Doyle Gallery, Chicago/Paris, 1974
Mel Bochner Parasol Press Ltd., New York City, 1973, 1974, 1975–1978
Chuck Close Parasol Press Ltd., New York City, 1972, and Pace Editions Inc., New York City, 1977
Dan Flavin Parasol Press Ltd., New York City, 1973
Helen Frankenthaler John Berggruen Gallery, San Francisco, 1971
Marco Gastini Parasol Press Ltd., New York City, 1977
Susan Hall Brooke Alexander, 1973
Bryan Hunt Parasol Press Ltd., New York City, 1978, 1979
Barry Le Va Parasol Press Ltd., New York City, 1979, 1981
Sol LeWitt Parasol Press Ltd., New York City, 1971, 1973, 1974, 1975, 1976, 1977; Parasol Press and Wadsworth Atheneum, 1971; self-published 1975
Robert Mangold Parasol Press Ltd., New York City, 1973, 1974, 1975
Sylvia Plimack Mangold Parasol Press Ltd., New York City, 1977
Brice Marden Parasol Press Ltd., New York City, 1971, 1973, 1977, 1979
Agnes Martin prints not published, worked at Crown Point Press for Parasol Press in 1974
Don Nice Parasol Press Ltd., New York City, 1975
Arthur Okamura self-published, 1967
Claes Oldenburg Multiples, Inc. and Castelli Graphics, New York City, 1975, 1976; Multiples, Inc., New York City, 1976
Joseph Raffael self-published, 1975; Special Projects Group, Chicago, 1976
Edda Renouf Parasol Press Ltd., New York City, 1974, 1976, 1977, 1979
Dorothea Rockburne Parasol Press Ltd., New York City, 1972
Susan Rothenberg prints not published, worked at Crown Point Press for Parasol Press in 1979
Robert Ryman Parasol Press Ltd., New York City, 1972, 1975; self-published, 1972
Richard Smith Bernard Jacobson, London, 1976
Donald Sultan Parasol Press Ltd., New York City, 1979, 1980
Wayne Thiebaud Parasol Press Ltd., New York City, 1971, 1979
Beth Van Hoesen self-published 1971, 1972, 1976

Master Printers 1962–1997

Most printers at Crown Point Press begin work with little or no professional training and serve an apprenticeship of about three years before receiving the Master Printer title. The dates shown indicate the years each printer worked at Crown Point. Only printers who achieved Master Printer status are listed.

Nancy Anello 1978–1981, 1986–1987, 1988–1990

Marcia Bartholme 1980–1987

Renée Bott 1985–1996

Patricia Branstead 1969–1974

Kathan Brown 1962–present

Mark Callen 1987–1990

Jeannie Fine 1973–1975

Patrick Foy 1974–1978

Lawrence Hamlin 1985–1994

David Kelso 1978–1979

Paul Mullowney 1989–1993, December 1996– January 1997

Lothar Osterburg 1989–1993

Jeryl Parker 1962–1964, 1974–1977

Pamela Paulson 1987–1993

Peter Pettengill 1979–1985

Dena Schuckit 1994–present

Brian Shure 1987–1993

John Slivon 1976–1978

Doris Simmelink 1974–1978

Paul Singdahlsen 1977–1982

Daria Sywulak 1987–present

Hidekatsu Takada 1978–1986

Stephen Thomas 1975–1980

Lilah Toland 1978–1983

Program in Japan 1981–1991

Hidekatsu Takada
(program facilitator)

Kathan Brown and Constance Lewallen
(program coordinators)

SHIUNDO WORKSHOP, KYOTO
Tadashi Toda (printer)
Reizo Monjyu (carver)
Shunzo Matsuda (carver)

Program in the People's Republic of China 1987–1994

Xia Wei and Yong Hua Yang
(program facilitators)

Kathan Brown and Brian Shure
(program coordinators)

RONG BAO ZHAI STUDIO, BEIJING
Jin Shan Chang (carver)
Shu Mei Sun (printer)
Shi Juin Wang (printer and carver)

DUO YUN XUAN STUDIO, SHANGHAI
Qin Yun Hu (printer)
Gui Yin Li (printer)
Jiang Ming (carver)
Zheng Ji Qi (printer)
Yadi Xia (carver)

TAO HUA WU STUDIO, SUZHOU
Jin Da Fong (printer)
Zhi Jin Gu (printer and carver)
Tang Hong (carver)
Zhu Di Wang (printer)

CROWN POINT PRESS STUDIO, HANGZHOU
Zhi Jin Gu (carver and printer)
Qin Yun Hu (printer)

INDEPENDENT PRINTERS, HANGZHOU
Yin She Xu (carver and printer)
Cai Yan (carver and printer)

Support Staff 1962–1997

DIRECTOR/ASSOCIATE DIRECTOR
Kathan Brown*
Constance Lewallen
Karen McCready

GALLERY DIRECTOR
Frederica Drotos
Karen McCready
Vandy Seeburg
Valerie Wade*
Thomas Way

GALLERY ASSOCIATE
Stephanie Bleecher
Meg Malloy
Kerry O'Shea
Jody Rhone
Kim Schmidt
Katrina Traywick
Bao Vo*
Margaret Wrinkle

REGISTRAR
Mari Andrews*
Janice Capecci
Carol Drobeck
Miriam Mason

ADMINISTRATOR
Sasha Baguskas*
Wendy Diamond
Chantal Guillemin
Susan Jay
Jan Mehn
Janice Nessibou
Richard Pinegar
Russ Richardson
Stacie Scammell*
Nicole Siddharta
Kyle Wood

SHIPPING/FRAMING/BUILDING MANAGEMENT
Jonathan Byerly
Claire Radigan
Danny Ryan
Robert Seidler*
Stephan von Mason

SILK PROGRAM
Mady Jones
Deborra Stewart-Pettengill

POINT PUBLICATIONS
Constance Lewallen
Karin Victoria
Robin White

*Current staff (1997)

Publications

View, VOLS. **1–8** (1978–1993)

A series of interviews with artists,
most of whom have worked at Crown Point Press.

VOL. **1**

Cage, John. Interview by Robin White, 1978. *View*, vol. 1, no. 1 (April
 1978). Oakland, California: Point Publications, 1978.
Barry, Robert. Interview by Robin White, 1978. *View*, vol. 1, no. 2 (May
 1978). Oakland, California: Point Publications, 1978.
Steir, Pat. Interview by Robin White, 1978. *View*, vol. 1, no. 3 (June
 1978). Oakland, California: Point Publications, 1978.
Reich, Steve. Interview by Robin White, 1978. *View,* vol. 1, no. 4
 (September 1978). Oakland, California: Point Publications, 1978.
Marioni, Tom. Interview by Robin White, 1978. *View*, vol. 1, no. 5
 (October 1978). Oakland, California: Point Publications, 1978.
Haacke, Hans. Interview by Robin White, 1978. *View*, vol. 1, no. 6
 (November 1978). Oakland, California: Point Publications, 1978.
Mangold, Robert. Interview by Robin White, 1978. *View*, vol. 1, no. 7
 (December 1978). Oakland, California: Point Publications, 1978.
Burden, Chris. Interview by Robin White, 1978. *View*, vol. 1, no. 8
 (January 1979). Oakland, California: Point Publications, 1979.
Buren, Daniel. Interview by Robin White, 1979. *View*, vol. 1, no. 9
 (February 1979). Oakland, California: Point Publications, 1979.
Kounellis, Jannis. Interview by Robin White, 1979. *View*, vol. 1, no. 10
 (March 1979). Oakland, California: Point Publications, 1979.

VOL. **2**

Jonas, Joan. Interview by Robin White, 1979. *View*, vol. 2, no. 1 (April
 1979). Oakland, California: Point Publications, 1979.
Wiley, William T. Interview by Robin White, 1979. *View*, vol. 2, no. 2
 (May 1979). Oakland, California: Point Publications, 1979.
Fox, Terry. Interview by Robin White, 1979. *View*, vol. 2, no. 3 (June
 1979). Oakland, California: Point Publications, 1979.
Baxter, Iain. Interview by Robin White, 1979. *View*, vol. 2, no. 4
 (September 1979). Oakland, California: Point Publications, 1979.
Acconci, Vito. Interview by Robin White, 1979. *View*, vol. 2, nos. 5/6
 (October/November 1979). Oakland, California: Point Publications, 1979.
Fried, Howard. Interview by Robin White, 1979. *View*, vol. 2, no. 7
 (December 1979). Oakland, California: Point Publications, 1979.
Anderson, Laurie. Interview by Robin White, 1979. *View*, vol. 2, no. 8
 (January 1980). Oakland, California: Point Publications, 1980.
Kushner, Robert. Interview by Robin White, 1980. *View,* vol. 2, nos. 9/10
 (February/March 1980). Oakland, California: Point Publications, 1980.

VOL. **3**

Hunt, Bryan. Interview by Robin White, 1980. *View*, vol. 3, no. 1 (April
 1980). Oakland, California: Point Publications, 1980.
Marden, Brice. Interview by Robin White, 1980. *View*, vol. 3, no. 2
 (June 1980). Oakland, California: Point Publications, 1980.
Kozloff, Joyce. Interview by Robin White, 1981. *View*, vol. 3, no. 3
 (March 1981). Oakland, California: Point Publications, 1981.
Fisher, Joel. Interview by Robin White, 1981. *View*, vol. 3, no. 4 (July
 1981). San Francisco: Point Publications, 1981.
Scanga, Italo. Interview by Robin White, 1981. *View*, vol. 3, no. 5
 (September 1981). Oakland, California: Point Publications, 1981.
Clemente, Francesco. Interview by Robin White, 1981. *View*, vol. 3,
 no. 6 (November 1981). Oakland, California: Point
 Publications, 1981.

VOL. 4

Bechtle, Robert. Interview by Robin White, 1982. *View*, vol. 4, no. 1 (Spring 1983). Oakland, California: Point Publications, 1983.

Fulton, Hamish. Interview by Robin White, 1981. *View*, vol. 4, no. 2 (Spring 1983). Oakland, California: Point Publications, 1983.

Brus, Günter. Interview by Margarete Roeder, 1983. *View*, vol. 4, no. 3 (Spring 1986). Oakland, California: Point Publications, 1986.

Holland, Tom. Interview by Wendy Diamond, 1985. *View*, vol. 4, no. 4 (Spring 1986). Oakland, California: Point Publications, 1986.

True, David. Interview by Margaret Wrinkle, 1987. *View*, vol. 4, no. 5 (Spring 1988). San Francisco: Point Publications, 1988.

Brice, William. Interview: Part 1 by Wendy Diamond, December 1985; Part 2 by Constance Lewallen, March 1988. *View*, vol. 4, no. 6 (Spring 1988). San Francisco: Point Publications, 1988.

VOL. 5

De Kooning, Elaine. Interview by Robin White, 1985. *View*, vol. 5, no. 1 (Spring 1988). San Francisco: Point Publications, 1988.

Lavier, Bertrand. Interview by Constance Lewallen, 1988. *View*, vol. 5, no. 2 (Spring 1988). San Francisco: Point Publications, 1988.

Pfaff, Judy. Interview by Constance Lewallen, 1988. *View*, vol. 5, no. 3 (Summer 1988). San Francisco: Point Publications, 1988.

Scully, Sean. Interview by Constance Lewallen, 1988. *View*, vol. 5, no. 4 (Fall 1988). San Francisco: Point Publications, 1988.

Fischl, Eric. Interview: Part 1 by Tazmi Shinoda, 1988; Part 2: by Constance Lewallen, 1988. *View*, vol. 5, no. 5 (Fall 1988). San Francisco: Point Publications, 1988.

Gornik, April. Interview by Constance Lewallen, 1988. *View*, vol. 5, no. 6 (Fall 1988). San Francisco: Point Publications, 1988.

VOL. 6

Cragg, Tony. Interview by Constance Lewallen, September 1988. *View*, vol. 6, no. 1 (Winter 1988). San Francisco: Point Publications, 1989.

Moskowitz, Robert. Interview by Constance Lewallen, 1988. *View*, vol. 6, no. 2 (Winter 1989). San Francisco: Point Publications, 1989.

Held, Al. Interview by Constance Lewallen, 1989. *View*, vol. 6, no. 3 (Winter 1989). San Francisco: Point Publications, 1989.

Ida, Shoichi. Interview by Constance Lewallen, June 1989. *View*, vol. 6, no. 4 (Fall 1989). San Francisco: Point Publications, 1989.

Rollins, Tim, + K.O.S. Interview by Constance Lewallen, August, 1989. *View*, vol. 6, no. 5 (Winter 1990). San Francisco: Point Publications, 1990

Thiebaud, Wayne. Interview by Constance Lewallen, August, 1990. *View*, vol. 6, no. 6 (Winter 1990). San Francisco: Point Publications, 1990

VOL. 7

Provisor, Janis. Interview by Constance Lewallen, February 1990. *View*, vol. 7, no. 1 (Spring 1990). San Francisco: Point Publications, 1990

Stephan, Gary. Interview by Constance Lewallen, March 1990. *View*, vol. 7, no. 2 (Spring 1990). San Francisco: Point Publications, 1990.

Funakoshi, Katsura. Interview by Constance Lewallen, August 1990. *View*, vol. 7, no. 3 (Fall 1990). San Francisco: Point Publications, 1990

Kapoor, Anish. Interview by Constance Lewallen, September 1990. *View*, vol. 7, no. 4 (Fall 1991). San Francisco: Point Publications, 1991

Katz, Alex. Interview by Constance Lewallen, November 1990. *View*, vol. 7, no. 5 (Fall 1991). San Francisco: Point Publications, 1991.

Steir, Pat. Interview by Constance Lewallen, November 1990. *View*, vol. 7, no. 6 (Fall 1991). San Francisco: Point Publications, 1991.

VOL. 8

Baldessari, John. Interview by Constance Lewallen, July 1992. *View*, vol. 8, no. 1 (Winter 1993). San Francisco: Point Publications, 1993.

Brown, Christopher. Interview by Constance Lewallen, July, 1992. *View*, vol. 8, no. 2 (Winter 1993). San Francisco: Point Publications, 1993.

Vision, VOLS. 1–5 (1975–1981)

An art journal published in limited editions of 1000.

Marioni, Tom, ed. "California." *Vision*, vol. 1. Oakland, California: Crown Point Press, 1975.

Marioni, Tom, ed. "Eastern Europe." *Vision*, vol. 2. Oakland, California: Crown Point Press, 1976.

Marioni, Tom, ed. "New York City."*Vision*, vol. 3. Oakland, California: Crown Point Press, 1976.

Marioni, Tom, ed. "Word of Mouth." *Vision*, vol. 4. Phonograph record of prepared talks by Laurie Anderson, Chris Burden, Daniel Buren, John Cage, Bryan Hunt, Joan Jonas, Robert Kushner, Brice Marden, Tom Marioni, Pat Steir, Marina Abramovic/Ulay, William T. Wiley. Oakland, California: Crown Point Press, 1980.

Marioni, Tom, ed. "Artists' Photographs." *Vision*, vol. 5. Oakland, California: Crown Point Press, 1981.

Overview

An illustrated newsletter for Crown Point Press, published intermittently from 1984 through the present.

Spring 1984. Ed. Kathan Brown; Fall 1984. Ed. Wendy Diamond; Spring 1985. Ed. Wendy Diamond; Spring 1986. Ed. Wendy Diamond; Spring 1987. Ed. Wendy Diamond; Fall 1988. Ed. Constance Lewallen; Spring 1989. Ed. Constance Lewallen; Fall 1989. Ed. Constance Lewallen; January 1989. Ed. Constance Lewallen; Fall 1990. Ed. Constance Lewallen; Winter 1990. Ed. Constance Lewallen; Spring 1991 (May 15, 1991). Ed. Constance Lewallen; Fall 1991 (Sept. 21, 1991). Ed. Constance Lewallen; Spring 1992. Ed. Constance Lewallen; Fall 1992. Ed. Constance Lewallen; Winter 1992. Ed. Constance Lewallen; Spring 1993. Ed. Constance Lewallen; Fall 1993. Ed. Kathan Brown; Winter 1993. Ed. Constance Lewallen; Fall 1994; June 1994; March 1994; Winter 1994; April 1994; Fall 1994; November 1994; February 1995; April 1995; Fall 1995; Winter 1995; Spring 1996.

Crown Point Press Publications by Kathan Brown

With Kevin Parker and Anthony Marioni. *Voyage to the Cities of the Dawn*. Oakland: Crown Point Press, 1976.

Crown Point Press 1977. Oakland: Crown Point Press, 1977.

A Discussion of Value. Oakland: Crown Point Press, 1978.

A Discussion of Meaning. Oakland: Crown Point Press, 1979.

A Discussion of Beauty. Oakland: Crown Point Press, 1980.

With Jackson MacLow, William Spurlock, Peter Frank, and Douglas Crimp. *Music Sound Language Theater: John Cage, Tom Marioni, Robert Barry, Joan Jonas*. Oakland, California: Point Publications, 1980.

Italians and American Italians. Oakland, California: Point Publications, 1981.

Pat Steir: Etchings and Paintings. Oakland, California: Point Publications, 1981.

Representing Reality: Fragments from the Image Field. Oakland, California: Point Publications, 1982.

Diebenkorn Etchings. Oakland, California: Point Publications, 1982.

With Lilah Toland, Paul Singdahlsen, John Cage, and Anne d'Harnoncourt. *John Cage Etchings 1978–1982*. Oakland, California: Point Publications, 1982.

Ink, Paper, Metal, Wood: How to Recognize Contemporary Artist's Prints, a Handbook. San Francisco: Point Publications, 1992.

Additional Crown Point Press Publications

Lewallen, Constance. *William T. Wiley at Crown Point Press*. San Francisco: Point Publications, 1989.

Glossary

Definitions were compiled by Karin Breuer from Kathan Brown's brochures and publications and reflect the practices at Crown Point Press. For in-depth explanations, see Brown, *ink, paper, metal, wood: Painters and Sculptors at Crown Point Press* (San Francisco: Chronicle Books, 1996).

Aquatint: A tonal method of etching. At Crown Point Press, granular tree rosin is dusted on the metal plate (usually copper), then melted to make it adhere. Areas where tone is not wanted are blocked out with varnish. Acid bites around each grain of rosin, giving the plate a tooth to hold ink. There are several types of aquatint, all of which allow the artist to paint an image on the plate to create a gestural effect.

Sugar lift aquatint: The artist paints an image on a bare plate with a sugar and water solution that is flexible and easily wiped off. When completed, the drawing is dried and covered with varnish, dried again, and then placed in water. The sugar lifts in the water but the varnish around it remains to protect the plate, leaving the image area unprotected. The plate is dusted with rosin and bitten in a tray of acid. The varnish is the ground that protects the plate. The printed image is dark against a light background.

Soap ground aquatint, also called **white ground aquatint**: After a plate is prepared with rosin, the artist paints an image with soap that acts as an imperfect ground. When the plate is submerged in acid, the acid bites unevenly according to variations in the soap's thickness. The printed image is light against a dark background.

Spit bite aquatint: No ground is used to create the image. The plate is not submerged in a tray of acid. Instead the artist paints the acid directly on a plate already prepared to bite as an aquatint. An unevenness of tone results from the artist's handling of the brush and from the amount of acid used.

Color printing: Usually achieved when several plates are printed one on top of the other. A separate plate is required when areas of different colors overlap one another. *À la poupée* is a method of color printing in which several colors are inked on a single plate.

Drypoint: A linear process in which an artist draws with a sharp tool directly onto the plate. The lines produced are characteristically soft and fuzzy because the displaced metal, or burr, raised by the tool remains to hold ink along with the incised groove.

195

Edition: The prints from any image that are offered for sale. Each bears a serial number above another number indicating the edition size. The number appears as a fraction, e.g., print 1/25 is number one in an edition of twenty-five. The top number does not necessarily indicate the order of printing.

Engraving: A linear process in which an artist cuts directly into the plate with a faceted tool called a burin to produce a sharp line.

Hard ground etching, sometimes simply called **etching**: A plate is coated with wax or varnish, called a ground or resist. A sharp tool called a needle is used to scratch away the ground. The plate is immersed in acid which attacks (bites) the areas that have been scratched away, incising lines that are later filled with ink and printed. A sharp line is characteristic of hard ground etching. The extent of the acid bite is controlled by the length of time the plate remains in the acid. A deeper bite yields a darker line or tone.

Intaglio (to cut or incise, from the Italian *intagliare*): Describes a number of printing processes including engraving, etching, drypoint, aquatint, and mezzotint. A metal plate is incised, coated with ink that is pressed into the incised areas, then wiped clean, usually with the palm of the hand. The inked plate is laid on the flat bed of an etching press, covered with damp paper and layers of felt, then subjected by the press roller to many tons of pressure, transferring the image to the paper. At Crown Point Press, and throughout this book, the term **etching** is used interchangeably with **intaglio** as a generic representing many different techniques described here.

Mezzotint: A process in which the artist works from dark to light. A solid black plate is usually created by working a shaped tool made of little spikes, called a rocker, over it to produce a tooth. The artist scrapes away the tooth in varying degrees to create areas that remain white or print in various shades of gray.

Photogravure: An image is put on a plate photographically, the plate is bitten to different depths, and tone (or tooth) is applied with aquatint, then printed in intaglio. Direct gravure is a variant without use of a camera in which the artist draws an image on a plastic film for transfer to the plate.

Photoetching: Photographic images are applied to the plate using a plastic ground and a halftone screen to create tooth instead of aquatint, as in photogravure.

Plate mark: The indented impression of the edge of the plate in the paper resulting from the pressure of the printing press. If the plate edge has been filed and wiped clean, the mark will be a clean indentation. Otherwise, it will hold ink and print an irregular line.

Proof impressions: Prints in addition to the numbered edition that are retained by the artist, the printers, and the publisher.

Artist's Proofs: Printed for distribution to the artists, the printers, and the publisher. At Crown Point Press, ten Artist's Proofs are printed of which half become the property of the artist. They are equal in quality to the edition.

Trial Proofs: Equal in quality to the edition, or slightly imperfect prints whose flaws are acceptable to the artist.

OK to Print Proof, also called the **Right to Print** or *Bon à Tirer:* The first proof that meets the approval of the artist. It is used as a model by the printers when they print the edition. It may have pinholes, fingerprints, and minor technical flaws.

Working Proofs or **State Proofs**: Usually pulled before the plate is finished and different from the edition. They often record an artist's progress at various stages of a project.

Roulette: A small, spike-wheeled tool used for making marks on the plate to produce a closely dotted, soft, and furry line.

Scraping and burnishing: Methods of making changes in the incised plate. Scraping is done first. A triangular, wedge-shaped tool with a knife blade at each edge is used to scrape away the metal below the level of the incision. The scraped area no longer holds ink. The burnisher, a bent rounded tool, smoothes and polishes the surface after it has been scraped.

Soft ground etching: The wax ground, or resist, is soft enough to be removed by pressing something into it. Traditionally, paper is laid over the waxed plate and pressure is applied with pencil, pen, fingers, or crayon, transferring the wax to the back of the paper and exposing areas of the plate to be etched. When printed, soft ground lines are similar to pencil or crayon lines. Soft ground can also be used to obtain the image of anything flat, flexible, and textured, such as a leaf.

Photo Credits

Numbers refer to essay figures.

RUTH E. FINE ESSAY
Joseph McDonald: 6, 19, 26, 38
Richard Barnes: 22
Mildred Bowman: 1
Kathan Brown: 8, 9, 17, 20, 25, 27, 31, 32, 33, 39–42
Patrick Dullanty: 4, 7
Denise Hall: 24
Tom Marioni: 23
Colin McRae: 3, 5, 12, 13, 15, 18, 21, 29, 30, 35–37
Kevin Parker: 11, 14, 16
Donald J. Saff: 10
Hidekatsu Takada: 28

KARIN BREUER ESSAY
Joseph McDonald: all figures

STEVEN A. NASH ESSAY
M. Lee Fatherree (courtesy Palo Alto Cultural Center): 12
Joseph McDonald: 1, 2, 4, 5, 8, 10
Robert Miller Gallery: 6
James R. Palmer: 3
Daniel Weinberg Gallery: 9

EXHIBITION CATALOGUE (INCLUDES COVER AND FRONTISPIECE)
Joseph McDonald: all catalogue plates

THIRTY-FIVE YEARS AT CROWN POINT PRESS:
MAKING PRINTS, DOING ART

Produced by the Publications Department of the Fine Arts Museums of San Francisco
Ann Heath Karlstrom, Director of Publications and Graphic Design
Karen Kevorkian, Managing Editor

Book and cover design by Michael Sumner
Copyediting and design assistance by Melody Sumner Carnahan
Typeset in Janson and Univers by Michael Sumner/Burning Books, Santa Fe, New Mexico

Printed and bound by C&C Offset Printing Co., Hong Kong